*THE BOOK OF THE*

# CORONATION
# PACIFICS

## A Photographic Accompaniment:3

# More Big 'Uns

### Notes by Allan C. Baker

## IRWELL PRESS Ltd.

First published in the United Kingdom in 2007
by Irwell Press Limited, 59A, High Street, Clophill,
Bedfordshire MK45 4BE
Printed by Latimer Trends, Plymouth

# Preface

*A*nother book of picture of Stanier's legendary 'Duchess' Pacifics? Why not if, like me, the reader considers these magnificent express passenger locomotive the finest ever to have run in this country. Surely, it's impossible to have enough of them? And the publisher is in thrall to them too! These few words will of course bring out the partisan feelings of the rival Crewe and Doncaster schools, not to mention Swindon and those south of the Thames, but I stand by my convictions.

Indeed I too, have written about these engines many times before, both in books and articles and I have been summoned up by the present publishers on numerous occasions when items concerning them have appeared in the pages of *British Railways Illustrated*, along with various books. So when a mountain of hitherto (largely) unpublished and excellent pictures of these engines descended on me with the suggestion that I might like to select around a hundred, caption them and form them into a book, I jumped at the chance. You can never, to my mind, tire of writing of one's favourite main line locomotives!

To someone born and brought up in the Potteries, the ex-LMS Pacifics were very infrequent visitors, but we were only a few miles from the West Coast Main Line (WCML) as it passed through the Severn-Trent watershed between Crewe and Stafford. I was lucky in that my father had a great interest in railways, being an accomplished model engineer building live steam locomotives in both 3½in and 5in gauges, so a study of the 'real-things' was a prerequisite to his hobby! From very young days a trip out into the countryside on Saturday and Sunday afternoons not infrequently had a least some time by the lineside somewhere or other, as often as not at Stableford on the WCML just south of Whitmore and the well known water troughs. Here the highlight of the

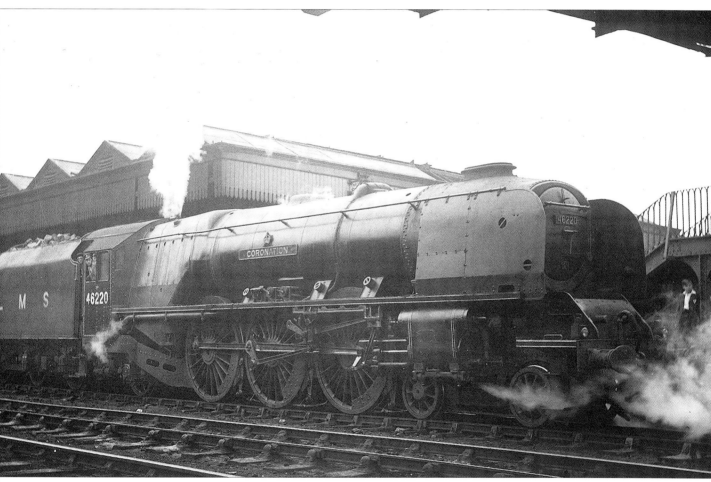

The doyen of the class, 46220 CORONATION itself, in very early BR days at the north end of platform 2, Crewe. It has a 27A shed plate for Polmadie, altered to 66A when the LMS system of coding was adopted across BR in mid-1949 and CORONATION received its BR number in July 1948, so this picture probably dates from early 1949. It is in the straw lined black livery still with L M S on the tender. This is full of coal and presumably the engine has just come onto the train and will be heading home. Notice the prominent Fowler-Anderson cylinder by-pass valves below the cylinder. The first five engines were all fitted with this valve which is strange, and I have never found anybody who could explain why. By the time these engines were built these valves had already been discredited; the piston rings in them had a bad habit of breaking with the result both ends of the cylinder got steam at the same time, not a very good idea! Their purpose was to connect both ends of the cylinder when the engines were coasting and thus prevent air compression problems, but simple anti-vacuum valves were equally effective. There was absolutely no logic in them being fitted in this case and the five were the only Stanier engines to have them; perhaps some die-hard in the design office, still smarting over the disappearance of everything Derby, was trying to make a stand! Whatever the case, by the time the engines were 'defrocked' ordinary anti-vacuum valves had been fitted and the Fowler-Anderson valves blanked off. Nevertheless it was some time before they were removed and in the case of 46223 and 46224 they never were, not on the outside cylinders at least. Photograph The Transport Treasury.

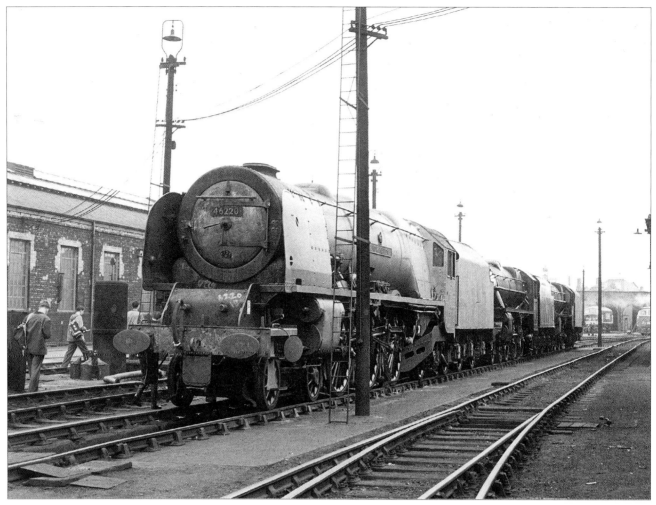

CORONATION on the Vacuum Pits at Crewe, awaiting entry to the Paint Shop for a complete repaint. This indicates a General repair, doubtless its last and I would date this picture at around June 1962. Notice the D1000 class 'Western' diesel hydraulic outside the shop; the first of these built at Crewe was ex-works in July 1962, overlapping a small order of 2,500hp Type 4s. One of these can also be seen in the background. 46220 went from Crewe North to Carlisle Upperby (note the 12B plate) in February 1961. The 'spotters' walking around suggest this is a Sunday and if the engine had not yet been steam tested, it would be before painting later in the week. By this time the Fowler-Anderson cylinder by-pass valves have gone; one of the anti-vacuum valves that replaced them can just be discerned in front of the left-hand valve chest cover. Photograph Paul Chancellor Collection.

afternoon would be the passing of the up 'Royal Scot', in those times almost always Duchess-hauled, with headboard. What always fascinated me was the special board on the vestibule of the last coach with the tartan paintwork and thistle.

There were also trips with dad on occasional Saturday mornings from our local station at Etruria to Crewe. How fondly I recall the invite from a kindly driver and his mate up on to the footplate of 46229 DUCHESS OF HAMILTON, fresh from overhaul at Crewe and resplendent in the BR green livery, at Platform 6 on a running in turn from Chester. This and my first sight of one of the engines in the then new maroon livery, 46247 CITY OF LIVERPOOL, one of a string of 'fresh off' engines en-route from the Works to Crewe South shed on another Saturday morning. I can see them both now and I suspect they are memories that will remain with me always. Later still, now mobile with a push-bike, I would set off on Saturdays and during school holidays for Stableford, Whitmore or on occasions Madeley. With mum's

packed lunch and the ABCs in the saddle bags I would spend days by the lineside. The Scottish Region engines were always elusive, especially south of Crewe, and I well remember my first sighting of 46227 DUCHESS OF DEVONSHIRE, always allocated to 66A Polmadie as I recall, with Caledonian blue background to the smoke box number plate and name plates. I was about to leave for home at the time as it was getting late, and marvelled on the 'cop' all the way home, wondering if my mates would believe me. I was home almost before I knew it, hardly noticing the seven miles! It was immensely enjoyable before going to bed later that evening, to proudly and neatly underline the relevant entry in the Ian Allan ABC – which I still have by the way – and I slept very soundly and contentedly that night!

I suppose it follows then, that from almost as early an age as was possible, it was a foregone conclusion that I would become a railwayman, and I have told before how this came about. Suffice it to say here that I commenced an apprenticeship in the Motive Power

Department at Crewe North shed, and the very first engine I worked on was 46253 CITY OF ST ALBANS. Like the three engines of the class I have already mentioned, I can see her now standing at the extreme southern end of No.8 road in the Middle Shed with sister engine 48228 DUCHESS OF RUTLAND alongside on No.7 road. Both engines were undergoing valve and piston examinations at 36,000 miles or thereabouts, at the time the principal scheduled shed mileage examinations. In the case of the LMR Class 8 Pacifics all such examinations were undertaken at Crewe North, irrespective of the home depot – for more of which, see below.

Over the next year or so I worked on a number of Duchesses – we called them *Big 'Uns* – as well as a few of the earlier Princess class – known as *Lizzies* – but withdrawal of these latter engines had already commenced. While I have already written extensively about my experiences at Crewe North, a few more words will not go amiss here. At the time Crewe North was in a rather dilapidated state and despite some

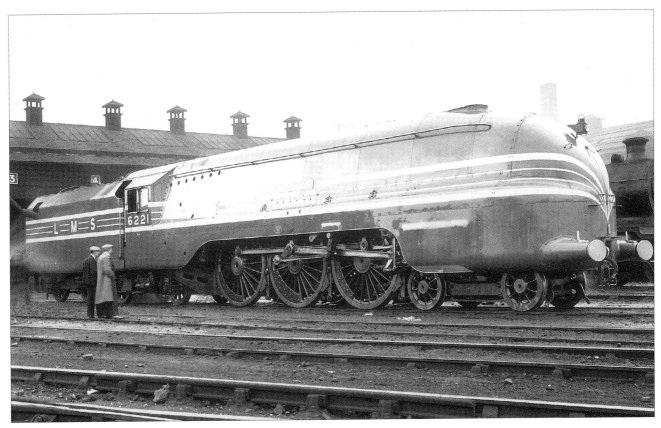

Presumably taken on the same occasion, two stirring pre-war views of 6221 QUEEN ELIZABETH on Polmadie shed. It is in the light blue livery to match the train sets used on the 'Coronation Scot' between Euston and Glasgow. QUEEN ELIZABETH looks quite new so I would date the pictures at some time in 1937 (it was new in June that year). Note the door in the streamlined tender fairing for the water bag and, in the second picture, the reporting number W27. If both were taken on the same date, then the engine has been made ready to work the train and is about to head off to Glasgow Central. I cannot find this number in the Working Timetables of the period, so it may have been a special of some sort. The 'Coronation Scot' reporting number in the down direction was W126, and the 'Royal Scot' W96, the two most likely workings in normal circumstances. Notice the speedometer drive from the trailing coupled axle on the left side and the bowler hatted Inspector. Notice too, the fancy lamps to match the streamlining. Photograph W. Hermiston, The Transport Treasury.

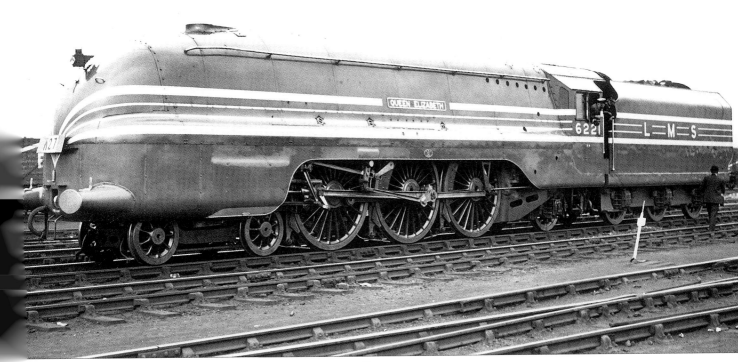

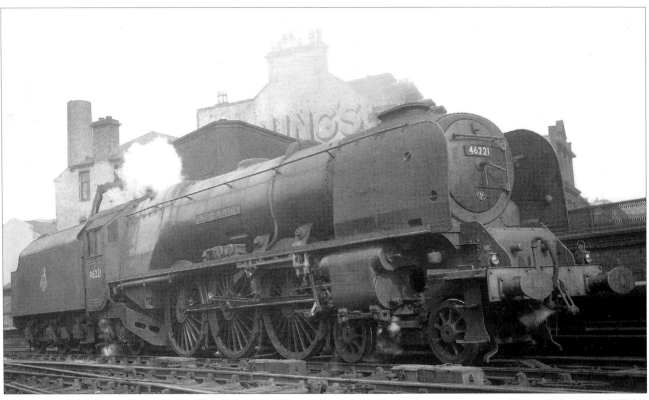

In the short-lived blue livery originally chosen by BR for Class 8 express passenger engines, Polmadie's 46221 QUEEN ELIZABETH is taking water at Glasgow St Enoch, doubtless prior to picking up its train. It would have travelled some distance from the shed to St Enoch, so the crew would be taking the opportunity to top up before heading south via the Glasgow & South Western route to Carlisle. Good enginemen never missed an opportunity to 'put the bag in!' The engine only carried this livery between October 1950 and January 1953, so the picture dates from that period. Photograph The Transport Treasury.

improvements which included a new semi-roundhouse, coaling and ash handling plants, the wholesale transformation envisaged in the immediate post-war years had failed to materialise. The Middle Shed, so called as originally it had been in the middle of three sheds, was a wonderful place to work; surrounded with what was already my life-long love, it was utopia indeed! Steam disappeared in this country comparatively quickly and the rot had already started when I commenced my apprenticeship, so I spent around half of it on other forms of traction. But it has been a lasting pleasure and enjoyment that I was able to work with steam locomotives as they went about their daily activities. I would not have forsaken the experience for anything and I treasure my memories, my note books, friendships made and other acquaintances probably as much as, if not more than anything else in my railway career, now in its 46th year.

In efforts to improve the availability and hence utilisation of all the Pacifics, the LMS had concentrated what were termed the 'No.8' valve and piston examinations (due at 30,000-36,000 miles) at Crewe North. The reasoning was simple, the convenience of the nearby works; Crewe in any event was responsible for the maintenance of the class, so any components needing attention could be speedily despatched, attended to and returned. A number of the small motion parts, the combining

lever for example, had needle roller bearings which were beyond us at the sheds, and the rocker arms on the Duchesses sometimes needed attention that we were unable to give. Although I was never personally involved I was told by my new-found 'mates', that sometimes the eccentrics driving the inside motion on the 'Lizzies' needed attention beyond the shed's resources and these components too, went to the works for repairs. By this process the engines could be turned round in five days; they would be 'stopped' on Sunday evenings and positioned for work to start on Monday morning and, provided all went to plan (it almost always did) they would be released on Friday afternoon so as to return to traffic some time on Saturday.

I have no quantitative information on what if any improvement this arrangement made to the utilisation of these engines, but after nationalisation pressure from the newly-formed Scottish Region led to the Polmadie 'Big 'Uns' being dealt with there. It is a fact that the Scottish-based engines almost always accumulated a lower mileage than their English counterparts and occasionally efforts had been made to improve this, by instituting through working between Glasgow and Euston, for instance, on cyclic diagrams. I will describe some of the Scottish Region Pacific workings in a later volume; suffice to say here, LMR folk felt that while the Polmadie engines were often cleaner than their south of the border

brethren, the mechanical condition did not compete. Stories circulated that on occasion Polmadie would undertake the valve and piston examinations in two stages; for example one side of the engine might be attended to during one period when the engine was 'stopped', and the other side on another occasion! We reckoned if they had put as much effort into maintenance as they did cleaning, it would have been effort better spent.

When the time came for the engines to be withdrawn from service there was talk of transferring some of them (a figure of eleven was mentioned in some circles) to the Southern Region to help out the Bullieds on the Western Division. Geoff Sands who had been Shedmaster at Crewe North until the early months of 1964, and who later migrated to the Southern Region as Motive Power Officer for the Western Division was a keen advocate of such a move. Two issues of concern were some tight clearances and the water capacity of the tenders. In the event nothing came of the proposition and the remaining members of the class went to the breakers. This was premature, many would aver, especially as the troubles persisted with the diesels, the train heating boilers among other dismal problems. It would have been good to see how they would have pitted themselves against the rebuilt Bullieds, especially after the men became accustomed to them. On the odd occasion when members of the class

were loaned to the Western Region they gave a good account of themselves; Stanier would have been very proud of this I am sure!

This is perhaps a good juncture to say something about 46242 CITY OF GLASGOW, the engine off the 8.15 pm Perth-Euston, involved in the terrible Harrow & Wealdstone accident on 8 October 1952. Of the three engines caught up in the disaster this was the only one repaired and returned to service. It had taken over the train at Crewe and was in the charge of driver Bob Jones and fireman Colin Turnock from Crewe North. There has been much speculation over the years, in view of the extensive damage this locomotive suffered, that in fact what emerged from Crewe over a year later in late October 1953 was a completely new engine. I have written about this before because when doing one of my stints in Crewe Works, I came across a few men who had actually worked on it on that occasion. All motive power apprentices in BR days spent some time in a main works, usually the one nearest to where they lived, but even so in a lot of cases it meant lodging. In my case it was of course Crewe, and not a lot different in journey time from my home in Newcastle-under-Lyme than the North Shed or the later Diesel Depot. When I was in the main erecting shop (we called it 'Ten Shop') I used to engage my new-found mates in conversation at lunch (of course in those days we called it 'dinner time') and tea breaks as well as

on other occasions when we managed to hide away from the foreman! I came across a couple of older fellows who had actually worked in 46242 after Harrow and they told me that what in fact happened was that whilst a lot of the engine was new, part of the main frames, the rear end frame extensions and the trailing truck were not, and that part of the front end frames and cylinders came from one of the other engines involved. This was 46202, the former turbine-driven 'Princess Royal', which had recently been rebuilt and had an identical front end to a 'Duchess', as opposed to the different layout of the other 'Princess Royals'. The remnants of this engine was then scrapped.

The fact that 46242 was not a new engine was confirmed in my mind by another fellow involved at the time. This was Frank Jones who was a member of the Crewe Model Engineering Society, known through dad's model engineering activities and at the time an instructor in the Crewe Works Apprentice Training School. Frank had for a long time been one of the Works Inspectors and among other activities he used to get involved with complaints from sheds and other operating people about engines that had been in the Works, or were considered in need of main works attention. In these latter cases Frank was often called upon to adjudicate. The sheds of course were always trying to get more engines into main works while the works people were always

trying to keep them out! Frank told me that after 46242 had returned to traffic complaints were received to the effect that smoke was entering the cab and making conditions unpleasant. Initially it was considered this might just be superstitious crews as there were other rumours about of men not wanting to work on 'Bob Jones' engine'. Both driver and fireman had been killed at Harrow and it has never been established exactly why the Perth train ran past signals at danger to bring about the collision. Eventually, after complaints arrived from enginemen not based at Crewe, Frank went to have a look and in riding on the engine himself confirmed that indeed in certain circumstances smoke did enter the cab. On a detailed examination it turned out that the roof was slightly lower than the front plate of the tender, allowing drifting smoke to be diverted inside.

When CITY OF GLASGOW was returned to Crewe for further investigation it was discovered that despite the cab being a new structure, the framing on which it was mounted was slightly out of line, a point not appreciated during the rebuilding. It was not a big job to rectify it and subsequently all was well. The point is that this slight mis-alignment of the framing would hardly have occurred if the engine had been a completely new one. Frank too, was of the opinion that the engine had been repaired, albeit extensively, and was not a completely new one. He had seen the work

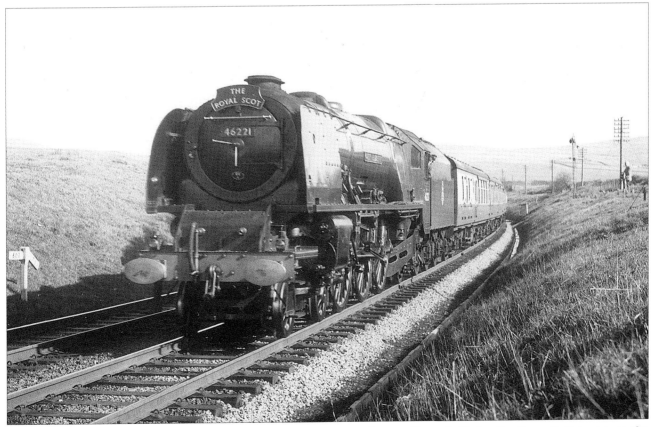

QUEEN ELIZABETH climbing Beattock, almost at the summit on the northbound climb – the Summit distant is to the right. A clear exhaust as the fire would have been well burnt through by now; it is downhill almost all the way from the summit to Glasgow. The train is the down 'Royal Scot' and the date 2 May 1953. Notice the gradient post as the climb eases from 1 in 75 to 1 in 800. Photograph The Transport Treasury.

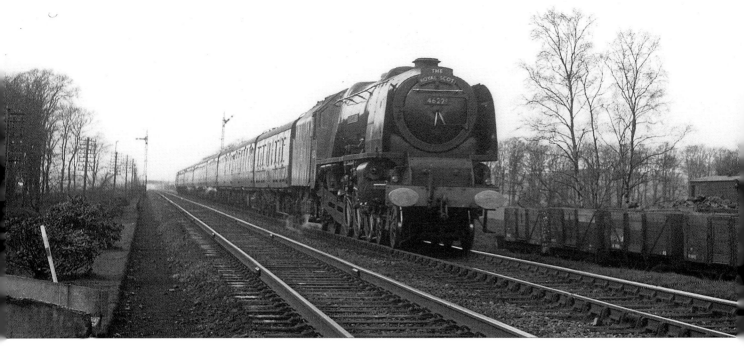

progressing on occasions when he had cause to visit the Erecting Shop.

Most of the pictures in this book were taken in the 1950s and early 1960s. After the war the track and other structures, for obvious reasons, were in pretty run-down condition. Hence the timings of trains had been gradually lengthened to accommodate the numerous speed restrictions. As the 1950s progressed a gradual tightening of timings took place as the arrears in maintenance and relaying were tackled on most lines. This was particularly so on the West Coast Main Line for the Anglo-Scottish services and it was on these services that the 'Duchess' Pacifics were largely employed. The most significant single improvement came with the summer 1954 timetable when the engines on both the 'Royal Scot' and 'Mid-Day Scot' worked through between Euston and Glasgow in both directions. This working was usually shared between Polmadie, Carlisle Upperby and Camden crews but with Polmadie and Camden engines. The improvements culminated, so far as steam traction was concerned, with the introduction of a new named train, 'The Caledonian' in the summer of 1957, with a six hour 40 minute timing in each direction between Euston and Glasgow. The down train left Euston at 16.15 and the up train Glasgow at 08.30, the load always being limited to eight coaches including a restaurant car. In June 1958 a second working was introduced leaving Euston at 07.45 and Glasgow at 16.00 – the two trains thereafter became known as the Morning and Afternoon 'Caledonian'. However, the second train proved unpopular with the travelling public and only ran for the summer timetable of 1958. The working of these trains was the only case in BR days of consistent through

working of engines between Euston and Glasgow, with a crew change at Carlisle. The service operated on Monday to Fridays only so, suitably augmented with other vehicles, the coaches were utilised on summer Saturdays for a somewhat slower train between the two cities.

The timing of the trains over different sections of the route were laid down in what was referred to as 'The Loads Book' ('Loads of Passenger Trains with Relative Instructions'; there were separate issues for each Division of each Region) and the time allowed varied according to the particular tare loadings. The variables for the Western Division of the London Midland Region were Full Load, Limited Load, Special Limit and XL Limit. For example, on the section between Carnforth and Shap Summit going north, the Full Load allowance for the Pacifics (class 8 in the BR power classification) was 570 tons, Limited Load 500 tons and Special Limit 450 tons. As a comparison for class 7 engines (e.g. 'Royal Scots' and 'Britannias') the loads were respectively 465 tons, 420 tons and 330 tons. There was no XL Limit for the Carnforth to Shap section as this particular loading was intended for the Euston to Birmingham and Crewe routes. In the case of Euston to Crewe it was 510 tons for the Pacifics and 405 tons for a Class 7 engine. Of course on occasions these limits were exceeded and then due allowance would be made for the crews if time was lost as a consequence.

But I have said enough by way of introduction, so let's get on with a pictorial study of these fine engines. Magnificent machines they were, but be it remembered, as that great raconteur of the steam locomotive the late Dr W.A. Tuplin was apt to say, 'no engine is better than its fireman'. These

stalwarts were so often the forgotten members of the locomotive fraternity; consider their lot as you study some of the fine displays of power in the pages that follow! As I said earlier, so far as I am aware very few if any of these pictures have appeared in print before; I have done my best to describe them and in doing so have included at least one picture of each individual engine. In many cases dates are missing, but again I have tried to pin-point them as best I can and in all cases where the information is known, the original photographer is identified. We should be grateful to the individual photographers for this selection for us all to savour. Also the Transport Treasury, a fine repository for photograph collections from which much of the content of this book has originated. I will say no more, other than to thank Chris Hawkins for the invitation and the enjoyable exercise this has been. So let's get on with it and just let the pictures speak for themselves.

**Allan C. Baker,**
High Halden,
May 2007

***Top.*** **QUEEN ELIZABETH with the southbound 'Royal Scot', approaching Carstairs from the north in winter. This is quite an early BR view as the engine retains the 'semi' smoke box which it lost in September 1952. It is in the usual very clean condition which characterised the Polmadie engines at the time; the modest mileage, usually no more than one out and home run to Carlisle and back each day, afforded plenty of time for the cleaners to be kept busy! They are former Caledonian Railway signal posts in the background. Photograph The Transport Treasury.**

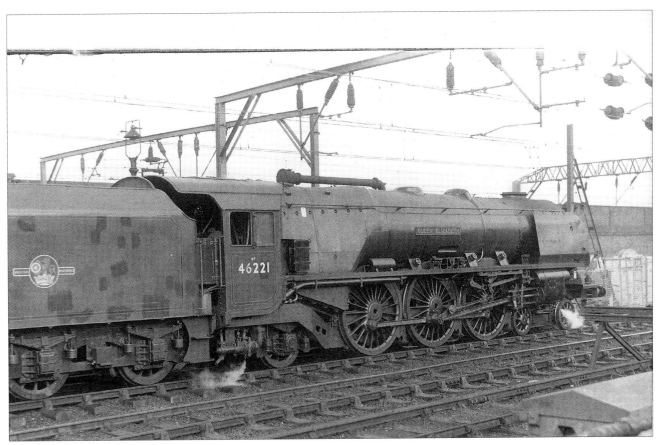

Before we move on, one more shot of 46221, about 1960 at the south end of No.5 platform at Crewe. It would appear to have recently undergone an Intermediate repair; notice the touched up paintwork and recent AWS equipment – that is the battery box just in front of the cab on the foot framing. Tender low in coal so doubtless the engine, an 'English' one from 1958, would be on a Carlisle to Euston diagram. Photograph Paul Chancellor Collection.

46222 QUEEN MARY heading north from Carstairs on 21 July 1956. The reporting number W67 tells us this is the morning Birmingham-Glasgow and Edinburgh train which would have detached the Edinburgh coaches at Carstairs. The engine would have been working through from Crewe where in all probability it took over from a Crewe North 'Scot'. Notice the ex-LNER van behind the tender. Photograph J. Robertson, The Transport Treasury.

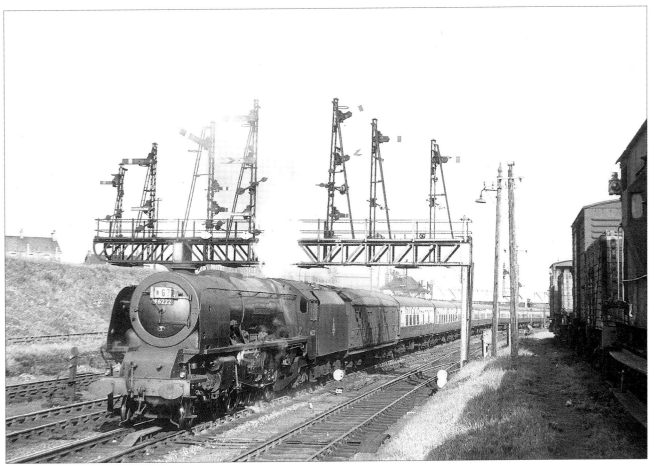

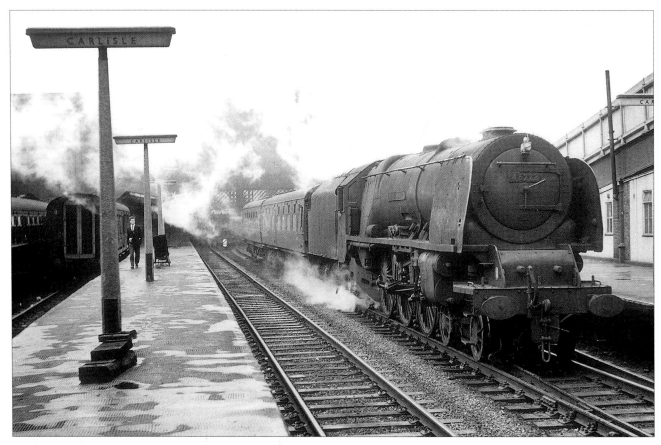

A mundane duty for QUEEN MARY, about to leave Carlisle for the north on a local train of some sort. The date is 17 March 1963 and the engine had but six months active life before withdrawal. Its begrimed condition was not typical of Polmadie in its hey-day. Photograph Paul Chancellor Collection.

This is more like the Polmadie turn-out, 46223 PRINCESS ALICE waiting to leave Glasgow Central on the up 'Royal Scot'. What a lovely picture and with the later headboard originally designed for use with the diesels 10000-10001. This engine had its 'semi' smoke box modified to the more conventional pattern in August 1956 and the BR tender emblem exchanged for the later 'ferret and dartboard' design in November 1958, which would suggest the picture dates from somewhere between those two events. Ten o' clock from Glasgow; notice the sleeping coaches from an overnight train from Euston to the left; they would be waiting removal to the carriage sidings. Photograph The Transport Treasury.

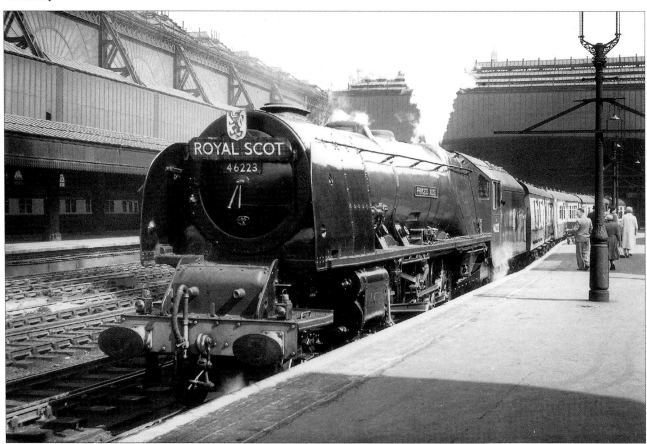

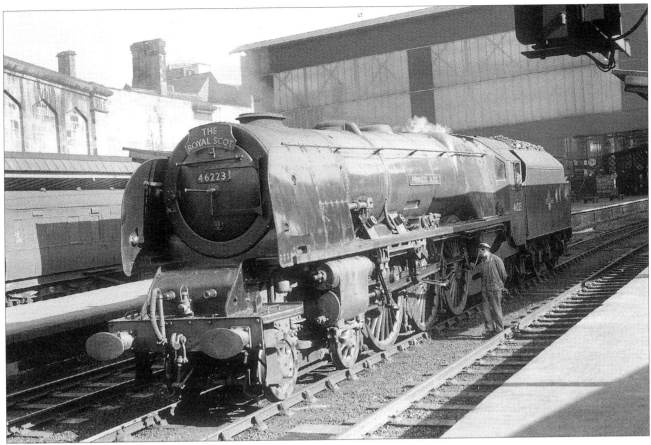

PRINCESS ALICE at the north end of Carlisle station on 29 September 1959, awaiting the arrival of the down 'Royal Scot', which it will take forward to Glasgow. The station clock says 14.50; at this period the train was due away at 14.31, so it was running a bit late. It still retains the Fowler-Anderson cylinder by-pass valves, and I reckon that's the fireman having a look around prior to departure. Photograph Paul Chancellor Collection.

One more shot of 46223 and again at Carlisle, standing to the west of the platforms in front of the original external wall, dating from when the station had a complete overall roof. The period is probably about 1962; the IM25 headboard indicates that PRINCESS ALICE would have come south on the up 'Royal Scot' and is probably waiting to go to either Kingmoor or Upperby for servicing, though as it's in backward gear I would wager it is headed for Kingmoor. The 3F tank was one of those displaced from Devon's Road in East London on dieselisation, and migrated north to Carlisle Kingmoor in August 1958. Photograph Paul Chancellor Collection.

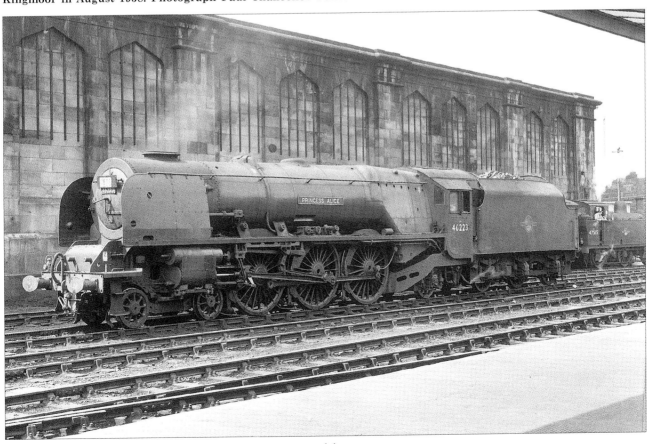

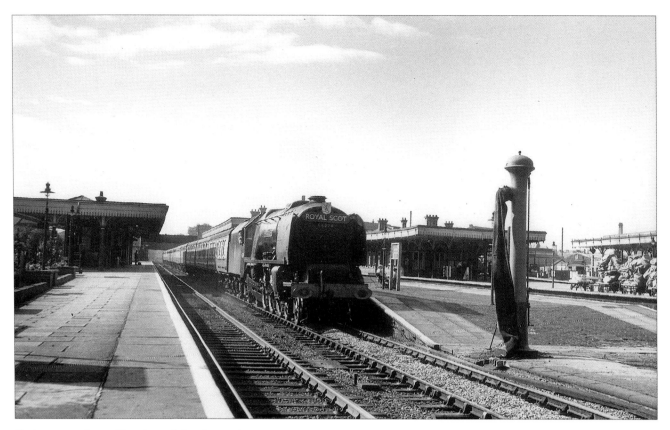

To improve the utilisation of the Scottish Region Pacifics during the period of the summer timetables in the 1950s, through diagrams were introduced which brought the Polmadie engines south of Crewe. On occasions they actually worked right through with a crew change at Carlisle, but on others arrived at Euston via a series of cyclic diagrams; the Camden engines did the same in reverse. 46224 PRINCESS ALEXANDRA is heading south through Watford Junction. It retains its 'semi' smoke box and as this was modified in October 1954, I would date the picture at about 1953. A clear exhaust as all the work would be over, the crew taking it easy on the down grades to the terminus. Notice the impressive piles of mail bags on the platform trucks to the right! Photograph The Transport Treasury.

This time we have 46224 PRINCESS ALEXANDRA, on shed at Carlisle Kingmoor prepared and ready to take the northbound 'Royal Scot'; it would have arrived earlier in the day on the southbound working. The large diameter and prominent pipe under the foot framing and alongside the firebox is the exhaust steam pipe to the exhaust injector. The engine still needs to be turned and this would be done as it left the shed. The picture was probably taken in late spring; notice that the Class 5 to the left (45499, a St Rollox engine at the time) retains its miniature snow plough and observe the big buffer beam-mounted ploughs to the right. Photograph The Transport Treasury.

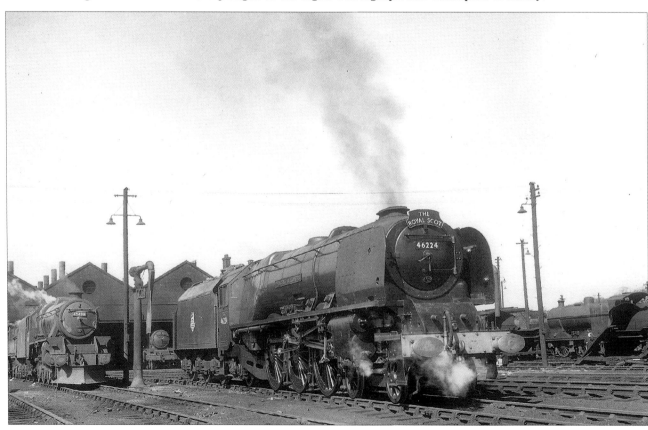

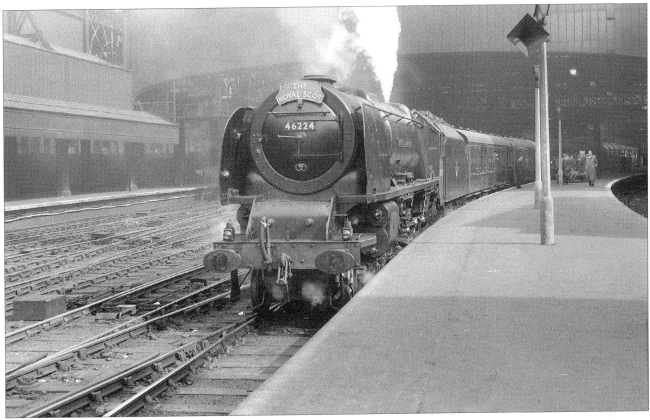

Glasgow Central, and 46224 waits this time to depart south on the up 'Royal Scot'. This is a much later view, for the engine has the second BR emblem which it received in August 1957 and the coaches are in the all maroon livery – about 1959-60 would be right. Tender full, safety valves blowing slightly and a bit of haze from the chimney. I bet the fireman has just put a few shovelfuls on the fire to help 'quieten her down' before the right of way. Photograph Paul Chancellor Collection.

What a super study of one of these magnificent beasts! Carlisle again, and 46224 PRINCESS ALEXANDRA awaits the arrival of the down 'Royal Scot', which it will take forward to Glasgow. The date is 26 September 1959 and the time according to the station clock 15.30; the train was due away in five minutes so either some slick working was to ensue, or the train was running late. Like its Polmadie sister 46223, this engine retained its cylinder by-pass valves until the end, although standard anti-vacuum valves had long been fitted and the by-pass valves blanked off. Engines fitted with these by-pass valves had somewhat different cylinder castings from the later ones. From this I think it is safe to assume that at least in the case of the outside cylinders, 46223 and 46224 retained their originals until withdrawal. However in the case of the other three, at some time in the late 1950s new cylinders were fitted. Photograph Paul Chancellor Collection.

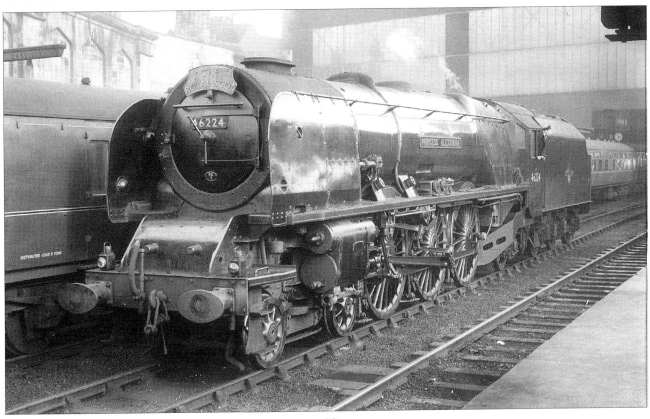

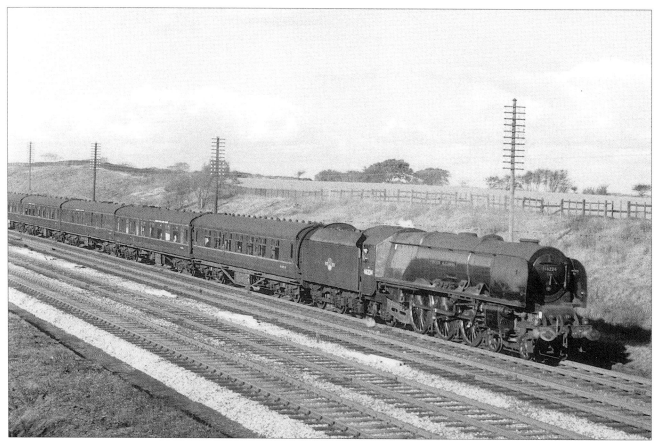

One last view of PRINCESS ALEXANDRA, heading south at Standish Junction north of Warrington with the 14.38 Glasgow-Birmingham, on 12 October 1960. The engine would come off this train at Crewe and in all probability it would then be worked forward by either a Crewe North 'Scot' or a Bushbury 'Jubilee'. Photograph Dr A.H. Roscoe, The Transport Treasury.

The first of the 'Duchesses' proper one might say, 46225 DUCHESS OF GLOUCESTER on Edge Hill shed. It got the BR number in June 1948 and was painted blue in April 1950, so the picture dates from in between. A handful of Pacifics were allocated to Edge Hill shed in Liverpool for the London jobs, but this was never one of them; in fact it was at Crewe North for almost all its BR life; it went to Upperby in June 1959. It has the later design of twin brake blocks in articulated hangers on the driving wheels. Only the first five engines had the single brake block arrangement and they were never modified in line with the later ones. That is the exhaust injector dripping water underneath the cab. Photograph The Transport Treasury.

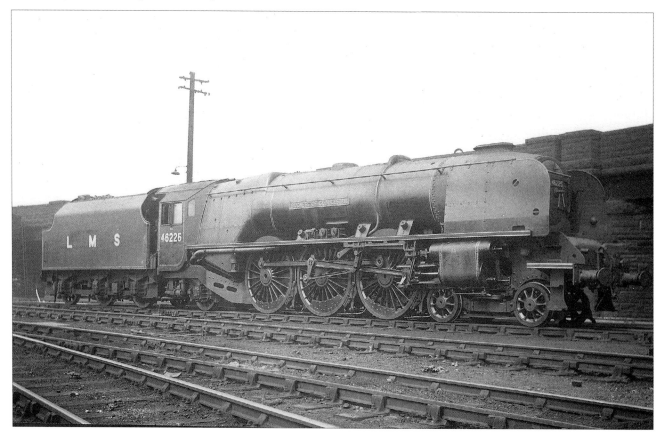

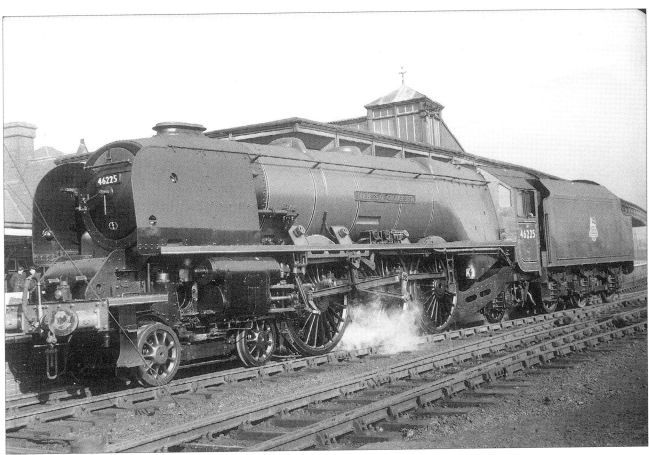

I think it a safe bet that this picture was taken in late April 1950, as DUCHESS OF GLOUCESTER is resplendent in the blue livery which was applied during a Light Classified repair at Crewe at that time – it was ex-works on 21 April. The location is probably Whitchurch, between Crewe and Shrewsbury and the engine would be running in light before returning to service. Notice that although the speedometer bracket is fitted by the trailing wheelset, the equipment itself is absent. Photograph The Transport Treasury.

Still in the blue livery 46225 DUCHESS OF GLOUCESTER heads the up 'Royal Scot' at Farrington, south of Preston, on 11 September 1954. The engine would almost certainly have worked this train from Glasgow as part of a cyclic diagram and would come off at Crewe. It was painted green in March 1956. Photograph A.W. Battson, The Transport Treasury.

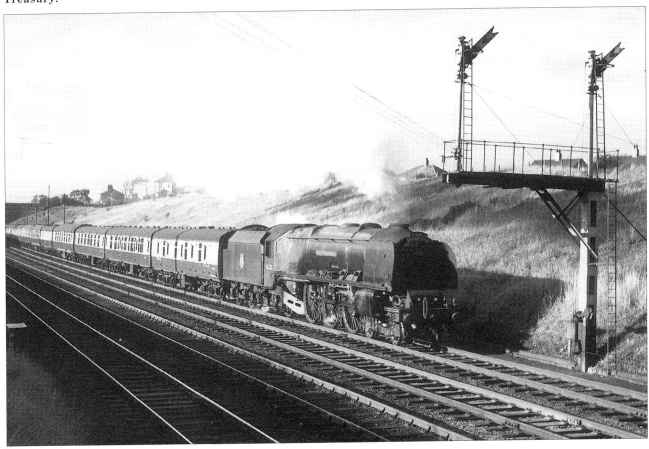

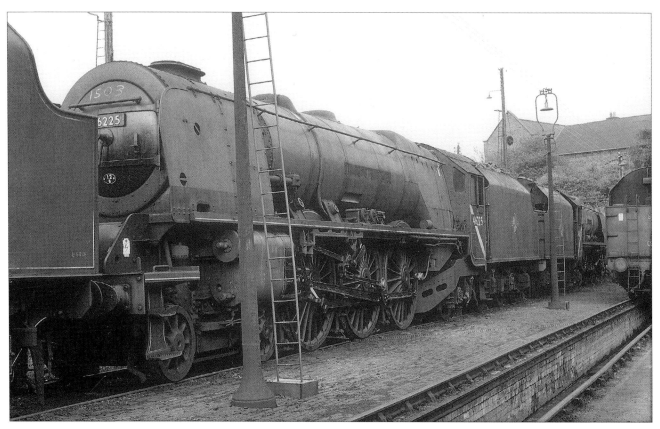

A rather sorry DUCHESS OF GLOUCESTER in store at Carlisle Upperby along with at least three of its sisters in August 1964. Notice that while the name plates have been removed the motion has been greased, so somebody thought it might do some more work. In the end, along with the others remaining at Kingmoor it was withdrawn on 12 September that year, and did not steam again. It looks as if the last train it worked had the reporting number 1S03, which was the 19.25 Euston-Perth. Presumably it worked forward from Crewe to Carlisle, although that would not be a specific locomotive diagram at the time. An EE Type 4 would have been diagrammed to work this train through from Crewe to Perth; perhaps one had not been available on the night in question for the Crewe to Carlisle leg, in which case the engine would have gone down fighting, so to speak! At least these engines never suffered the indignity of running in service with the name and number plates removed, unlike numerous other types that lasted in service a few years longer. Photograph J.G. Walmsley, The Transport Treasury.

The Up 'Royal Scot' arriving at Carlisle in April 1959 behind Upperby's rather grimy 46226 DUCHESS OF NORFOLK. Despite being a Carlisle engine it could well be working through to Crewe on a cyclic diagram. Notice it still does not have AWS equipment fitted. The Stanier Class 3 tank on the right, according to the ABCs, was always allocated to Southport, so how it came to be at Carlisle is a mystery. But I bet it got the local 'spotters' excited! Photograph A.W. Battson, The Transport Treasury.

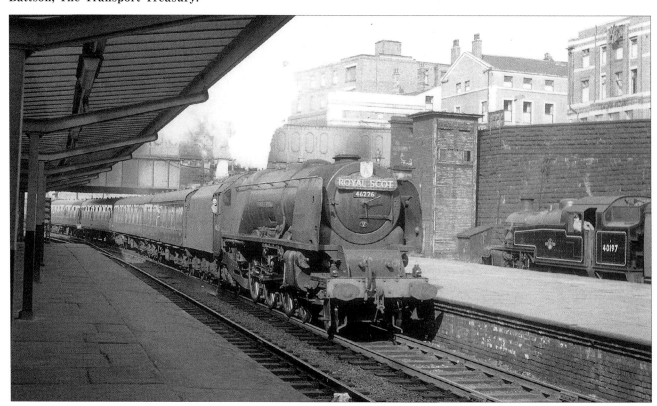

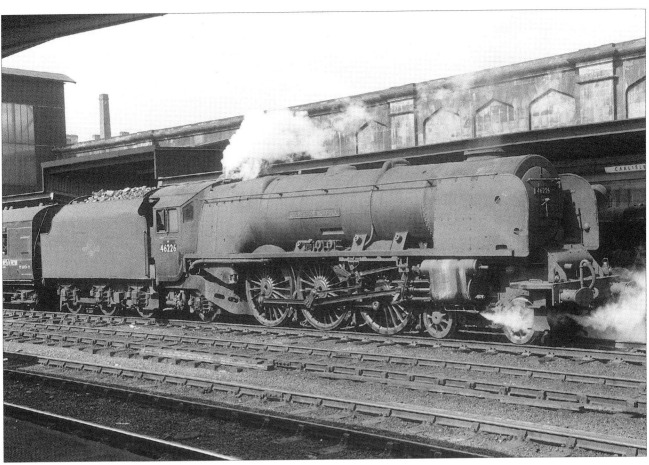

Still no cleaner in this view, in fact even dirtier! About to leave Carlisle for the south on 31 July 1959, DUCHESS OF NORFOLK is ready for the off. Photograph Paul Chancellor Collection.

Starting the northbound climb to Beattock on 30 May 1953 is 46227 DUCHESS OF DEVONSHIRE, a Polmadie engine for all its BR life. The train is the down 'Royal Scot' and with its winter timetable loading the driver has decided to take a banker which can just be seen giving its worth at the rear – obviously not Crewe North men! Photograph The Transport Treasury.

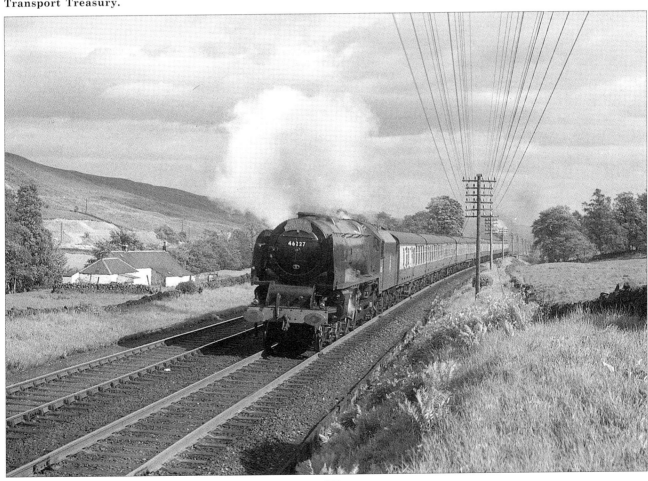

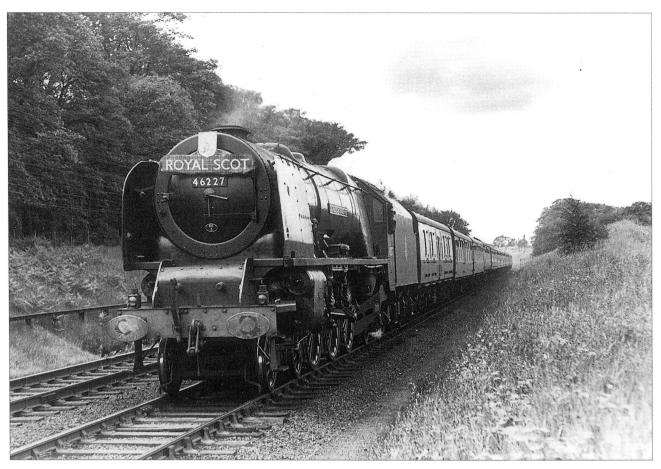

DUCHESS OF DEVONSHIRE with the up 'Royal Scot' at Hartford, south of Weaver Junction, on 19 June 1954, when the Polmadie engines were working south on cyclic diagrams. Photograph T. Lewis, Norman Preedy Archive.

A moodily atmospheric late winter afternoon at Polmadie with 46227 DUCHESS OF DEVONSHIRE ready to take a train south, presumably one of the 'overnights' at least as far as Carlisle. The picture is undated but this engine lost its 'semi' smoke box in May 1953, so a reasonable estimation of the period would be about 1952. The high building to the right is the Repair Shop. A goodly smattering of old 'Caley' stalwarts can be observed to the right. Photograph The Transport Treasury.

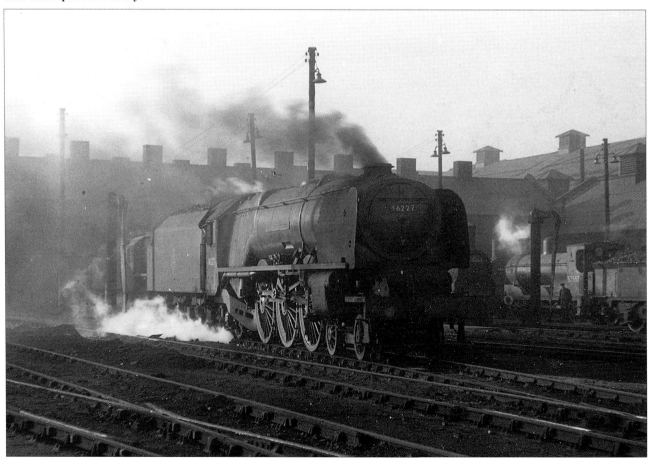

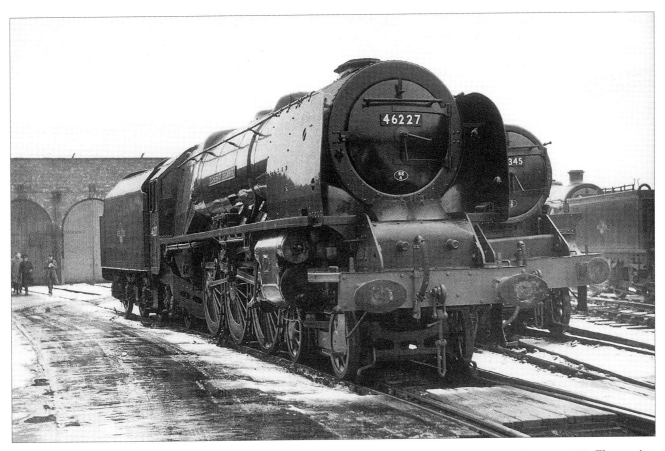

A splendid DUCHESS OF DEVONSHIRE outside the Paint Shop at Crewe in the snow, 9 February 1959. The engine appears to have already been painted and is having some last minute attention; that is the double exhaust chimney petticoat pipe just in front of the smoke box, temporarily removed for some reason or other. The engine may have come back for 'rectification', but I doubt it as there is no coal showing in the tender. This would be the occasion of an official visit, with the uniformed guide escorting members of the party to the extreme left.

Crewe North's 46228 DUCHESS OF RUTLAND waiting to leave Carlisle for the south about 1960; this engine was transferred from Carlisle Upperby in June the previous year. Notice it has been fitted with AWS equipment and is in the usual clean condition of the Crewe North engines at that period. Geoff Sands was in charge and he ensured that however short he was of cleaners, priority went to the Pacifics. The Type 4 diesels were usually filthy! Photograph Paul Chancellor Collection.

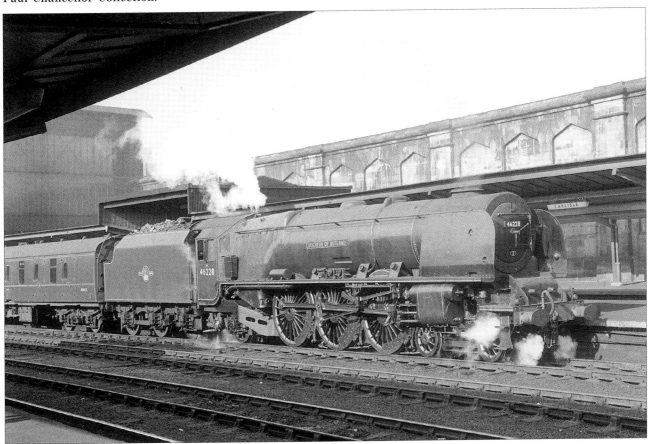

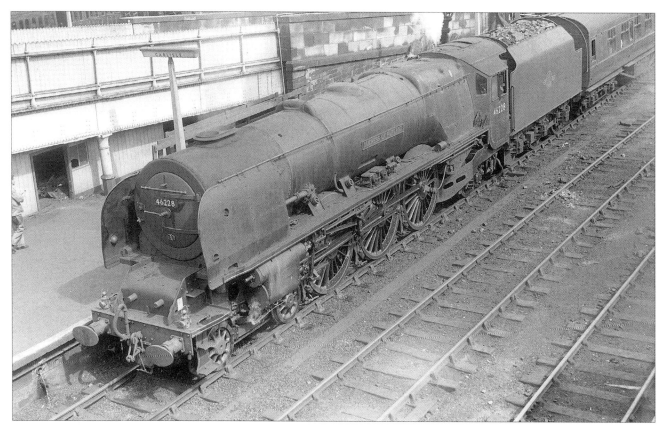

DUCHESS OF RUTLAND at Carlisle again, in a somewhat later view, this time waiting to head north. The engine is taking water and I would put the year at about 1963; the train is probably a summer relief. Notice how the four safety valves, all set to blow at slightly different pressures, are actually mounted within the cab. Despite being a Crewe North engine at the time, as it has a tender full of coal it must have come on the train at Carlisle. Photograph Paul Chancellor Collection.

DUCHESS OF RUTLAND, only the second one I worked on, towards the end of its career at Preston on a southbound class 2 train, the 09.37 to Crewe on 4 May 1964. This train was away from Carlisle at 06.20 and called at almost every station that was still open to arrive at Crewe at 11.32. The engine was diagrammed to work a similar train north again later in the day. Usually covered at this time by Carlisle-based engines it was not diagrammed to be serviced at Crewe but instead turned at the South shed before taking up the return working. For some reason a 5A engine has found its way onto the job on this occasion, perhaps an opportunity to work it 'home' off an unbalanced job. This engine was withdrawn in September the same year. By this time cleaners were at a premium and the engines were largely confined to less prestigious trains like this one. Photograph A.W. Battson, The Transport Treasury.

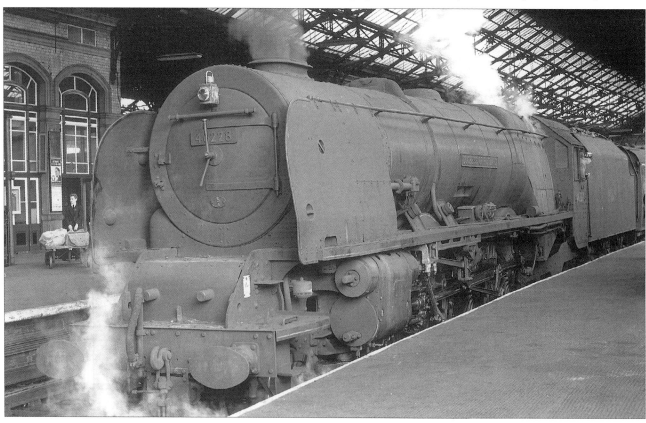

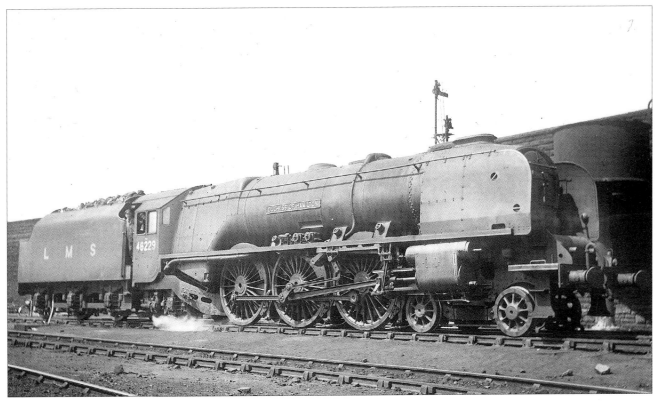

This is the engine that represented the LMS in America for the New York World's Fair in 1939. DUCHESS OF HAMILTON exchanged identities with 6220 CORONATION so that a brand new engine could be used. On its return to this country, which due to the war was not until 1942, the two engines exchanged identities again. It is in the wartime plain black livery on 17 June 1948, waiting to leave Edge Hill shed; it has the new BR number but retains the L M S on the tender. A Crewe North engine at the time, it was at one time allocated to Edge Hill but not until much later, in 1961 in fact. This locomotive was saved from the scrap man and initially went to Butlin's Holiday Camp at Minehead for static preservation. Observe the splendid tender full of lump coal, I bet that made the fireman smile! Photograph The Transport Treasury.

Crewe North's 46229 DUCHESS OF HAMILTON heading north on the down 'Mid-Day Scot' near Hatch End in the London suburbs on 28 December 1951. The photographer has very conveniently recorded the time as 1.40pm. There are at least 14 coaches, doubtless full of folk heading north for Hogmanay. This train was a traditional Crewe North job for both engines and men, and they would be working through to Crewe, where a second North shed engine and men would take over for the onward journey to Glasgow. An atmospheric winter scene. Photograph A. Lathey, The Transport Treasury.

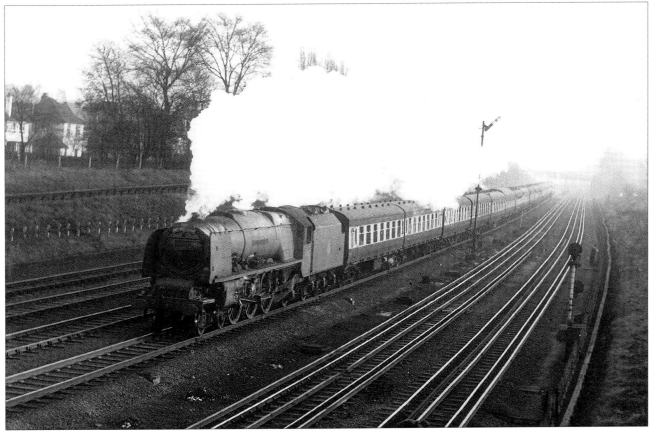

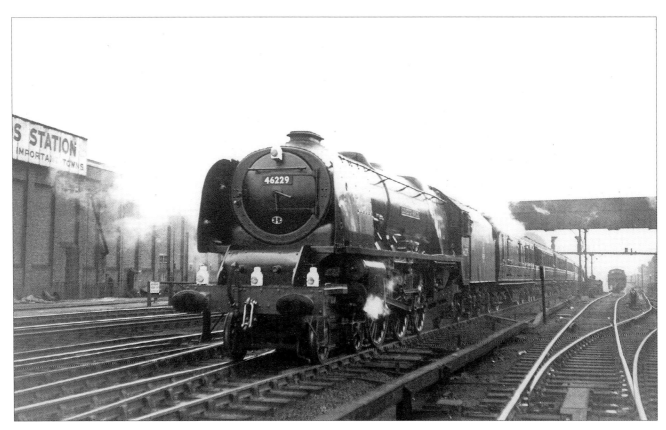

Royal Train duty for DUCHESS OF HAMILTON, the engine having transferred to Camden in June 1952. This picture was taken in the late evening of 7 August that year and the train is just breasting Camden bank, about to pass the engine sheds. The train seems to consist largely of the ex-LNWR vehicles and was taking the Royal family to Balmoral for their summer break. Bearing in mind that King George V had passed away in February that year, this would have been the Queen's first hosting of the long-standing tradition of a late summer holiday at Balmoral. Notice the excellent condition of the engine and the four lamp head code, usually signifying that the Monarch was on board. The engine would in all probability work through to Carlisle; the Scottish authorities would never allow an 'English' engine on a Royal train north of the border in those times! Photograph The Transport Treasury.

On a lovely summer's evening 46229 DUCHESS OF HAMILTON heads north at Carpenders Park on 7 July 1953. It had got the BR standard green livery a few months before, in April, but did not lose its 'semi' smoke box until February 1957. Judging by the shadows and the time of year, the train is probably one of the overnights to Glasgow or further north; they look like ex-LMS twelve wheel sleeping cars. The engine would be working through to Crewe where in all probability another Crewe North engine and men would work forward to Glasgow or Perth. Photograph The Transport Treasury.

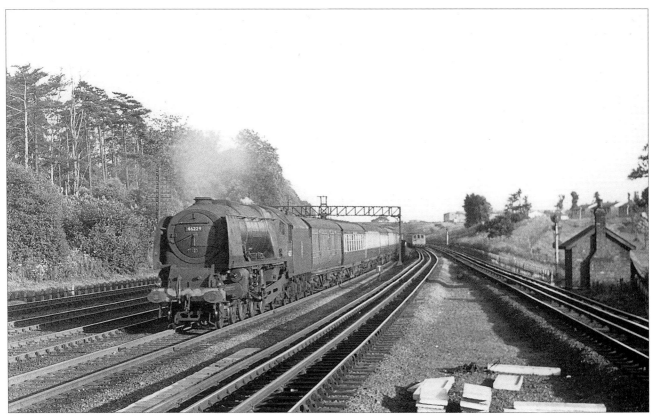

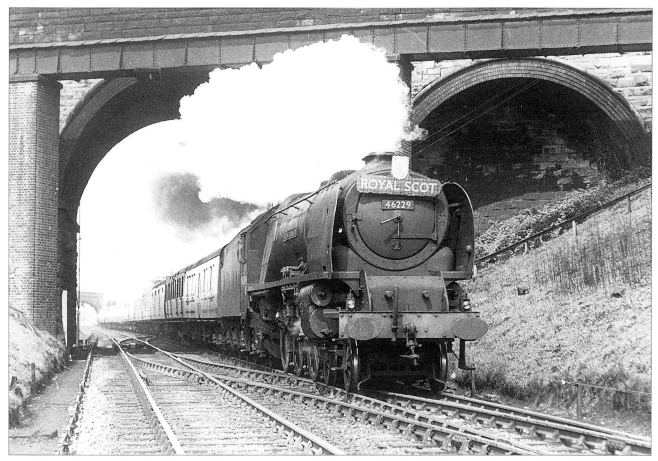

DUCHESS OF HAMILTON, a Camden engine by now, with the southbound 'Royal Scot' at Boars Head Junction on the downgrade just north of Wigan, on 1 May 1954. The load is augmented on this occasion (strangely) by a bogie van and an ex-LNER vehicle. Photograph T. Lewis, Norman Preedy Archive.

Heading north from Carstairs on 21 July 1956, 46229 is once again on the 'Royal Scot'. There is no coal showing in the tender as doubtless during the summer timetable of this year the engine would have worked the train through from Euston with a crew change at Carlisle. Photograph The Transport Treasury.

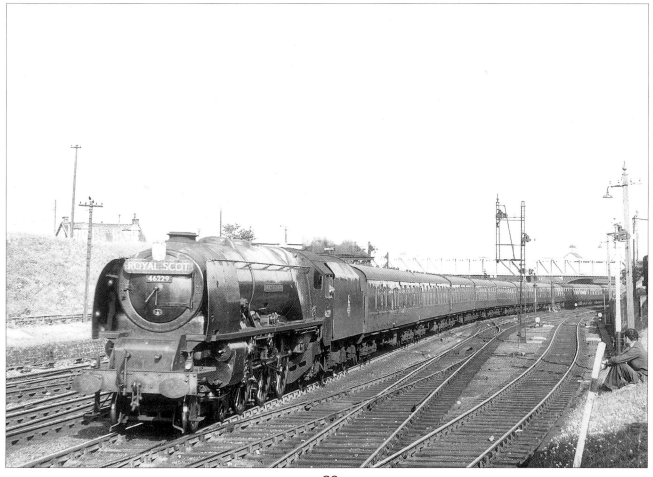

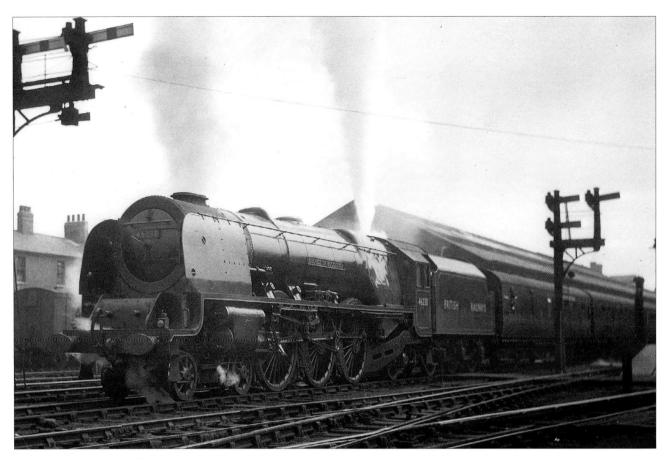

DUCHESS OF BUCCLEUCH was the first of the batch of five built without the streamlined casing, hence the continued foot plating in front of the outside cylinders. Along with the 'semi' smoke box there were also a few other minor differences from their streamlined sisters when those engines were eventually 'defrocked'. Here it is as BR 46230 leaving Stafford on a northbound train on 14 June 1948. It had been given the blue livery only the previous month, and has the short-lived BRITISH RAILWAYS title on the tender. This was a Polmadie engine for all its BR life, and would have been a 'rare-bird' south of Crewe at the time. Photograph The Transport Treasury.

In more familiar surroundings, 46230 DUCHESS OF BUCCLEUCH in charge of the down 'Royal Scot' leaving Carstairs on 12 July 1952. The picture shows well the smoke lifting effects of the deflectors. Compare the rather elegant ex-Caledonian Railway semaphore signals with their later BR replacements, seen in the picture of 46222 QUEEN MARY in July 1956, page 9. Photograph The Transport Treasury.

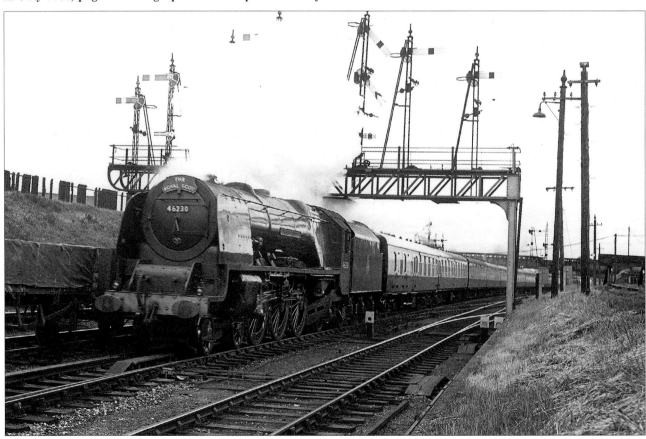

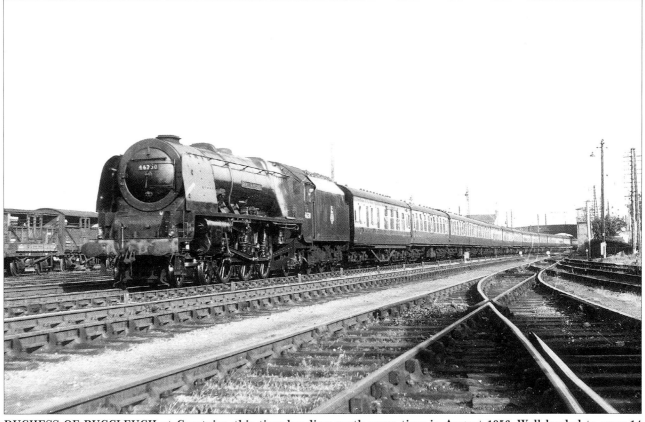

DUCHESS OF BUCCLEUCH at Carstairs, this time heading south some time in August 1956. Well loaded to over 14 vehicles, the first coach has a London-Glasgow board so it is probably a summer Saturday relief. The 'named' trains would have had loads limited to a maximum of around 12 vehicles at this time. The train consists of ex-LMS and the newer Mark 1 BR vehicles, suggesting a 'scratch' set. Photograph The Transport Treasury.

Second of the non-streamlined engines, 46231 DUCHESS OF ATHOLL, in blue livery at Carstairs shed. You'd have to wonder at what she might be doing there; the missing trailing truck wheel set would be the answer and it can be assumed that she has failed with a hot axle journal and been taken off a train. Note too that the tender is full; it would be a fairly safe bet that she was working an up, southbound, train. Presumably the wheel set and axle boxes had been sent to St Rollox works for attention, and the engine is waiting their return. Another of the Scottish engines that spent its entire existence under BR ownership at Polmadie, it is in the blue livery with the short-lived BRITISH RAILWAYS on the tender. It got this livery in May 1948, a more purple shade than was adopted later and it stayed thus until painted green in September 1955 – the lettering of course gave way to the first BR emblem long before that. Photograph The Transport Treasury.

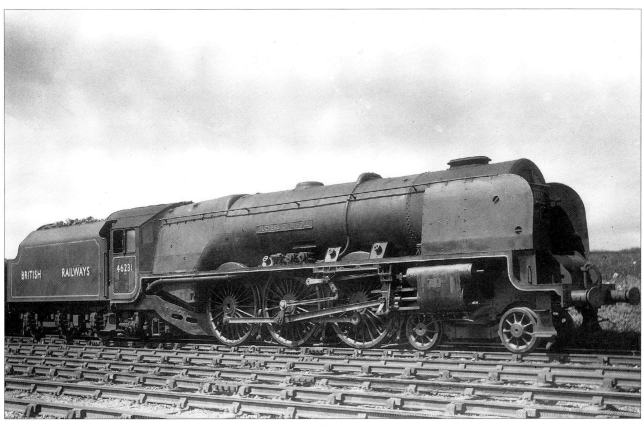

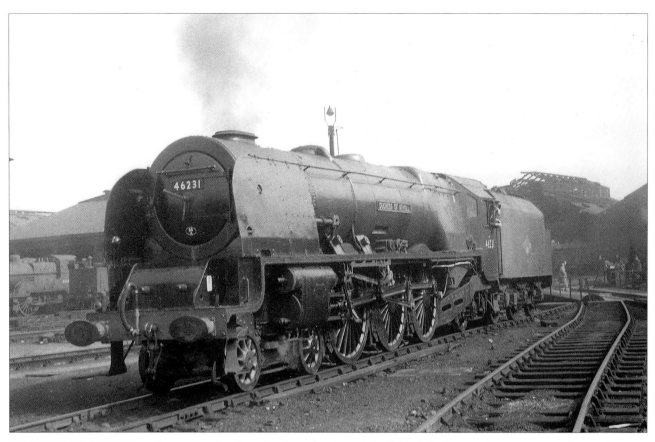

DUCHESS OF ATHOLL at Crewe North, when the last remains of the 'Abba' shed were disappearing – falling down in fact! The Midland 2P poking out of the Middle Shed to the left looks like Longsight's 40693, often to be seen at Crewe. It was withdrawn in June 1959 so the picture must predate this. The 'Duchess' looks recently ex-works; it had received a General in May 1958, and despite the dirty tender the photograph could have been taken about then. The engine has probably done a running in turn to Shrewsbury and will soon be heading north. Speedometer fitted but no AWS. Photograph Paul Chancellor Collection.

Another long-term Polmadie resident, 46232 DUCHESS OF MONTROSE in newly applied blue livery and just off works at Crewe South on 22 May 1948. It was usual for such 'fresh-off' engines to proceed first of all to the South shed, arriving probably with several others. After detaching, it is standing by the outlet signal, in all probability waiting to go to the North Shed. It would then be diagrammed for a running-in turn to Shrewsbury and back. The engine is in the earlier shade of blue, often described as more of a purple and later superseded by a lighter shade, although it seems all the blue engines did not get the later version. Notice the burnished cylinder and valve chest cover shields. Photograph Paul Chancellor Collection.

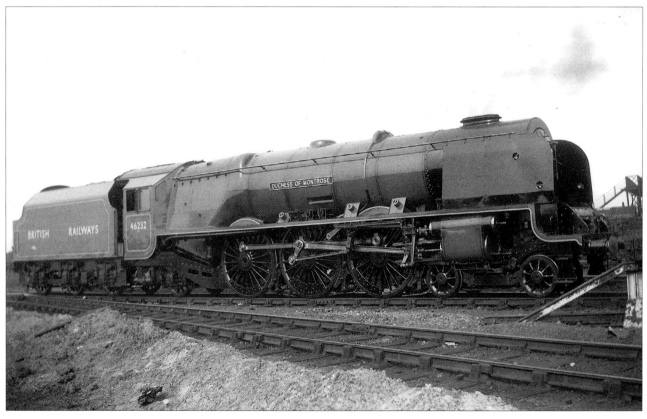

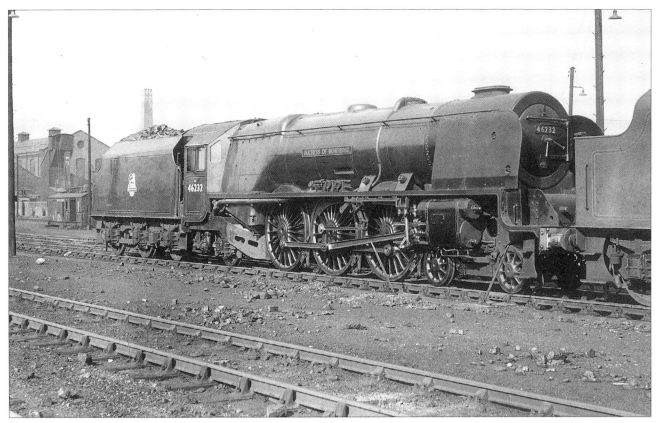

A pleasing portrait of 46232 DUCHESS OF MONTROSE 'at home' on Polmadie shed, 8 March 1952. This was the first of the class to be painted in the BR standard green livery for express engines, which it received in November 1951; it never got the lighter blue livery. The engine is fully coaled but appears to be out of steam, which is strange as the 8th of March was a Saturday. Personally I always preferred these engines in the BR green, perhaps because in my trainspotting days the Crewe North engines were usually green ones, for they worked predominantly the overnight trains. It was not thought worth the extra cost of the maroon paint for engines that were not seen much in daylight! Photograph The Transport Treasury.

One last view of 46232 DUCHESS OF MONTROSE, this time standing outside the paint shop at Crewe, on 24 June 1961. It looks as if it is just off an Intermediate repair of some sort as the paint is only a touch up job. Notice in that barrow by the tender a safety valve, so I wager the engine had been in trouble during steam tests on the nearby Vacuum Pits; it would have been pushed out of the way into this position for attention. I bet the men have gone to lunch – or should I say dinner? Notice too the speedometer and AWS. The houses behind the wall are railway owned (or were) and made up Bright and Richard Streets along with West Avenue. There was an LNWR 'Claughton' named after J.A. Bright, one of its Directors and the Richard would be Richard Moon, the one-time Chairman. Photograph Paul Chancellor Collection.

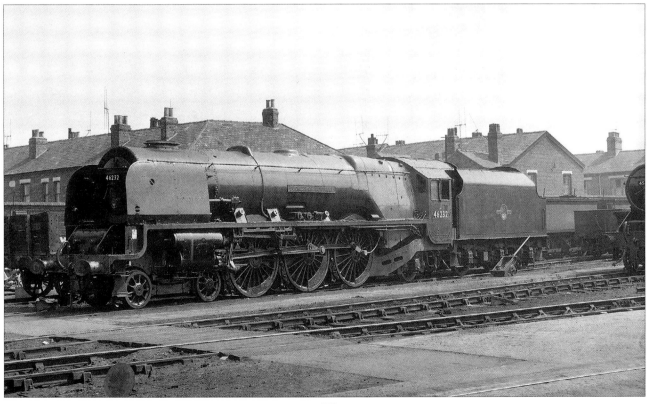

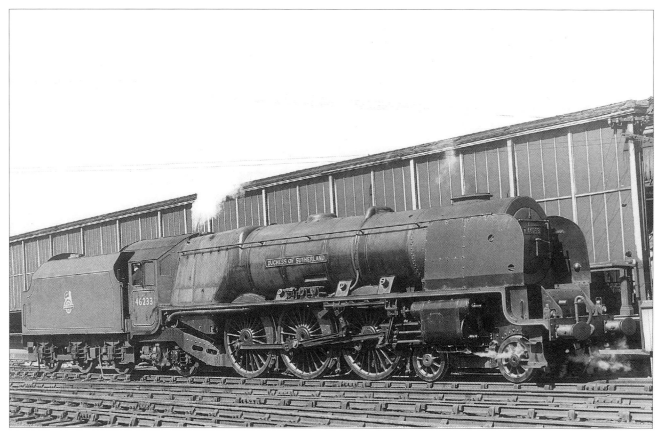

46233 DUCHESS OF SUTHERLAND in work-stained blue livery at the north end of Crewe station, 24 July 1952. This was a Crewe North engine except for a brief period in 1958, before going to Camden in April 1960. It would have come off a southbound train and is now heading for the North shed. The tender is low in coal and the engine in backward gear waiting for the signal. The blue did not weather at all well and this was one of the reasons for replacing it with the same green as used for the lesser breeds of express engine. DUCHESS OF SUTHERLAND was another of these engines saved for posterity by the late Billy Butlin, for display at the Heads of Ayr camp in Scotland. Photograph The Transport Treasury.

A crowded, highly atmospheric scene at the south end of Preston station on 10 November 1958. The up 'Royal Scot' is passing through while there are men at work on what appears to be a new signal gantry – this would not be allowed by today's health and safety zealots! Crewe North's 46233 DUCHESS OF SUTHERLAND would be on a cyclic diagram, working through from Carlisle to Euston. Photograph A.W. Battson, The Transport Treasury.

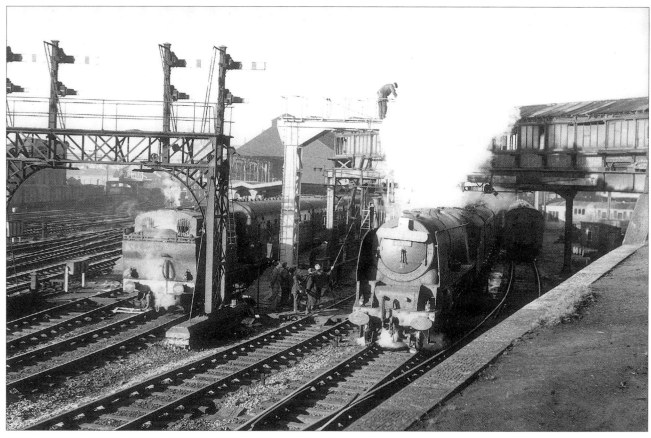

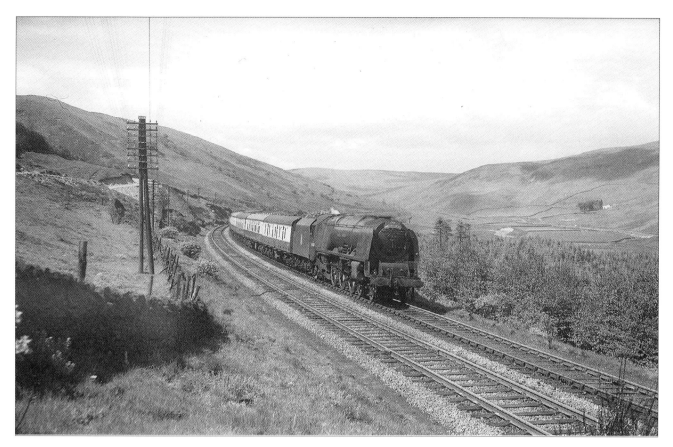

The up 'Mid-Day Scot' headed by 46234 DUCHESS OF ABERCORN threading the Lune Gorge south of Dillicar on what looks like a still, calm and sunny summer's afternoon, about 1955. There is a good load of coal on the tender so the engine would have come on the train at Carlisle and would work through to London. This is my favourite part of the West Coast Main Line and I think my favourite part of the entire BR system, somewhat spoilt now with the intrusion of the M6 motorway and the overhead catenary. I have never tired of travelling over the line from Grayrigg through to Tebay. The men always liked it too, especially on the down run as it allowed a respite between the Grayrigg and Shap climbs. The signal to the left of the train is the Low Gill down intermediate block home, controlled from Low Gill box; it was situated nearly two miles from the signal box. Photograph The Transport Treasury.

Last of the first batch of non-streamlined engines, 46234 DUCHESS OF ABERCORN, at its Crewe North home about 1950, in the blue livery. It was not painted green until August 1956. It is one of those with a drop grate and hopper ashpan – that's the operating gear for the ash pan protruding through the frames just in front of the trailing truck. This engine and 46229 had the arrangement from new, and from 46235 on they were all fitted (incidentally, this was another reason why 6229, as it then was, was selected to go to America rather than 6220). Notice too, the leading tender wheelset has been removed, doubtless another case of a hot axle journal – the errant wheelset will be in the Works for attention by now. There were facilities at the North shed to machine wheelset journals but if this was the case here I suspect the engine would have been left on the wheel drop road, as it would not take long to true up the journal. I'd bet that the damage was too great, necessitating works attention. Photograph The Transport Treasury.

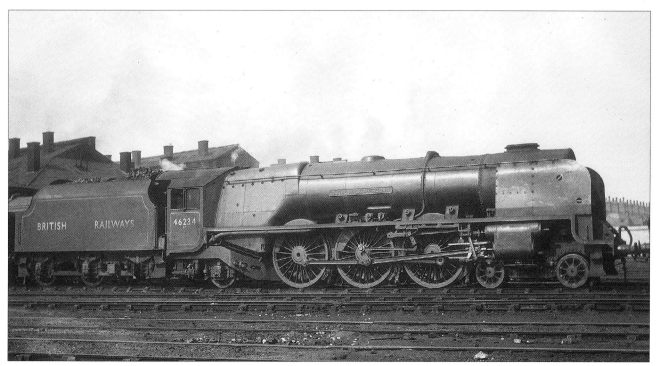

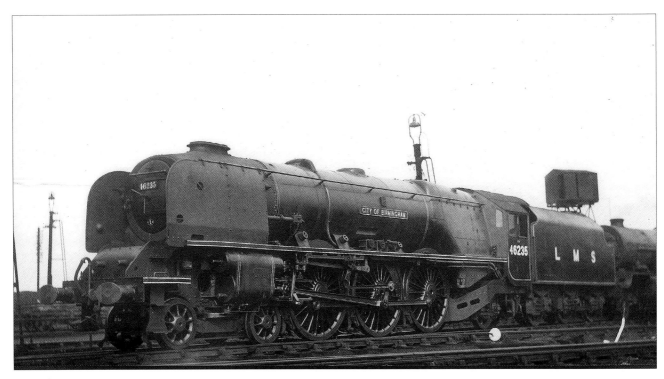

The next batch of nine engines were all streamlined and had double chimneys from new. The first one was 6235 CITY OF BIRMINGHAM, the first with a city name. Here it is at Crewe North (where it was for all its BR life) in the later LMS black with straw lining. It got the BR number in May 1948, so the picture dates from a short time after that, before the LMS lettering disappeared. This was the engine selected for the National Collection, a choice eased by the city's offer to house it in the Birmingham Museum of Science and Industry. It is still there, albeit in a newer building. There have been arguments that it should be liberated and allowed to run on the main lines again, but personally I think it best left where it is. It is in just about the same condition it was in when last in service, in my favourite green livery, while the other two preserved examples have been 'butchered' in one way or another! Photograph The Transport Treasury.

Standing outside the paint shop at Crewe is 46235 again, 'on 3 April 1955' according to the notes on the photograph. The records show a Heavy General at Crewe between 25 February and 7 April that year; one would have expected a full repaint but this picture shows it to have been more of a 'touch-up'. CITY OF BIRMINGHAM got the full smoke box top modification in July 1952, which would suggest that the date recorded for this picture is wrong. Then again, it appears to be in the green livery which it received in April 1953 – if readers have the answer, on a postcard please to the publisher! Photograph A.W. Battson, The Transport Treasury.

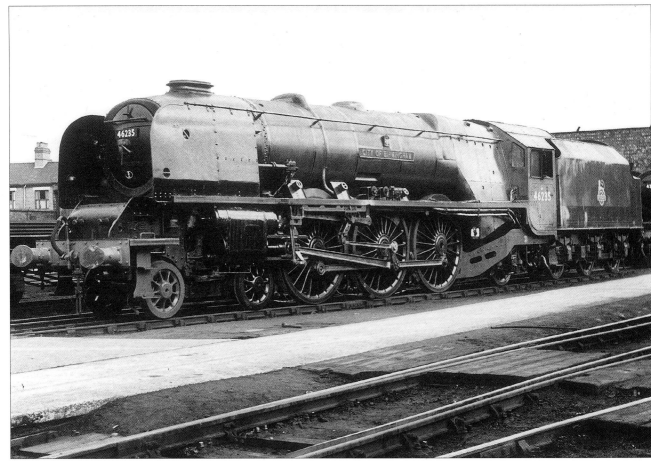

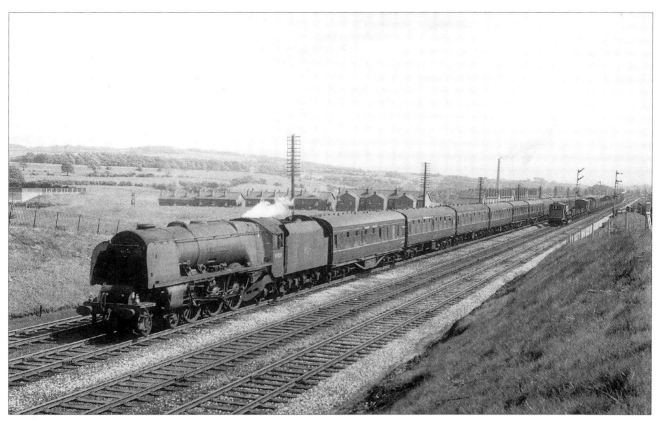

46236 CITY OF BRADFORD well into its stride on the long straight stretch north of Wigan, at Standish on 31 May 1961. As the first coach has a London-Carlisle board it could well be the 10.25 (or thereabouts; the departure time moved around a bit with successive timetables) Euston-Carlisle train; this had through coaches for Barrow and Workington which would be detached at Lancaster. A rather grimy engine and with little coal left in the tender so it must have worked through from Euston. The small semi-circle just visible in the tender coal space is part of the tunnel housing the coal pusher piston rod. Photograph Dr A.H. Roscoe, The Transport Treasury.

Parcels and van train leaving Preston for the south with 46236 CITY OF BRADFORD in charge on 23 October 1963. It was a Kingmoor engine at the time and during the autumn and early winter of 1963-64 that shed's Pacifics were used almost exclusively on this type of traffic. I used to see one or more of them at Crewe on most days. After the 1963 summer service all the Crewe North examples were stored, until brought out again for the Christmas traffic. After Christmas continuing problems with the steam heating boilers on the diesels kept them busy and the original plan to return them to store had to be abandoned! Photograph A.W. Battson, The Transport Treasury.

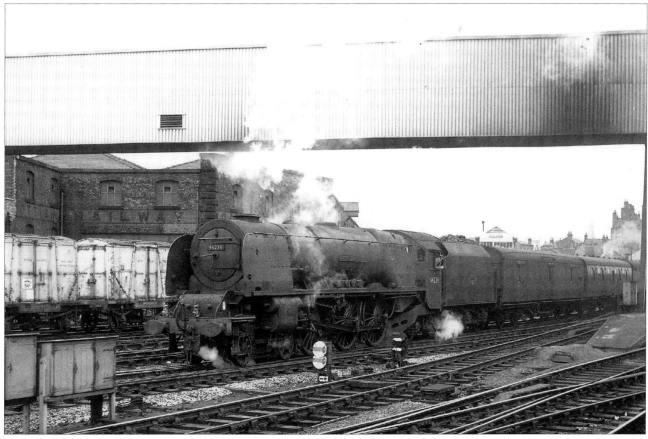

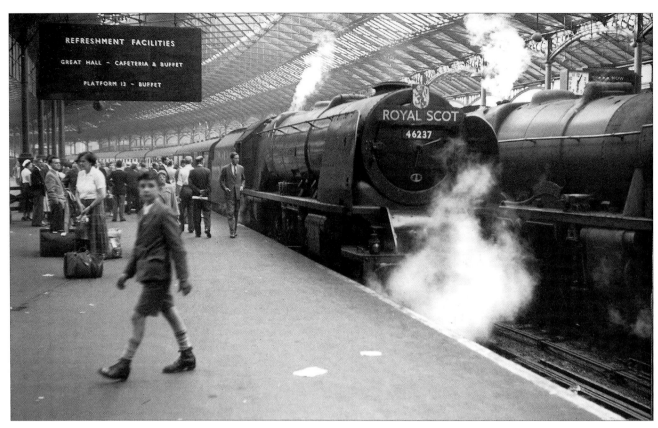

This photograph is not dated but it illustrates the up 'Royal Scot' after arrival at Euston a little after 6 pm, so the train might well have been late; it was due at 5.20 pm. The engine is 46237 CITY OF BRISTOL, a Camden resident for much of the time. It went to Carlisle in May 1958 so this scene pre-dates that move. The engine would be waiting release of the stock to enable it to run light to Camden for servicing before heading north again; I wonder what all the folk are waiting for? Photograph Paul Chancellor Collection.

In the spring of 1955 CITY OF BRISTOL was loaned to the WR, ostensibly for comparison with 'Kings' which apparently were performing indifferently at the time – this was before the fitting of double chimneys – though the trials appear to have been inconclusive. This is 46237 leaving Paddington on the down 'Merchant Venturer' to Bristol on 23 April 1955. The Pacific also worked turns to Plymouth and Wolverhampton, and note that Old Oak Common have wasted no time in fitting a set of the Western Region reporting number brackets! O.S. Nock (*Railway World*, July 1955) recorded the fastest ever climb to Whiteball summit (with an equivalent load – 393 tons) on the down 'Cornish Riviera' to Plymouth on 17 May 1955. Nock was riding in the dynamometer car so we can take his statement as accurate; 46237 and its train went over the top at 46 mph and was doing 85 at Tiverton Junction. It was a nice touch to select one of the only two to have Western connotations for these trials; CITY OF HEREFORD would have been the alternative. Photograph Norman Preedy Archive.

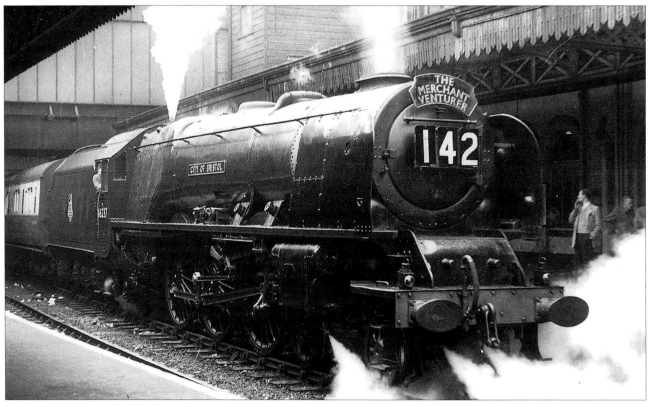

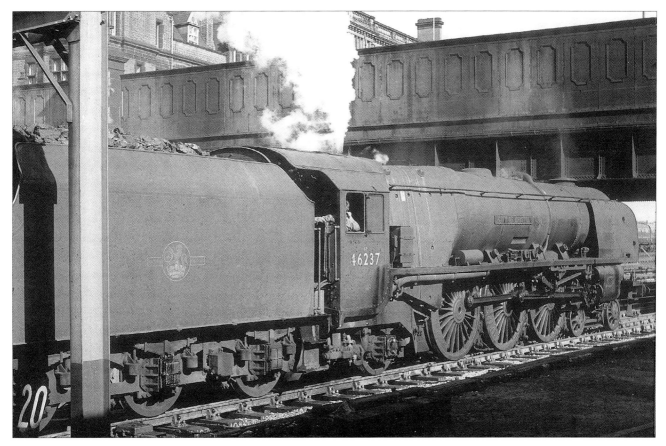

Towards the end of their days the engines were used more and more on mundane duties. Here is 46237 again, this time at Preston, about to head north on a parcels and van train on 20 May 1963. It was a Carlisle engine by this date and somewhat grimy too. Notice the AWS battery box just in front of the cab and the operating mechanism for the hopper ashpan protruding from the splayed-out main frame extension just in front of the trailing truck. Photograph A.W. Battson, The Transport Treasury.

CITY OF CARLISLE at Carlisle on 13 April 1960, waiting to depart for the south. Appropriately enough a Carlisle engine for almost all its BR career, 46238 is in the later style of maroon livery which it received in June 1958. This was akin to the livery used in LMS days, particularly the style of lining. This engine hauled the very last down 'Caledonian' at the end of the 1964 summer timetable. Crewe North rostered it to work the train forward from Crewe complete with headboard on Friday 4 September (the train did not run on Saturdays) that year, a very appropriate touch indeed. Polmadie by the way, turned out a Type 4 for the up train! With one exception all the remaining 'Big 'Uns' were withdrawn the following week. Photograph Paul Chancellor Collection.

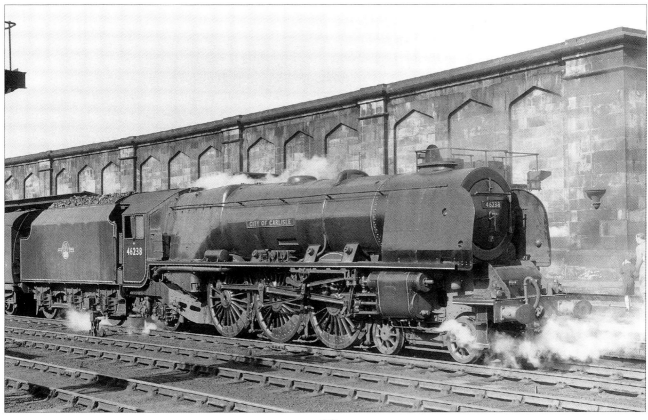

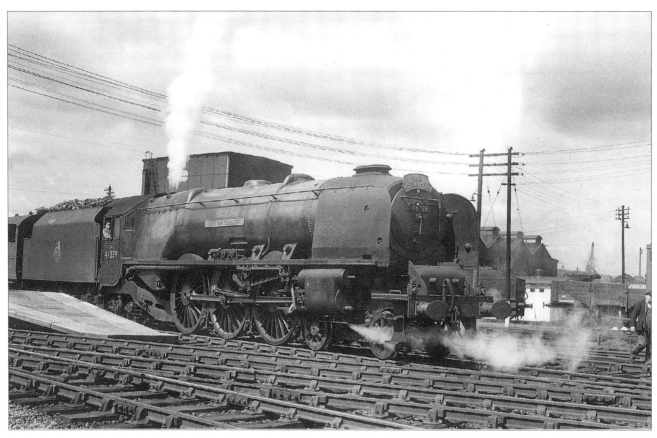

Although 46239 CITY OF CHESTER was a Camden engine almost until its last year in service, it was a favourite of mine, perhaps because it was never painted maroon and was one of the first I worked on. It was at Crewe North for a No.8 valve and piston exam shortly after I started my apprenticeship there. Here it is in the later, lighter shade of blue, at Carstairs some time in the early 1950s. The engine is heading the up 'Mid-Day Scot' and judging by the coal neatly stacked on the tender may well be working through to Euston. The train would have stopped here to attach the Edinburgh coaches. The nameplate appears to be painted in a different colour from the more usual black – light red perhaps? That is Carstairs shed to the right. Photograph The Transport Treasury.

I think this is the same train on the same day, in which case the unknown photographer must have made quite a sprint! CITY OF CHESTER is leaving Carstairs for the south with the up 'Mid-Day Scot' – look at the van behind the engine and compare the neatly stacked coal! If it is the same train then we have a date, 30 July 1952. The 'Crab' alongside, 42832, was a Corkerhill engine. Photograph The Transport Treasury.

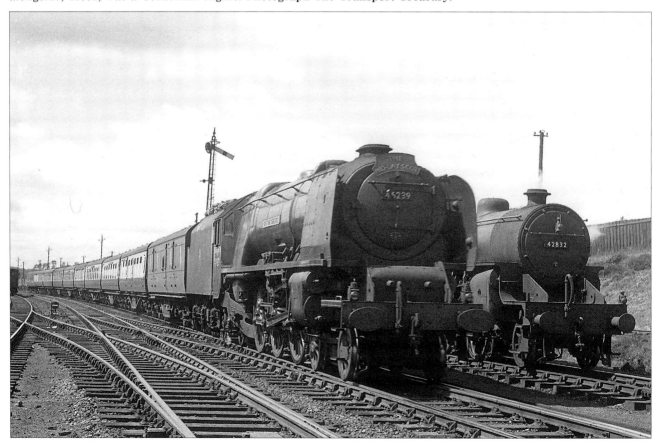

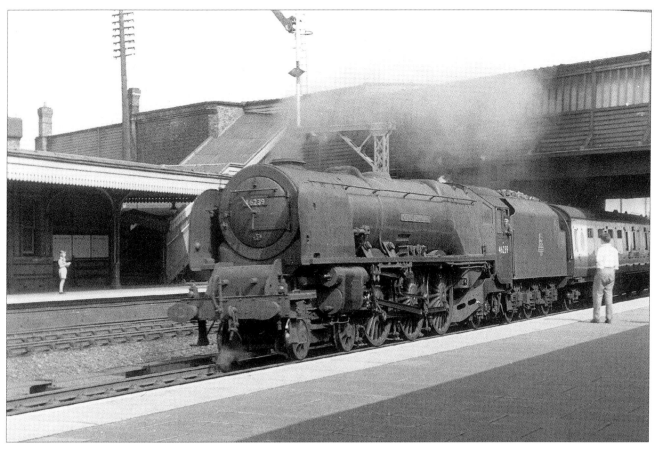

Speeding north through Tamworth Low Level, 46239 CITY OF CHESTER leans into the curve, a fine sight as it heads north. By this time the engine has had the smoke box modification, which makes the period post-February 1957; as it appears to be painted green it would in fact be some time after March the following year. Photograph Paul Chancellor Collection.

46240 CITY OF COVENTRY entering Crewe from the south on 26 July 1952, heading for No.2 platform. It was one of the handful with CITY names also to have the relevant crest mounted above the plate. This was another Camden engine for just about all its BR life. The reporting number W251 indicates that the train is the 10.40 Euston-Carlisle with through coaches for Barrow and Workington as well as Windermere. Due away from Crewe at 13.54, the through coaches would be detached at Lancaster, with the train due into Carlisle at 15.28. Notice the Western Region coach at the rear of the train. Photograph The Transport Treasury.

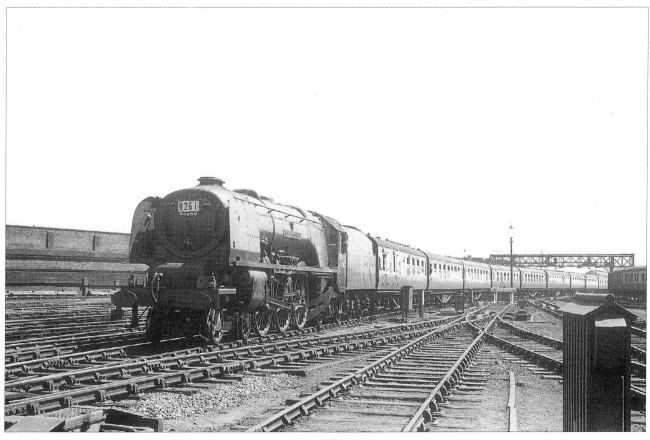

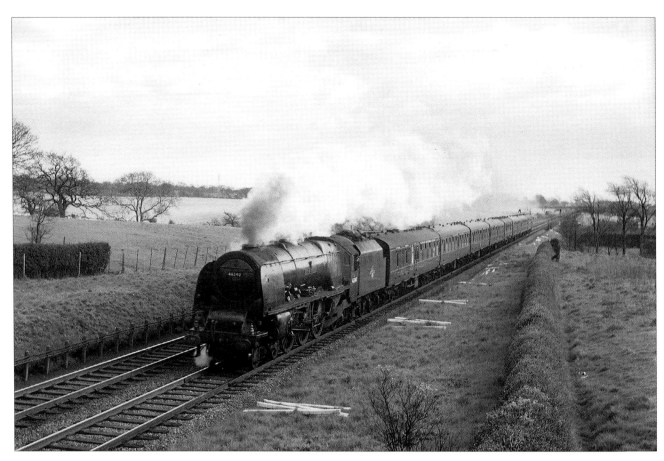

The down 'Mid-Day Scot', though 46240 CITY OF COVENTRY is without the headboard, at speed on the easy gradients at Bilsborrow, between Barton & Broughton and Garstang & Catterall, 16 April 1960. The train consists of the standard winter eight coach formation of this period which the engine would be working through to Glasgow, and the climbing would soon start! The engine is in the early style of maroon adopted by BR for some of the class, with the BR style lining; it received this livery in July 1958. Photograph A.W. Battson, The Transport Treasury.

An undated view of the down 'Caledonian', passing Watford Junction with 46240 CITY OF COVENTRY in charge – it was due to arrive at Euston at 15.45. The engine is still in the early version of the maroon livery, which it kept until April 1962, so I'd suggest the picture dates from around 1960. Photograph The Transport Treasury.

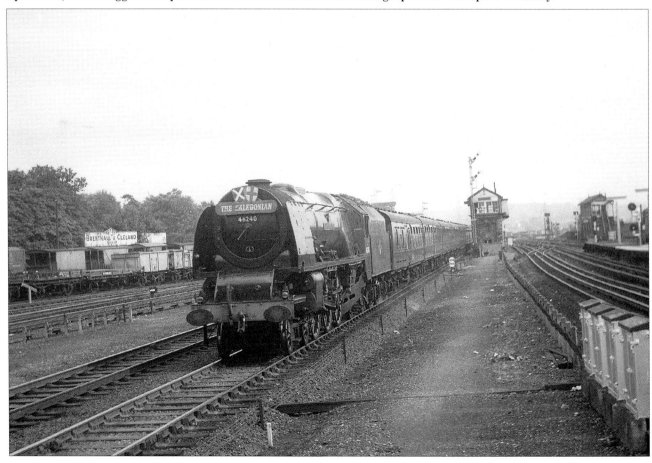

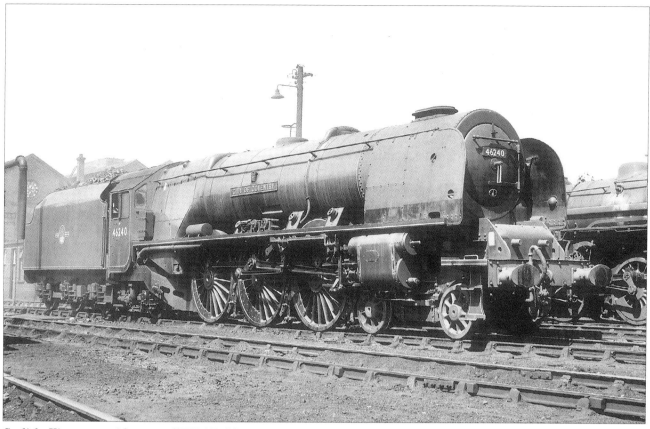

Carlisle Kingmoor with 46240 CITY OF COVENTRY on shed, awaiting its next turn of duty. This is an undated view but the engine is in the later style of maroon livery with the LMS style lining, and by this time has been fitted with AWS and electrification flashes. Photograph Paul Chancellor Collection.

One more rather pleasing portrait of 46240 CITY OF COVENTRY before we move on, at Willesden in March 1964. The equipment just to the rear of the smoke deflector is the vacuum ejector and the engine by now has a speedometer. The last three at Camden, 46239, 46240 and 46244, transferred to Willesden in September 1963 at the end of the summer timetable, with Camden shed closed to steam from that time. In August the following year they went to Crewe North, in anticipation of the ban on working south of Crewe due to the revised overhead line clearances. They did little work from Crewe, however, and it was soon decided to withdraw all the remaining examples at the end of the 1964 summer timetable. I well remember them arriving and they were all in lovely condition; Willesden had done them proud and was clearly sorry to lose them. Photograph J.A.C. Kirke, The Transport Treasury.

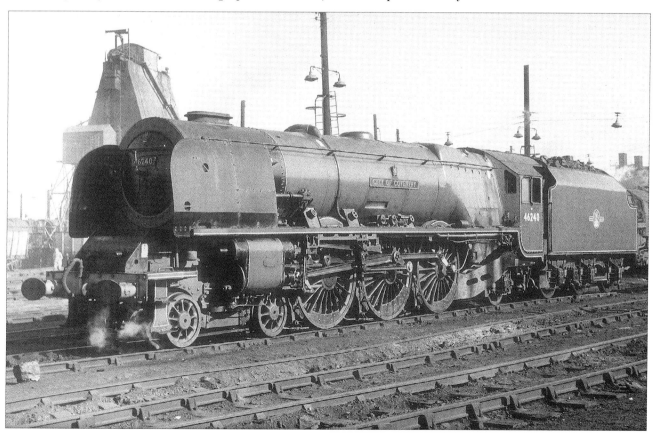

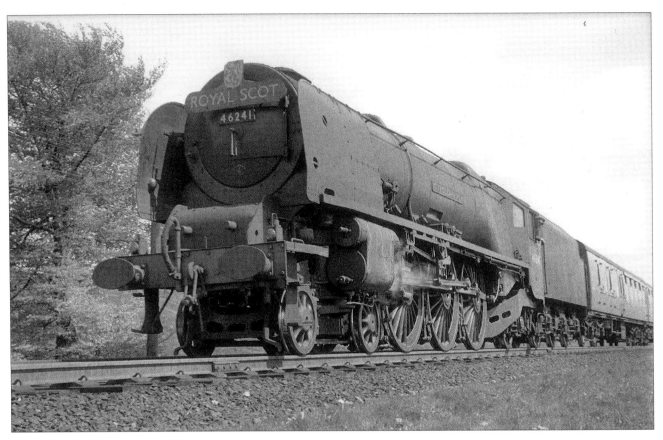

46241 CITY OF EDINBURGH, which despite its name was long a Camden resident; in fact it was never allocated to Polmadie in BR days. It is on the 'Royal Scot', but unfortunately we know not where or when. I often used to wonder why this engine and the next one were not allocated to Polmadie, but the Scottish authorities seemed to prefer to hang on to the ones with a Royal air about them! Photograph The Transport Treasury.

Like CITY OF EDINBURGH, sister engine 46242 CITY OF GLASGOW was never allocated to Polmadie either, at least not until March 1961. Instead it spent its days at Camden and Crewe North. It is seen here heading south at Carstairs on 22 July 1952. This is the engine that was hauling the Perth to Euston train on the occasion of the terrible double collision at Harrow & Wealdstone in October the same year. It had originally been built with streamlined casing and was 'defrocked' in March 1947; hence it has the gap in the foot plating in front of the valve chests. During rebuilding after the accident it acquired the full smoke box and, somewhat strangely perhaps, the full foot plating at the front. This was despite the fact that the last two built had the gap, though they had never been streamlined! Photograph The Transport Treasury.

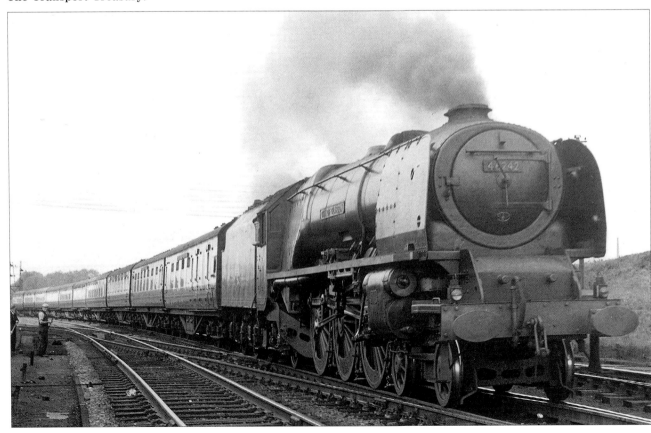

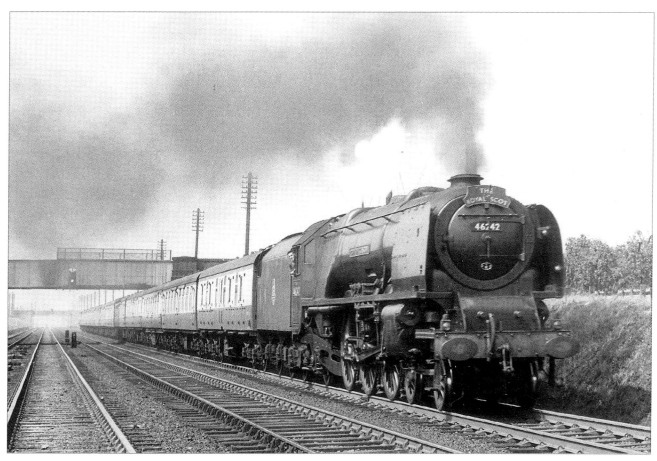

46242 CITY OF GLASGOW on 25 July 1952, just a few days after the previous view. This time it is heading the up 'Royal Scot' at Basford Hall, just south of Crewe. The engine is working hard as it gathers speed on the ten mile climb to Madeley, and a fine sight it makes too. Photograph The Transport Treasury.

Another of the engines to receive the later LMS style maroon livery was 46243 CITY OF LANCASTER, seen here at Carlisle waiting to depart south on 19 August 1961. Notice the traces of steam from the twin coal pusher exhaust pipes at the rear of the tender – the control valve must have been blowing through a little. Photograph Paul Chancellor Collection.

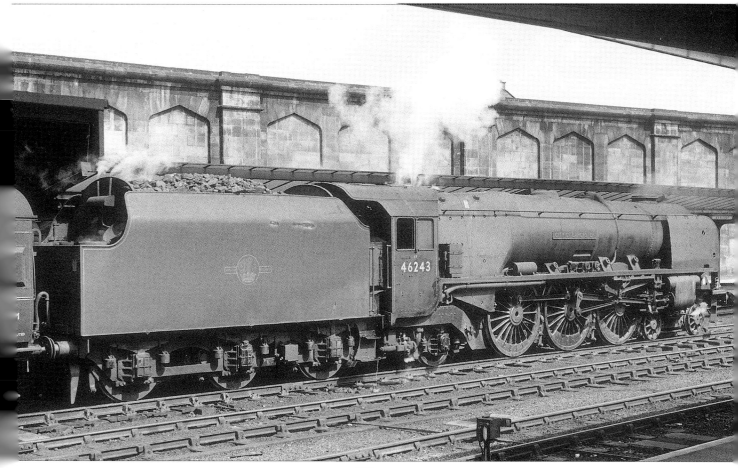

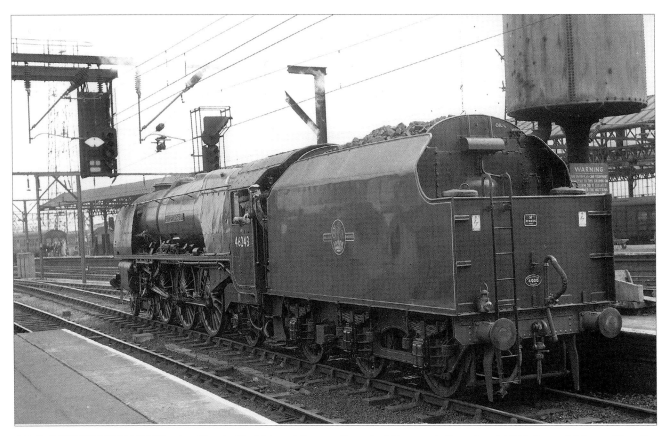

46243 CITY OF LANCASTER, standing in No.3 Bay at the south end of Crewe station about 1962. It would be waiting for an up train which it would subsequently work south, probably a Liverpool or Manchester which by this date would have been electrically hauled as far as Crewe. The sign by the water column tells crews that the overhead line equipment in the bay platform road is isolated to allow them to use the column. This view shows well the coal pusher engine exhaust pipes and lubricator, as well as back end features such as the twin fillers and extended sides, relics of the tender's streamlined days. The AWS visual indicator and reset handle can just be discerned in the cab above the fireman's head. That is the Divisional Civil Engineer's inspection saloon to the left, in its usual resting place at this period. Photograph Paul Chancellor Collection.

A break was made in the sequence of city names with 6244 which became KING GEORGE VI after the reigning Monarch in April 1941. It was originally CITY OF LEEDS, a name that appeared again on a later engine. This is Crewe North, in all probability just after the engine had emerged from Crewe Works in the new shade of blue. If this is the case the period would be January 1949; this engine in fact was probably the prototype for this shade. The lining was black and yellow, but this was later changed to black and white. Photograph The Transport Treasury.

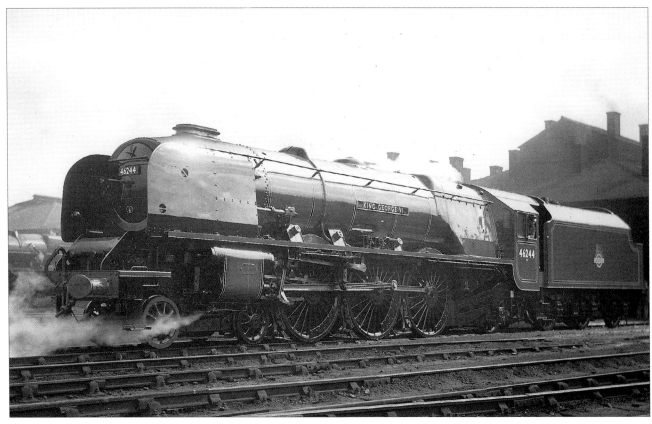

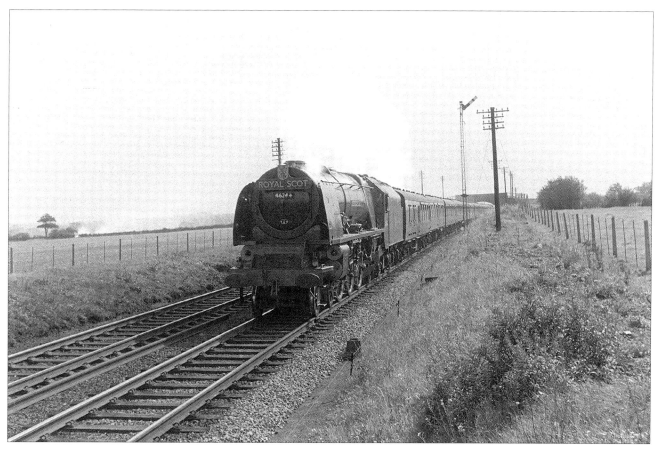

A much later view of 46244, heading north near Lichfield with the 'Royal Scot', after the smoke box modification of July 1953. For obvious reasons KING GEORGE VI was a favourite with Camden for Royal trains. Notice the burnished cylinder and valve chest cover plates suggesting indeed a recent 'Royal' working. At Crewe North we kept a set of these plates along with front buffers, draw hook and screw coupling all highly burnished. We kept ours in the stores and only fitted them when appropriate, recovering them soon afterwards, otherwise it was a laborious job the get them clean again, as I well remember! Photograph The Transport Treasury.

KING GEORGE VI, work-stained and grubby, departing for the north from Preston with the 10.40 Euston-Carlisle on 5 July 1958. This train had through coaches for Barrow and Workington which would be detached at Lancaster, hence the load of no less than sixteen coaches snaking behind. In May 1958 46244 had been transferred to Carlisle Upperby, so it would have been on its way 'home' on this occasion. Photograph A.W. Battson, The Transport Treasury.

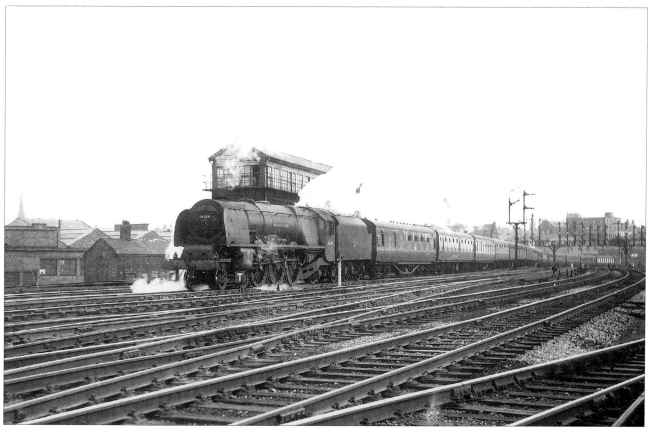

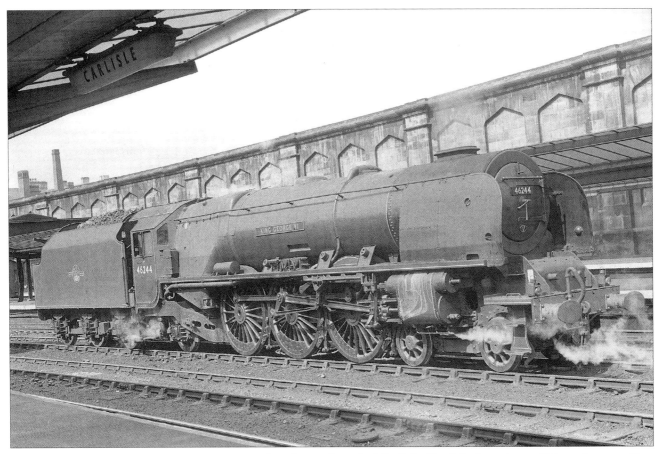

A last look at 46244, this time in the centre road at the south end of Carlisle Citadel where it would have been waiting to take over a southbound train. By this time the engine is in the later maroon livery with LMS lining. The picture is unfortunately undated but I reckon about 1961; note AWS equipment. Interestingly, when the engines were painted green the cylinder casings were always painted black. However, when they were in any of the blue or maroon liveries the cylinder casings were painted the respective colour. Just one of those quirks! Photograph Paul Chancellor Collection.

CITY OF LONDON on safari! Towards the end of the careers several were used on special enthusiast workings, sometimes taking them to other Regions. This is 46245 CITY OF LONDON in uncharted territory, at Doncaster shed after working a special for the Home Counties Railway Society from King Cross on 9 June 1963; later in the day it worked the train back to Kings Cross. A Camden engine at the time, it was an obvious choice for such a job, and would clearly have put any of the Eastern Region's engines to shame! Photograph The Transport Treasury.

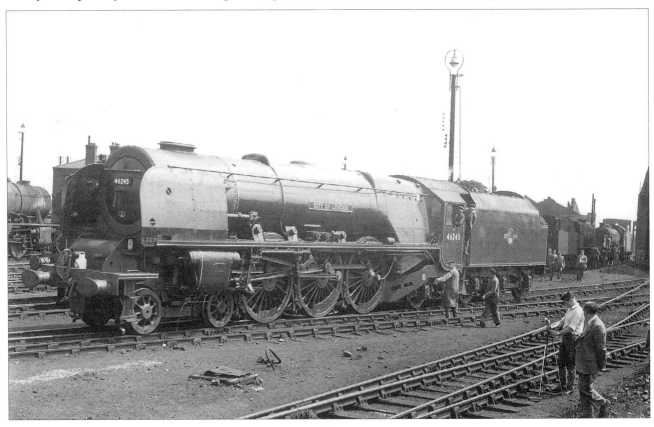

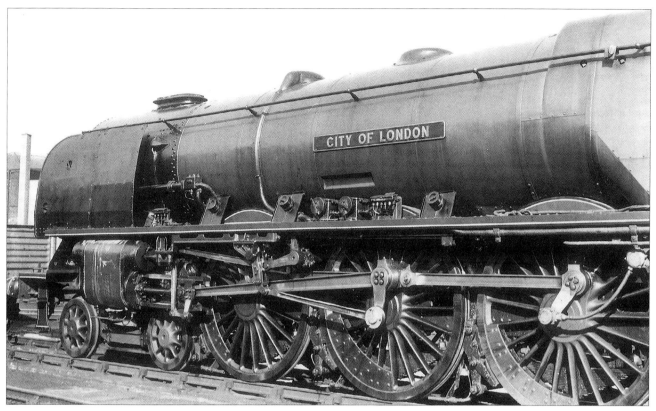

An impressive close up of the cylinders and motion of 46245. Note the twin brake blocks, a modification from the original design and applied from 46225 onwards. The earlier engines were never altered to this arrangement. When changing this type of brake block (it was an arrangement common to many Stanier designs) it was normal practice to swap the bottom block with the top one as it tended to wear less and then put a new block in the bottom. Observe too the later Smith's speedometer equipment, lubricators, oil boxes and sand box fillers. The steam sanding gear is clearly visible too, two sets for forward running and one for back. Photograph R.C. Riley, The Transport Treasury.

When electrification began to extend south from Rugby, clearances were reduced between the catenary, the trains and any fixed structures, in order to cut the cost of bridge alterations and so on. Certain steam types were then prohibited south of Rugby and in view of the potentially serious consequences of any transgression a prominent yellow diagonal stripe was painted on the cab sides. Actually, although the restriction only applied south of Rugby, the instructions banned the engines working south of Crewe after 1 September 1964. I well remember the 'Works' painters descending on Crewe North some time in the early summer to put the stripes on 'our' engines. There are nevertheless a number of known cases, supported by photographs, where engines so adorned did venture a good way south of Crewe! 46245 CITY OF LONDON is at the south end of Crewe station on 1 September 1964; just visible is the Ian Allan headboard, as on this day the engine worked a special to Paddington and back. This was the last occasion when one of these engines visited a London terminus in BR service. Photograph Norman Preedy.

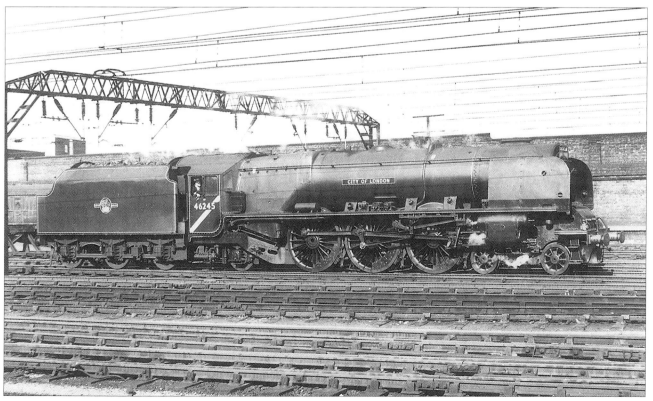

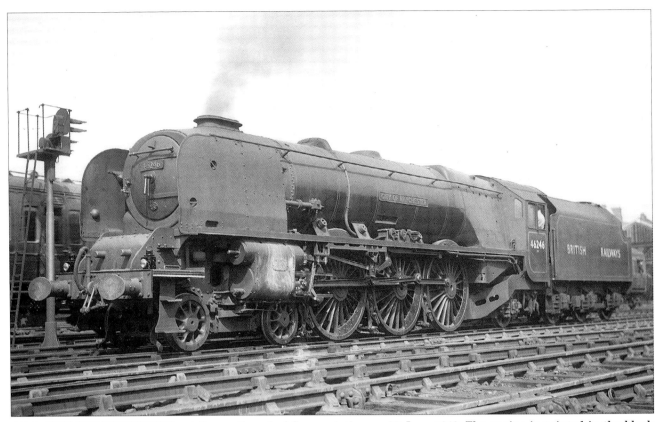

46246 CITY OF MANCHESTER, at the south end of Crewe station on 20 June 1949. The engine is painted in the black livery with LNWR style lining which it carried from February that year. This engine never got either of the shades of blue and went direct from black to green in June 1954. As no coal is showing in the tender, it's a fair assumption that it has just arrived from the north and is waiting to go to the North shed. It was a Crewe engine for most of its life under BR. Photograph The Transport Treasury.

CITY OF MANCHESTER was the last to retain the 'semi' smoke box and was not modified until May 1960, about two years after the penultimate one. Because of this there are few pictures of it with the full smoke box and the 'cycling lion' BR emblem on the tender. This is Carlisle about 1958 or 1959, when the overall roof was still there (more or less). The engine would have just arrived light from one of the sheds, for the tender is full of coal. This is strange as it carries the 'Mid-Day Scot' headboard and this train was at the time a Crewe North job for both engines and men, and they worked through between Crewe and Glasgow. CITY OF MANCHESTER has a 5A Crewe North plate, so what is going on here I wonder? It will presumably work the train south, in all probability as far as Crewe; perhaps it had been in trouble on an earlier occasion and the opportunity was being taken to return it 'home' after repairs. Photograph Paul Chancellor Collection.

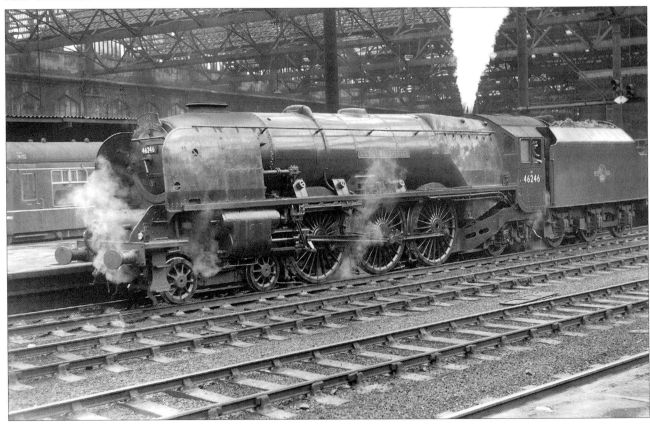

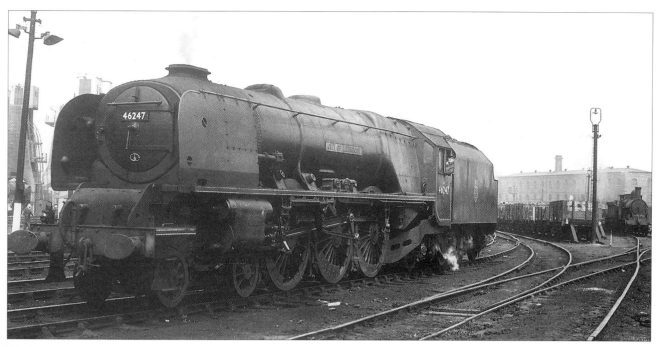

While 46246 CITY OF MANCHESTER was allocated to Crewe North for much of its BR life, its sister 46247 CITY OF LIVERPOOL was at Camden. It was never allocated to its home city as generally the Pacifics at Edge Hill were of the earlier 'Princess Royal' class. Here is 46247 on Crewe North on 24 July 1952 and it looks as if it is posed for the photographer as it makes its way off the shed to work a train south. Notice the engine is in backward gear and the driver is posing too! Surprisingly by this date the engine retains all or part of its LMS speedometer gear; it can be seen adjacent to the trailing coupled axle. Another one never to be painted blue, it still has the LMS lined black; it was painted green in May 1953. The large building to the right is part of the 'Old Works' with the ornate entrance arch to its right. The ex-LNW 'Cauliflower' 0-6-0 on the right would probably be shunting what we called the 'coal hole'; that is, wagons for the mechanical coaling plant which can just be glimpsed behind the two ash handing plants to the left. Photograph The Transport Treasury.

46248 CITY OF LEEDS at Manchester Piccadilly, 14 April 1962. Pacifics were 'rare birds' at Manchester, for they did not normally work any of the Manchester diagrams, and none of them was ever allocated to Longsight. No coal visible in the tender suggests a train from Euston. A lot of the London-Manchester services were routed via the North Stafford line through Stoke, from which these engines were originally prohibited. Later they were subject to several severe speed restrictions and this was one of the reasons for never allocating them to Longsight. Usually when they did find themselves at Manchester they would be sent *post haste* light engine back to Crewe. On the infrequent occasions they were diagrammed to work trains south from Manchester they would go light from Crewe to pick up the working, or perhaps work a local train. When I started work at Crewe North CITY OF LEEDS was 'our' Royal Train engine. Photograph Paul Chancellor Collection.

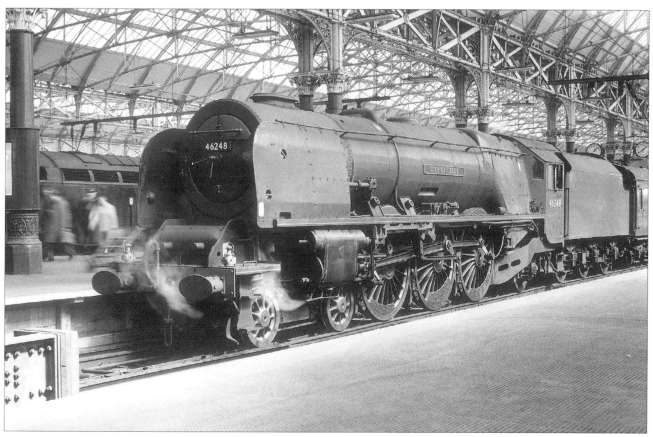

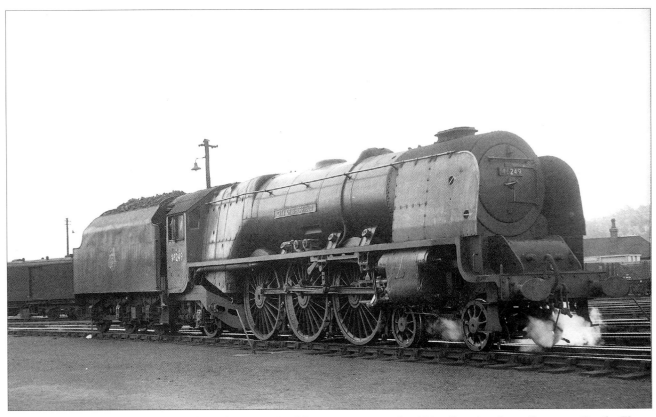

The longest regular rostered footplate diagrams in this country were the 296 mile trips from Crewe to Perth. There were two trains each way every night and they were worked north by Crewe North engines and men, on 'double home' turns lodging in Perth; they would return the following night with the same engines. 46249 CITY OF SHEFFIELD is at Perth shed some time in September 1955, having worked in the previous night. It has been coaled and serviced and is waiting for its return working; it is in forward gear and doubtless ready to 'ring off' the shed and make its way to the station. Trains from Inverness, Oban and Aberdeen would converge on Perth in the early evening with through coaches to the south, which would be combined to form the southbound job for the Pacifics. This was the first member of the second batch of these engines built without streamlining, hence the full foot plating at the front and downward extension of the smoke deflectors. Photograph The Transport Treasury.

In the classic shot on Shap just south of Scout Green, 46250 CITY OF LICHFIELD has a light eight coach load some time in August 1964, doubtless a relief working of some sort. It has the yellow cab stripe prohibiting its use south of Crewe. A Carlisle engine at the time it had but a few weeks left as the survivors were all withdrawn at the end of the 1964 summer service. The engine would be 'playing' with this load; observe the clear exhaust and wisp of steam at the safety valves, and not much coal appears to have been burnt on the way from Crewe either. Photograph J.G. Walmsley, The Transport Treasury.

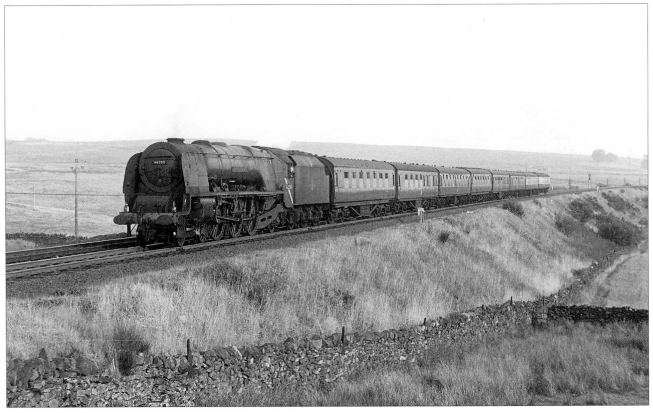

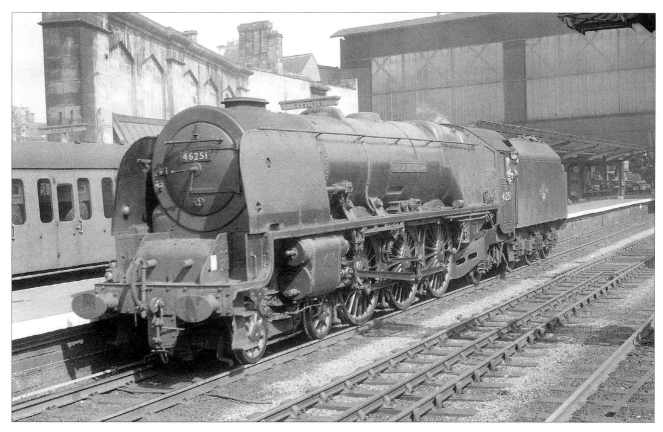

Crewe North's 46251 CITY OF NOTTINGHAM at Carlisle. The view is undated but the engine appears to be painted in the earlier version of the maroon livery with the BR style lining, so it would be some time between November 1958 and 1960, when it received the later LMS style lining. As AWS has been fitted it would be the later part of this period. It looks to me that the engine has come off a train from the south and is heading back through the station to Upperby shed – it is in backward gear and the crew are looking in the right direction for such a move. Photograph Paul Chancellor Collection.

46252 CITY OF LEICESTER at Crewe North on 21 June 1949, not long after receiving the black livery with LNWR style lining. A splendid group of cleaners in the cab, all making sure they are in the picture! On the right is the ancient LNWR mechanical coaling plant, one of the first in the country when it was installed. The scaffolding just visible beyond indicates that work has commenced on the new coal and ash handling plants. These formed part of the post-war reorganisation of Crewe North Motive Power Depot, a project destined never to be completed. Photograph The Transport Treasury.

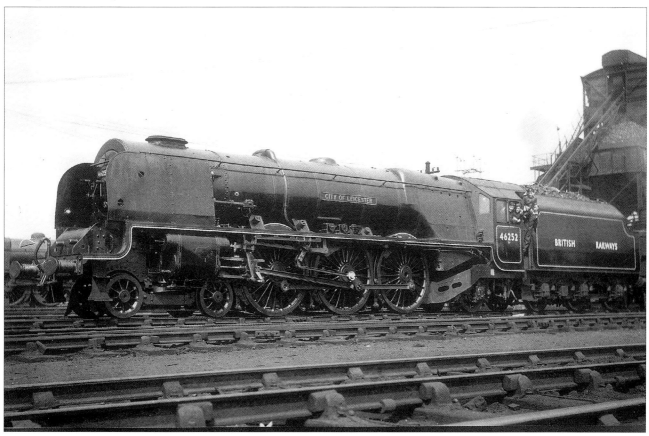

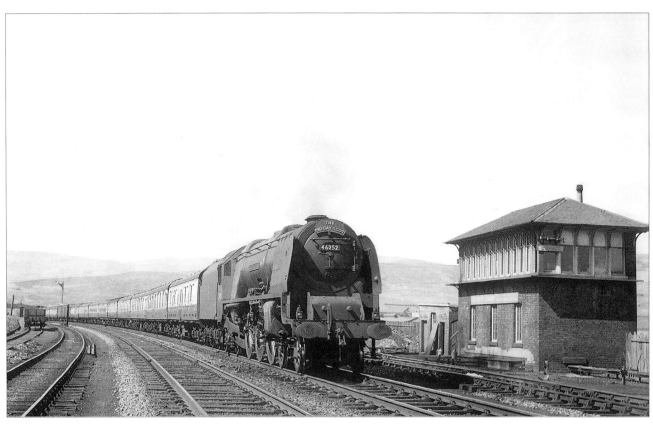

Breasting the summit of the southbound climb to Beattock, 46252 CITY OF LEICESTER with the 'Mid-Day Scot', 2 May 1953. A lodging turn to Glasgow, this was a job for Crewe North engines and men for many years. The crew and in all probability the engine too, would have worked the down 'Mid-Day Scot' into Glasgow the previous day and would work through to Crewe where engine and men would be changed. The train consists of at least thirteen coaches, the fire is nicely burnt through and the safety valves are wisping – an engine completely master of its job after 50 miles of almost continuous uphill since leaving Glasgow, culminating in two miles of 1 in 99. Photograph The Transport Treasury.

Outside the No.10 Erecting Shop at Crewe, 46253 CITY OF ST ALBANS is obviously just off a repair. The photograph is undated but the engine is in the lined black livery and it looks as if it has just received its BR number, which took place in September 1949. Whatever repair the engine has had it does not seem to have been a General, as it's only been patch painted, and not taken to the Paint Shop either. This picture shows well the two anti-vacuum valves just in front of the cylinder mounted on the main frames. The bottom one is for the left-hand inside cylinder and the top one for the left-hand outside cylinder. Photograph Paul Chancellor Collection.

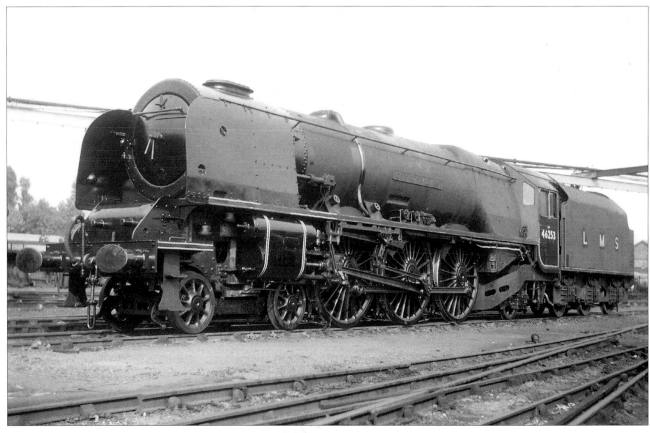

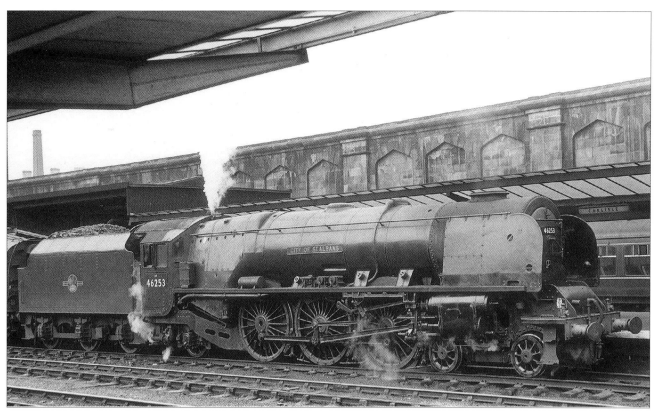

CITY OF ST ALBANS has to be one of my favourites. It was the very first engine I worked on and I can see it now standing at the end of No.8 road in the Middle Shed at Crewe North – memories! In this portrait it is in the classic position of so many superb 'Duchess' studies, at the south end of Carlisle station waiting to head south. Judging by the coal in the tender it has worked through from Glasgow. This picture was taken on 23 July 1960 and the engine was at Crewe North right through from September 1952 until it was withdrawn from service. Whatever might or might not be said about these engines when painted maroon, and after all that was the original livery of the early non-streamliners, I have a soft spot for them when they were painted green! Photograph Paul Chancellor Collection.

My home city, and thus another favourite; Crewe North again with 6254 CITY OF STOKE-ON-TRENT arriving on shed; notice no coal showing! The engine is in the late LMS lined black and as it received its BR number in July 1949, the picture must pre-date this. It is one of the few with 'City' names to have the crest above the plate. This engine has a manually operated boiler blow-down valve; there it is at the front of the firebox just to the rear of the trailing coupled axle with a rod to operate it from the cab. I think it was the only one so fitted; in any event it did not last for long. Photograph The Transport Treasury.

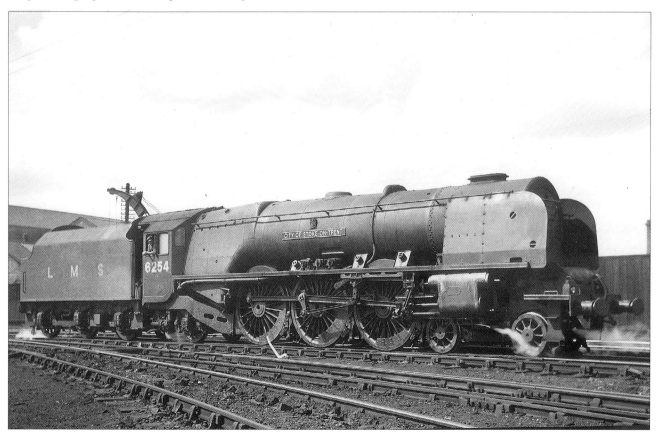

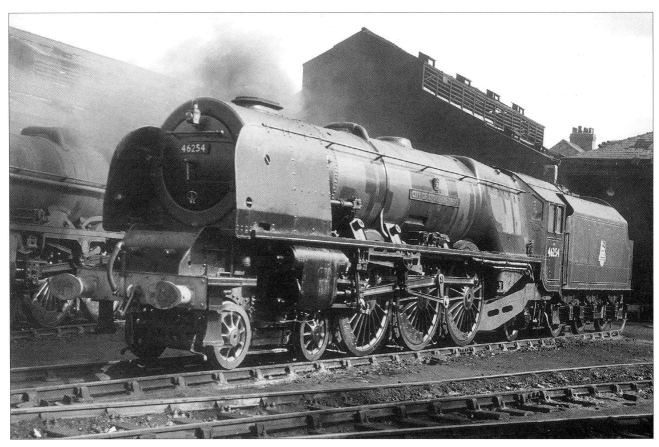

The remains of 'Abba' shed at Crewe North before what was left of it fell down! Whilst it spent quite a lot of time at Crewe, as indeed it should have, 46254 unlike many of its sisters had a somewhat nomadic existence having also been allocated at various periods under BR to Camden, Carlisle and Edge Hill. But it was at Crewe for all the time I was there, which pleased me! In this picture it is clearly 'fresh-off' works having had some spot repainting of its green livery – but what is it doing with that headlamp code? It received the maroon livery in September 1958 so this picture will date from a little before that. The engine is standing on one of the short roads radiating from the then relatively new 70ft turntable; some of these were later covered by a semi-roundhouse. Photograph The Transport Treasury.

One of the classic places at Crewe North for photographers and indeed a favourite with the indefatigable W.H. Whitworth. CITY OF STOKE-ON-TRENT is waiting to 'ring-off' the shed and take a train south. The large building is the stores of the 'Old Works' where, incidentally all the old nameplates and the like were kept. I talked my way in there once and oh! what a treasure trove. The engine has by this time (about 1962) been fitted with AWS and had long lost that blow-down valve shown earlier. Photograph Paul Chancellor Collection.

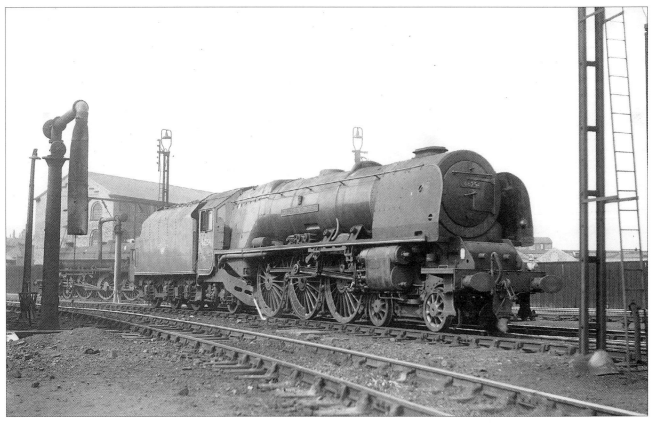

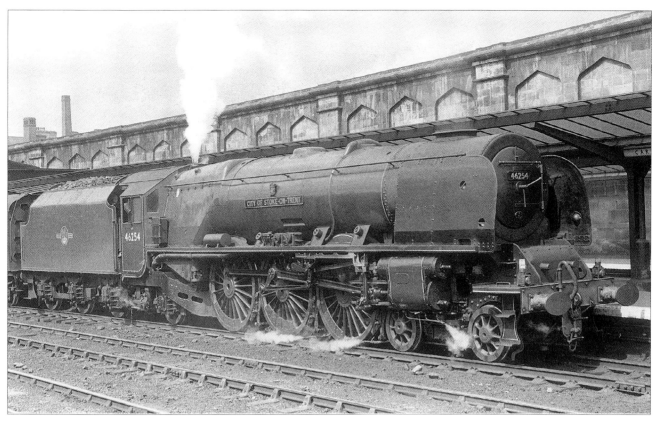

The south end of Carlisle station yet again, with 46254 waiting to depart for the south, 26 July 1960. The engine, allocated to Camden, would have come on at Carlisle and would work through to Euston. I think the train has just started to move and the driver has operated the steam sanders to ensure a smooth start; notice the steam issuing from them, or perhaps he was just putting some sand under the wheels ready for a clean get-away! Photograph Paul Chancellor Collection.

CITY OF HEREFORD at the west end of No.6 Belt, No.10 Erecting Shop at Crewe, 23 June 1960. The records show a Heavy Intermediate repair from 9 June to 17 August, which seems rather a long time. It looks to me as if the engine has only just arrived for stripping in this picture, so perhaps it was delayed being brought into the shop. Notice the number stencilled on various parts to ensure they were all married up again later! Note too that, as in the sheds, the initial 4 of the number was never used! That looks like a 9F behind – the dome-mounted regulator rules out a 'Britannia'. The principal item of interest in the foreground is a motion slipper block casting for Joy valve gear, off one of the 'Super D' 0-8-0s still receiving repairs. The whitewash of the east end traverser pit can just be seen in the foreground. Photograph Paul Chancellor Collection.

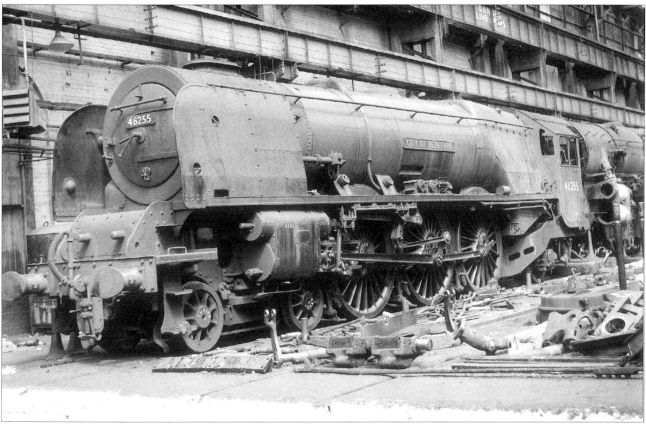

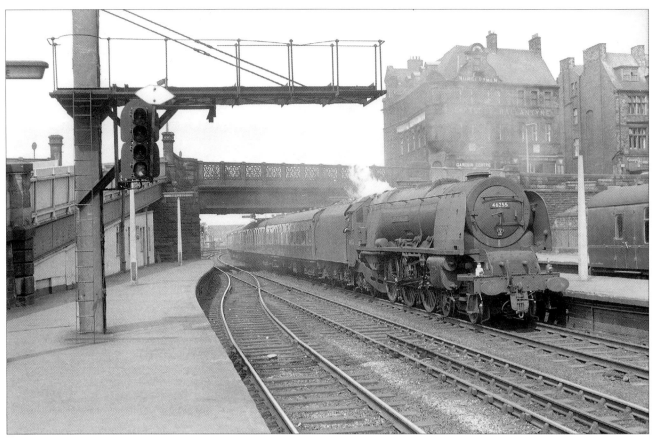

Arriving from the north at Carlisle 46255 CITY OF HEREFORD coasts in with safety valves wisping nicely. A Kingmoor engine, the period is probably around 1962. Photograph Paul Chancellor Collection.

The last two 'Big 'Uns' differed from the others in a number of respects. The rear end was redesigned and a 'Delta' type trailing truck substituted. This meant alterations to the rear end of the main frames and their extensions and in consequence the cab side sheets had to be altered too. Views are mixed among enthusiasts and professional railwaymen alike as to the aesthetics of this cab; certainly it imparted a rather austere look. The engines had roller bearing axle boxes all round, a slightly higher level of superheat, modified reversing gear, rocking grates with hopper ashpans and some time later were fitted with electric lighting. The first of the twins, as 6256, was the last one put into service under LMS auspices and was aptly named SIR WILLIAM A STANIER FRS. Here it is at Polmadie on 2 August 1952, in the blue livery which it kept until June 1954. That is the turbo-generator for the electric lights just behind the smoke deflector. Photograph The Transport Treasury.

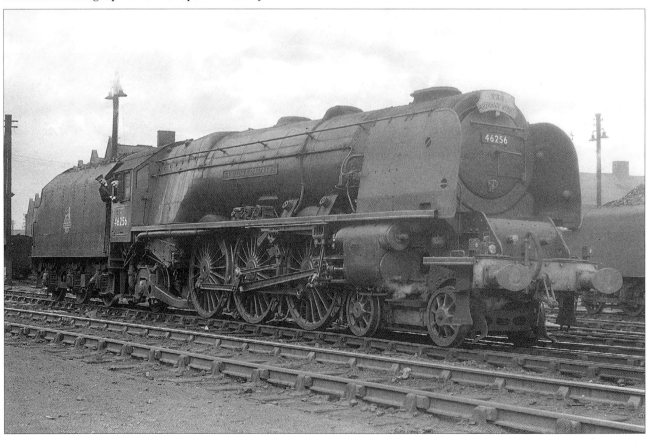

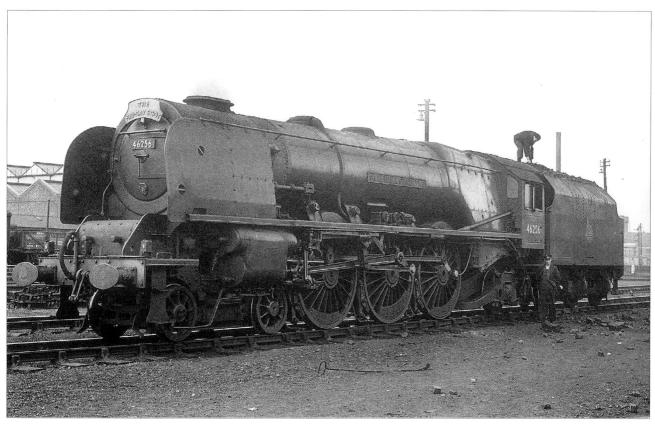

The opposite side of 46256 on the same occasion. A Camden engine at the time, this was one of the short periods when Crewe North engines did not work 'The Mid-Day Scot'. It is about to leave to take up the southbound working, though it would almost certainly come off the train at Crewe. Notice the reversing rod is circular as the reversing screw itself was mounted under the foot framing just behind the motion bracket, rather than in the cab. This method was later adopted for the larger designs of BR Standards. Notice too, the roller bearing axle boxes on the trailing truck and tender. The redesigned rear-end was primarily to allow for an improved grate and ashpan arrangement, the latter with a greater capacity. Ashpan capacity was an issue in working these engines through between Euston and Glasgow, especially with the soft Scottish coals. Photograph The Transport Treasury.

Perhaps it was just non-standard but the electric lighting was later removed from the two engines. SIR WILLIAM A STANIER FRS is standing at the north end of Carlisle station on 26 September 1959, after arrival from Euston on the 'Royal Scot'. Having come off its train it is waiting for a southbound train to depart before running light to Upperby shed. This engine was transferred to Crewe North in September 1960 and remained there for the rest of its life, so it was another of my favourites! It was also the last one to work in BR service, being retained after the other survivors were withdrawn on 12 September 1964, for an enthusiast special a week later. Photograph Paul Chancellor Collection.

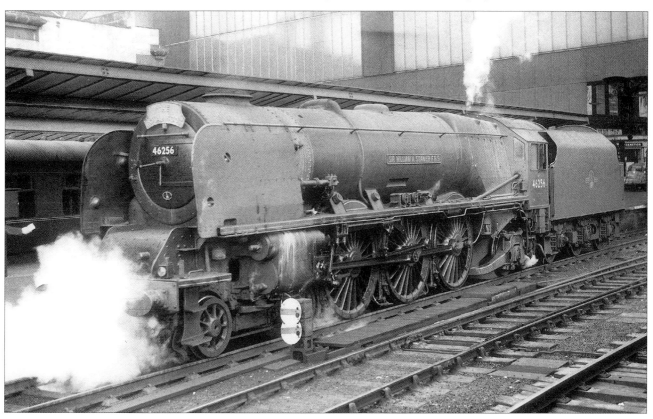

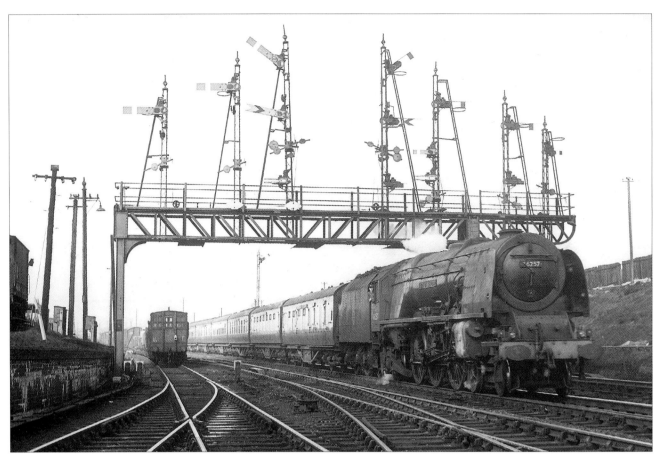

Last but by no means least, 46257 CITY OF SALFORD; it had not entered traffic until May 1948 and so was always a BR engine. Here it is approaching Carstairs from the north on 20 March 1953, when allocated to Camden. The coach boards appear to read Euston-Glasgow on the original photograph and the engine would doubtless be working through to Crewe. Photograph The Transport Treasury.

Still allocated to Camden, 46257 speeds through Watford on the up 'Royal Scot', the fireman taking a well-earned rest by now, his work done for the day as the train races along the favourable grades to the terminus at Euston. This view would have been taken during the period of a winter timetable, as in the summer this train ran with a limited load, supplemented as necessary by additional services. The tender has the later BR emblem, and the year would be about 1959. Photograph J. Robertson, The Transport Treasury.

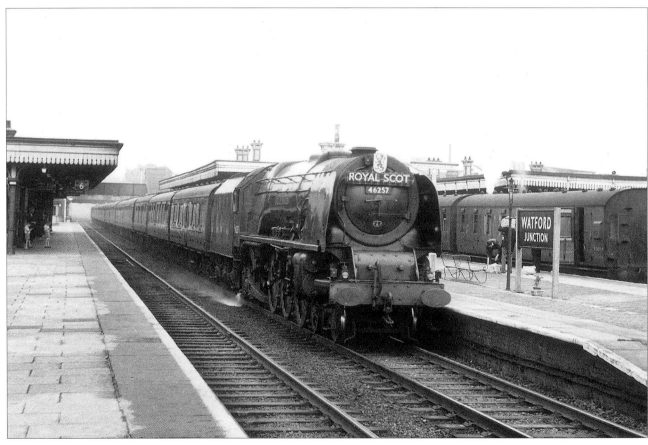

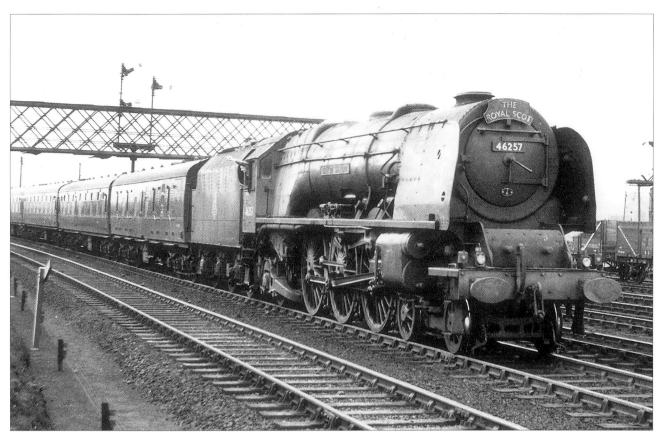

CITY OF SALFORD on the 'Royal Scot' again, this time heading south past Upperby sheds at Carlisle – from where it had been due to depart at 12.03 – and possibly working through to Euston on a cyclic diagram. However, as the date is 15 April 1957 I rather doubt it, for the through engine working was usually confined to the summer timetables. The fireman appears to be waving to somebody, but not the photographer! Photograph J. Robertson, The Transport Treasury.

A fine portrait, unfortunately undated, of CITY OF SALFORD at Carlisle. This is quite a late view as the engine is in green livery, with AWS and speedometer though it retains the electric lighting. I think this engine kept the lighting equipment later than its sister. That is the AWS battery box underneath the cab side sheet. On the other engines it was on the opposite side, just ahead of the cab on the foot framing alongside the firebox. The engine is standing at the south end of the station, in backward gear; from that, and given the stance of the driver, I reckon the crew are waiting for the signal to proceed to Upperby sheds, after coming off a train from the south. Photograph Paul Chancellor Collection.

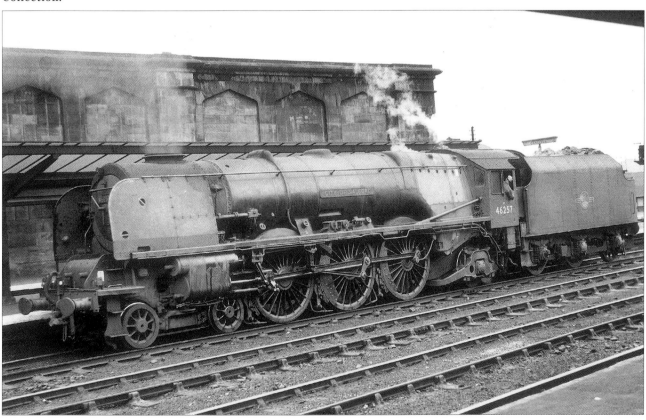

## Of Lupins and Other Matters

Shortly after the two beautiful Coronation *Accompaniments*, 1 and 2 were published, the howls of anguish across the giant studio and production complex of Irwell Press, Inc, told that the worst had come to pass – captions had been misjuggled to render them ever so slightly incomprehensible. Nothing to do with the author of this third volume, Allan Baker of course, writes Ian Sixsmith, who adds; 'I have gone into a Retreat'. Regular readers tend to be bemused, amused and intrigued by this sort of thing; principal among them was Mr Derek Dean of Wolverhampton; with his help and that of others we can now reproduce the *correct* captions...(bottom right).

Crumbling faculties meant that in **Accompaniment 2**, on page 14 46251 CITY OF NOTTINGHAM with Jubilee 45631 TANGANYIKA was misidentified as 46231 DUCHESS OF ATHOLL.

A number of further clarifications/ corrections have emerged though only quite recently, concerning the parent book. **Mr T. Glendinning of Hawick wrote**: ...the wheels on page 3 of your splendid *Book of the Coronation Pacifics* are said to be from a 'Big 'Un' but this is clearly not the case, for the LMS Pacifics had extended webs on the inside cranks, to balance the rotating masses and those in the photographs definitely do not. Also, while browsing through my copy of A.J. Powell's *Living With London Midland Locomotives* recently I found the very same picture, in which they are described as the wheels from a 2P 4-4-0, on the balancing machine at Derby Works. This seemed more realistic to me, for the cranks didn't look big enough for a mighty Duchess! I had suspected this for some time but it was not until coming across the picture in John Powell's book that I was able to write with confidence regarding the wheels' rightful owners!

**Mr Bernard Haste** and others of us were also exercised by a contradiction in the 'Book Of' relating to 46236; the casing was noted as being removed 10/ 7/48 and renumbering 17/7/48, while a photograph shows it already renumbered and uncased in April/May 1948, in the Locomotive Exchanges. This was the reply: 'There would certainly seem to be an error in the works date, for the loco was obviously 'de-cased' by the time of the Exchanges. As Sixsmith and others in the series try to explain, the data is transcribed from the original Record Cards and in all the thousands of entries there are some unnoticed errors. These occur either on the original cards (they were all filled in by hand) or in transcribing therefrom – typos if you like. There might even have been a blob of post-1948 ink obscuring it, for instance. Still, one might as well get it right! Checking back to the original LMS/BR card, behold! in careful copper plate is the plainly wrong '10/7/48' so at least we (sort of) can blame the anonymous clerk of sixty years ago. Still, it should have been spotted and I'm surprised it has never surfaced before, for it is pretty blindingly obvious, after all, given the contiguous photograph of CITY OF BRADFORD. Congratulations to Mr Haste for spying it. The great Brian Reed in one of his famous 'Profiles' gives the date of removal as 12/47 and I think we can take that as the correct one.

**Mr Cliff Richardson of Cheadle** writes: '...regarding Coronation Accompaniment 2 on page iii under the heading *Livery Changes* you can add 46238 to the list of locomotives which ran with BRITISH RAILWAYS on the tender'.

Thanks also to **Mr Michael Thomas of Preston,** and **Jim Norman of Wigan.** Finally, **Mr Jim Barnes'** comments are of some considerable interest: 'Like you, my initial exposure was to the Pacifics of the LNER, an everyday sight during my boyhood around Dundee. I soon became aware of a completely different range of engines at Perth where I became a regular as soon as parental supervision could be thrown off. My purpose in writing is to respond to the question on page 71 concerning the identity of the red Coronation on Haymarket shed. My candidate would be 46228 which I saw from a passing train on Haymarket on the evening of Wednesday 3 April 1963. We were on our way from Dundee to Newcastle during a week of 'Freedom of Scotland' spotting; Coronations sometimes worked to Edinburgh for rugby internationals but these were at weekends. My friend once saw 46251 at Waverley with a train of Welsh supporters, which it may have brought from Crewe. The most unusual Coronation working I ever came across was at Broughty Ferry, Dundee, on a Saturday afternoon. I was on the beach beside the main line when along came 46226 with a troop train composed entirely of green SR coaches. A little later the train came back heading for Dundee with the Coronation running tender first. This would have been the summer of 1963 or 1964.'

**Accompaniment 1**, page 53 lower 46252 CITY OF LEICESTER on the turntable at Kingmoor, 13 May 1961. Many of the later Coronations were doggedly English and this is the nearest they got to a 'Scottish' allocation, the former Caledonian shed, by now part of the LMR. Photograph Ian G. Holt.

**Accompaniment 1**, page 59 upper The lupins bob and dance in the wake of 46256 SIR WILLIAM A STANIER FRS with the down Royal Scot at Grayrigg station about 1961 or thereabouts. The station closed to passengers in 1954. The signals are Grayrigg Up Starters for the Up Main and Up Goods Loop and Mosedale Hall Crossing Distants. Photograph The Transport Treasury.

*Detailing and Improving*

# READY TO R

# WAGONS

**Model Railways Illustrated  Handbooks No.1**

# By Iain Rice

**IRWELL PRESS**

**For Rosalind and the Girls, For Putting Up With It All**

# CONTENTS

**ACKNOWLEDGEMENTS**

To wagon-knowledgeable friends, for information on demand, and to Alec Hodgson, Pete Lindsay and Chris Challis for finding me the bits, usually at very short notice.

Irwell Press,
15 Lover's Lane,
Grasscroft,
OLDHAM OL4 4DP.

*The RTR wagon taken to the limit? This ex-Hornby Dublo 'SD6' steel open has been modified with a tarpaulin bar, and sits on a largely scratch-built chassis to P4 standards.*

As it comes out of the box, the modern RTR wagon is, by and large, a pretty good model. The body will be a crisp, fine, well-detailed plastic moulding. The finish will be of a standard that few modellers could equal, especially in the matter of lettering. It will roll on a chassis using pin-point bearings, on wheels that, not so many years since, would have been regarded as 'finescale'. What then, can be done to improve this paragon of excellence? Actually, quite a lot.

'There is no thing made that cannot be made better', quoth the sage (don't ask me which sage!) and this is as true of RTR wagons as it is of motor cars and houses, to name but two things that everyone seems hell-bent on 'improving'. In the case of our redoubtable plastic wagon, improvements may be generally classified under two broad headings; modifications to make the wagon run better, and titivations to make it look, if not better, then perhaps a tad more realistic.

Such steps as can be simply taken in pursuit of these desirable ends are the stuff of this book. If you are looking for blow-by-blow accounts of elaborate surgery intended to remove an offending inch or two of 'scale length', or to otherwise correct minor defects of authenticity, then I am afraid this is not the volume you seek. The basic criteria on which I have based these 'conversions' (if I may so dignify them) are simply those of pleasing appearance and reliable performance.

There will also be a lack of distinction as to the matters of gauge and standards, for the good and sufficient reason that, in the context of the operations I am describing here, it makes not a jot of difference to

the work involved. To what extent you consider the improved fidelity imparted by a finer standard worthwhile is a personal decision, based on a number of factors of which appearance is just one. Finer standards do not, in themselves, necessarily make for more realistic models – a well built and finished 00 wagon will be more convincing than a poor P4 one.

Most of my recent layouts have made considerable use of RTR stock, both loco and wagons and I have found the task of making the modest improvements needed to fit these models for my own (admittedly somewhat relaxed, by contemporary 'hi-fi' standards) purposes every bit as satisfying

as assembling kits or indulging in hair-shirted scratchbuilding. And there is the added bonus that, by and large, use of RTR wagons is relatively quick and cheap, freeing valuable resources of time and money for other aspects of the layout, where a greater input is required.

Most of the projects described in this book amount to no more than a pleasant evening's work. It is very satisfying to start with an empty yard of track and, at the end of a fortnight or so, have it full of realistic, reliable wagons ready for traffic, all different and individual to your layout, rather than clones of a thousand others. Wagons roll!

*Faultless lettering? Even in close-up the 'small print' on this 1977-vintage Airfix PO wagon is superb.*

*A lovely model? Not really – the codfish eye rejects Bachmann's BR fitted mineral wagon as too long, with the wrong running gear. Shame.*

*Even on the standard RTR chassis, the Dapol (née Airfix) BR 12T van is pretty good; combine a mildly modified body with a Ratio plastic kit chassis, and the result is out of the top drawer for appearance and accuracy.*

# 'THE CODFISH AND THE TOOLBOX'

*Amid the usual workbench chaos, another wagon – a Hornby TTF tank – gets the treatment; new, inline brake gear and a spot of wire plumbing can work wonders.*

I do so like to kick these little essays off with an erudite literary quote – it saves thinking too hard first thing in the morning. So, failing anything suitable from the Bard of Avon or the Bore of the 'Strand' I will give you a snatch of Arthur Ransome: 'What her codfish eye can't see, her conger heart can't grieve over'. (Nancy Blackett, of the dreaded Great-Aunt in 'Swallowdale', for those without any 8 year old Swallows and Amazons freaks about the house...) Well, when it comes to modelling, a codfish eye is no bad thing to have. It is all too easy to become lost in admiration when beholding some of the truly delightful model wagonry that the Trade (Bless 'em) now offer us – whereas cold-eyed appraisal might suggest that what is merely good might actually be a good bit better.

I seem to have reached that age when everything appears to command ridiculous prices, but cool contemplation suggests that today's exquisite RTR wagons are actually relatively inexpensive. For the 'scale' modeller, desirous of obtaining the best of running and a high degree of realism, the fact that most of them need relatively little doing to them to fit them for his purposes makes them even more fiscally appealing. Using RTR models, it is quite possible to assemble a fairly comprehensive wagon fleet of pretty good authenticity without the assistance of either ERNIE or Methuselah. Mix them in with a selection of the equally authentic and economical plastic wagon kits from the likes of Ratio or Slaters – the join is pretty well seamless – and the world is your oyster.

I have long been a great user of RTR wagons; all of my various early BR period P4 layouts have relied heavily upon them and I find working with these exquisite mouldings allows me to produce better models than I ever could by scratchbuilding. It doesn't earn you many 'Finescale Brownie Points', mind; I have been upbraided many a time for using wagons that had some error in their dimensions or detailing. Viewed objectively, that may be so – but looked at subjectively, in the context of a model railway designed for relaxation and entertainment, rather than set up as a piece of historical scholarship, they give the right impression. Better than that – they look realistic, convincing, 'correct' in the context of a model that is every bit as fictitious as 'Swallows and Amazons'. (That is, based on reality but conveniently rearranged to suit a romantic or idealised version of that reality).

*Truly delightful! Who can resist a model as beautifully made and finished as this? I'm happy to forgive a few minor dimensional sins for such a super paint job.*

*The infinite variety of the British goods wagon lasted well into BR days.*

Enough of this misty-eyed philosophising; what does all this amount to in the grey reality of the goods yard? Well, it resolves itself into a set of aims or standards. What I'm aiming to do in my modelling of wagons is to produce models that are as correct as I can conveniently make them, with as much interest and variety as possible, finished to look as though they are real wagons carrying real traffic on a real railway, rather than ossified showcase specimens, and capable of reliable operation to replicate real railway working. The wonderful thing about railway wagons is their individuality; you can have a 40-wagon train of standard BR 16-ton minerals – and make each one different to its neighbour. The minor differences in basically similar wagon types on the British prototype are almost limitless and offer wonderful scope for entertaining and satisfying modelling. Reworking an RTR wagon – even into something quite far removed from what it sets out or purports to be – rarely takes more than a few hours; an evening's pleasant endeavour at most. So, to summarise what one might term the 'visual standard', I am out to correct really glaring errors, such as the wrong type of underframe, and to re-detail and finish my wagons so as to make them individual to my layout.

A major part of this process is, obviously, contained in the re-detailing area and the finishing. The other main element is in eliminating things about RTR wagons that I find visually unacceptable – which is where the old codfish eye comes in. Features likely to get the cold stare from Rice include brake gear way out of line with wheels, whopping great tension-lock couplings, anorexic buffers, silly unprototypical liveries and, for practical as well as aesthetic reasons, the coarser type of 00 wheelset. Most of these things are, you will be delighted to hear, readily capable of improvement or elimination – the means of so doing forming a large proportion of the ensuing chapters. It will not have escaped your notice that most of the black marks awarded above go to the underframes of RTR wagons, and these are indeed the main area of attention.

Work on the underframes of RTR wagons also needs to have regard to the running qualities of the vehicle. Here again, the codfish eye has a part to play. Obtaining the realism and atmosphere that is always a principle aim of my endeavours in layout construction depends upon getting things to move as convincingly as they look when standing still. This is not always easy, especially when working in 00. Why? Surely the least 'scale' and hence, by implication, least critical, of the 4mm scale standards should be the easiest to make work? Well, in my experience, it is not.

The problems have nothing whatever to do with gauge. As well as my dabblings in P4 British-prototype, I also have an HO American-prototype (Boston and Maine in New Hampshire) layout, which is ostensibly the same thing as standard British 00. But, in fact, it is a far cry. The difference? Well, leaving aside the obvious advantages of a correct scale-to-gauge ratio (it's as accurate as P4) and a top-notch auto-coupler that works like a dream and looks uncannily like the real thing, the main advantage is that US HO follows a set of precisely laid-down standards. These are promulgated by the American national association, the N.M.R.A. which covers all the gauges and scales in use in the US, ranging from Z to G (½″ to the foot). It has a huge membership, and speaks with a powerful voice for the hobby as a whole. The NMRA long ago laid down a fully-defined set of standards for all the various scales, that for HO covering such fundamentals as all track and wheelset parameters, vehicle weighting, wiring polarity for locos, coupler types and standard

*An RTR 'marriage of convenience' – a Lima body has its duff chassis replaced by a far better effort from the Bachmann stable. Most RTR parts can be 'mixed and matched' if need be.*

coupler mountings and a host of other criteria. The result? Virtually all HO model equipment sold in the States conforms, and hence can be inter-mixed, cross-kitted and reworked without impairing running quality.

The result is that high-quality running is taken for granted, and nobody ever has to think; 'If I am using type X pointwork, will type Y wheels run through it?' I can buy an American boxcar from any one of a dozen makers and know that the wheels supplied will suit my track, and that there will be a standard draft-gear box in which I can drop NMRA horn-hook or Kaydee buck-eye couplers as I see fit. Of course, I may decide to fit some better wheels, a metal in place of plastic, for instance – but I don't *have* to. Now try running a Lima wagon on scale bullhead track or through a (bump! lurch!) scale point. You get my drift... why the UK 00 makes did not simply 'lift' the so-well-proven and high workable NMRA HO standard years ago is beyond me. It is also incredible that, given that Britain was early in the field of 'craft' railway modelling, we do not have a national association of any sort to speak for us – but we don't. And the ghastly muddle that is 00, with its total lack of conformity in those vital areas upon which the functioning of *any* railway – real or model, or whatever gauge depends – is the inevitable result.

Sorry about this *cri de cœur* but I do think that lack of any unifying influence has damaged the British hobby, and it is to be hoped that one or other of the various 'finescale' societies that promulgate standards for their chosen gauge will broaden out to fill the vacuum currently existing in 00. In the meantime, all the poor 00 modeller can do is to try and set his or her own standard, a process largely compounded of trial and error. What must be accepted as inevitable is that it is going to involve trouble and expense, and quite a lot of tedious replacement of items like wheelsets and couplings. To formulate a standard properly also calls for quite a detailed knowledge of the complex and subtle wheel/track relationships which govern the functioning of railways. The enormous advantage that the 'defined' standards such as EM, P4 or NMRA HO have is that someone else has done this for you, and all you have to do is buy the bits – wheelsets, track parts, gauges and so on – and use them in the certain knowledge that all the players on your layout are running to the same set of rules.

Just about the only bit of true standardisation we do have in the British RTR market is the universal fitment of the 'tension lock' coupling. I will have a bit to say about this eyesore in Chapter 3, but I am afraid that I find it one of the most unacceptable aspects of RTR stock as, I am sure, do many people. But all the rest is a desert, a lot of stock even has a different ride height, for goodness' sake, and cannot take a simple wheel-swap without major work. So there is plenty to do, often best accomplished by substitution rather than surgery. To this end, I like to ensure that I have plenty of raw material to work from. This, in turn, means that no RTR wagon, however battered or broken, or carrying however ghastly and fictitious a livery, is without a value or use. Those 50p-a-go junk boxes at

swapmeets are manna to Rice, and a fiver's worth of treasure trove trawled from their depths may spawn a further half-dozen wagons.

There are other ingredients, of course. As well as mixing and matching RTR bodies and underframes, there are wider options open. If your bent be classic 'steam era' British wagons, then there are a number of things working in your favour. As will be revealed in the next chapter, there was more standardisation in the underpinnings and dimensions of these wagons than might be apparent, which means that parts, particularly chassis parts, can be found in the lists of the kitmakers. I have in mind particularly the excellent Ratio GW/RCH 10ft. wagon underframe kit, which I find absolutely invaluable as a starting point for a wide range of wagon chassis. The moulds are getting a spot worn these days, which means that there is a tad more flash than on other Ratio kits, but this is a gem of a chassis, easy to assemble, compatible with virtually any 17ft. 6in. long RTR wagon body (which is 90% of them), realistic and adaptable.

If you are prepared to be a little more adventurous and explore the ranges of more specialised components made for the scratchbuilders and the finescale kit-converters, then even more possibilities are opened up. As I shall hope to demonstrate,

Having a clear idea of the objective is, I have found, the key to all this. Part of this view is determined by the standard that you have chosen to work to; the rest is supplied by the prototype, which can call for a bit of homework. Ideally, I like to have a definite source to work from, which almost always comes down to a photograph. There are some excellent books about wagons, profusely illustrated, which contain an absolute wealth of information and inspiration. I list those that I have used at the end of this volume and I commend them to you. It should be possible to get any of these volumes from your local library, although you may have to request them. Modern high-resolution photocopiers will often reproduce black and white photographs well enough for modelling purposes, so it is possible to extract and store information from loaned books.

Model railway magazines are also useful sources of prototype data, though my impression is that they do not contain as much of this sort of material as they used to. Drawings can be useful, although really more relevant to scratch-building than re-working RTR models. Pictures are the best source as they will tell you about the way a wagon looked in reality, rather than how the designer intended it should look. I often make my models as 'portraits' of particular wagons shown in illustrations, replicating

*A simple chassis upgrade for a Mainline van body – here sitting on a Ratio plastic kit chassis, which fits as if made for the job.*

building your own chassis onto an RTR body is not that difficult, while these 'scale' bits can be added to RTR chassis in the quest for better running or greater authenticity. A bit of simple substitution of detail parts for moulded on fittings (torpedo vents being a case that springs immediately to mind) can make a big difference to the look of a wagon. The main thing, I find, is to have a clear idea of just what you are trying to achieve; all else is just a means to an end, and it matters not a jot if you achieve a desired improvement by transplanting RTR bits, nicking parts from a kit, or doing something nifty and clever with Plastikard and a bottle of solvent.

imperfections such as new planks or inserted welded patches, partial repaints, labels or chalk inscriptions.

You can also buy postcards of wagons from specialist societies like the HMRS, or from commercial sources like Photomatic, but these can often cost nearly as much as the wagon you end up building, so I tend to stick to books and magazines. Do not overlook the fact that virtually all 'general' railway albums contain pictures of wagons 'in service' which can suggest suitable subjects for models. I try and keep a note of any particularly good wagon pictures – it saves having to plough through half a dozen 'Bradford Bartons' in search of the

*The modern goods train often comes in 'block' form for special traffic working, such as these china-clay slurry tanks for the paper industry.*

very photo you need, clearly visible to the mind's eye but seemingly lost in all those pages. The only thing that you can be certain of is that it won't be in any of the books it *ought* to be in, but in something totally different and utterly unlikely...

Of course, if you are more up to date, then it is possible to observe the prototype at first hand, when details can be recorded at leisure (provided it's not belting by at 75 mph, of course). Sketches, notes and photographs, – colour photographs at that, even more informative – can be stored away against a day of modelling need. But need it is, for I find it quite impossible to produce realistic and satisfying models of whatever subject, without something to go by. In the present instance, it's a case of a guide, to get me from a starting point, an RTR wagon, to an objective; a model good enough to fool most of the people, most of the time...

**Methodology!**

Now there is a subhead to conjure with and one which, strictly speaking, has no place in any book written by Rice. For, as will have become painfully apparent by now, I have singularly failed to evolve any 'magic formula' which can be applied, willy nilly, to turn RTR caterpillars into scale-model butterflies. What I will do to any given wagon will vary from a simple change of wheels and couplings and a lick of paint to complex surgery amounting to a complete rebuild. In other words, there isn't a hard and fast methodology to prescribe, which poses a bit of a problem when it comes to describing the way I go about wagon bashing in a clear and logical fashion.

While it seems to me appropriate to discuss the various broad areas that need to be considered when contemplating RTR wagon improvement under such broad headings as 'underframes' or 'painting and weathering' that isn't the way I do things on the bench. I have, once or twice, tried 'conveyor-belt modelling' churning out batches of identical underframes, or spending a week of evenings just fitting couplings; I soon discovered that this wasn't for me. I far prefer to treat each wagon as a discreet project, to be followed through from the first opening of the box to the final, satisfied contemplation of the finished result over the rim of a whisky tumbler!

Given also the need to photographically record the processes involved and to illustrate all these words (and there are so very many of them, are there not?) then I felt that the best way to describe the way I deal with the different types of wagon was to do just that, in a sort of 'case history' format. But so that I didn't have to keep re-stating the rationale behind the various operations, I also felt that I needed to get over my philosophy and reasoning in a general way. So while you may light upon chapters purporting to tell you all about underframes or body detailing, these will deal only with basic information, techniques and ideas. The 'nuts and bolts' of specific, practical applications will, hopefully, be found in the 'Examples' chapter at the end of the book.

Selecting the 'case histories' to illustrate this book proved to be quite a ticklish problem, given the need to maintain balance both in respect of prototype subject and the various ranges of RTR models being worked upon. In point of fact, there is something of a divide here, which may

explain the predominance of 'late steam era' stock in the sample. If you study the catalogues of the various RTR firms it strikes you quite forcibly that, while the 'train set makers', Hornby and Lima, have a distinct bias towards the contemporary scene in the range of freight stock they produce, the opposite is true of those makers comprising what I shall choose to call the 'Hong Kong Faction' (all of the models sold by Replica and Bachmann and many of those in Dapol's range are actually made by Bachmann in Hong Kong or, latterly, mainland China).

It is also a truism that, for reasons touched on in the next chapter, most of the RTR models of modern freight stock made by Hornby, Lima and Joueff offer less scope for 'bashing', in that they are, by and large, pretty accurate scale models to start with. There is also far greater standardisation within the various types than was the case forty or so years ago, and, with concepts like block liner trains or stone trains, merry-go-round coal hauling and dedicated use fixed formation scheduled freight services, there is far less variety within an actual prototype train. In other words, there is rarely need to do much more to a lot of contemporary stock beyond the 'change of wheels and couplings and lick of paint' that forms the baseline of these operations. The more involved conversions all seem to relate to the steam-era stock (which term I use to describe the traditional SWB (Short Wheel Base) wagon fleet that predominated on Britain's railways up to the early 1970s) and so these types inevitably get more attention in these pages.

The sample has also been chosen with an eye to balance in the actual composi-

tion of a wagon fleet, in this case for a model railway based on the earlier years of BR's diesel era, from 1960 until about 1968 and 'TOPS'. These were, in many ways, the most interesting years for wagon buffs, with wooden-bodied pre-group survivors running alongside the first examples of the new generation of long-wheelbase, high speed, air-braked stock. Which may explain the different degree of weathering applied to the different wagon types, due to my attempt to reflect the differing periods that they would have been in traffic. More on all that in Chapter 5.

I have also tried to ensure that, somewhere in one of these 'case histories' I describe every technique, tip and wrinkle that I have had cause to use when converting RTR stock. I expect I have forgotten one or two but what is here should give a pretty clear and comprehensive picture of just what horrors I perpetuate upon hapless RTR wagons. The faint of heart and those easily offended may find some of these scenes disturbing.

### The Toolbox at Last

You have got your wagon; what else do you need to turn it into the model of your dreams? Surprisingly little, actually. In the oft-repeated words of half a thousand model railway articles, most of what is required the 'average modeller' will have on hand. Poppycock, really, but probably nearer the truth in this instance than in most cases.

Wagon butchery calls for two basic operations; cutting apart and glueing together. There are a few twiddly bits in between, but those are the fundamentals. Painting I shall treat as a separate subject, so all I am concerned with here are the tools and materials needed to get the wagon up to the painting stage. You also need to consider some way of keeping tabs on all the bits, and also of keeping a project on course if you get interrupted, which I always do.

I will start with tools. At its crudest level, hacking RTR wagons about calls for a good, stout craft knife and a small saw of some sort. I settle for a good old Stanley No.199 general-purpose craft knife with the ordinary straight blade, as available in virtually any hardware store in the land. My saw is a touch more refined, being an Exacto razor saw with a medium fine blade (the one it usually comes with) although a junior hacksaw, carefully wielded could accomplish almost as much.

Finer surgery calls, of course, for a scalpel, which is what I generally use, a Swann Morton No.4 handle (scrounged off the vet) with the ordinary No.24 blade. My local art/craft shop sells a plastic version of this handle for mere pence, and they also sell non-sterile blades which are astoundingly cheap. A good alternative is Swann Morton's little brass-handled craft knife with the No.2 curved blade. My last cutting implement is a trifle out of the ordinary, being what I understand to be a leather-toolers knife, a sort of miniature chisel that I picked up in a Radnorshire junkshop for next to nothing a year or several since. A small wood chisel or sharpened screwdriver would serve a similar purpose, but it's useful rather than essential.

Once you have cut it, you have got to smooth it and shape it. A few files and some abrasive paper should do the business. I find that a half-round needle file, a flat 6inch fine cut file and a nice big chunky 'mill file' serve most purposes, while some wet and dry paper of 180 and 240 grit grades will take care of finishing. I also find that a 'sanding board' of 180 grit stuck to an offcut of chipboard or MDF (Medium Density Fibre) board with 'Evo-Stick' is invaluable, while the sort of little 'rubbing stick' illustrated in the sketch will get into all the odd awkward corners.

*Cutting, smoothing, shaping and drilling – modifying RTR wagons does not call for an extensive tool kit.*

*Fabricating and fitting wire or metal strip detail calls for some basic engineering tools.*

If you are going to add detail parts, the chances are you will need to drill some holes. Power drills are a waste of time working in plastics only a millimetre or so thick, so I use either a small pin-vice (Eclipse No.121) or one of those little Archimedean screw drills you get from Proops or Shesto. Small drill bits seem to cost a fortune these days so I only keep a minimum range of sizes, using a fine taper brooch to open up holes to intermediate sizes. Metric drills are cheaper than the now-obsolete 'number' drills and I plump for 0·5mm, 0·7mm, 1·00mm, 1·2mm, 1·5mm and 2mm.

I avoid exercising my truly remarkable talent for busting small, expensive drill bits by avoiding the need to drill for handrails, pipework and the like. This I do by 'melting-in' such components which if undertaken with care, is a quick and effective way of adding metal details to plastic models. More on the 'how' in Chapter 4, but the 'wherefore' is an ordinary small soldering iron. I use my 25W Antex instrument iron, which is also plenty man enough for any straight soldering that might need doing about a wagon. In the case of these RTR conversions, the only soldering I find I ever need to do is concerned with the installation of some types of coupling. Nothing too daunting, and eased, as usual, by the use of 145° solder and phosphoric acid flux.

Mention of wire bits suggests that something to bend and cut wire with is no bad idea. I find that a fine pair of snipe-nosed pliers are among the most indispensable of modelling tools, while the most generally useful cutters I have struck to date are the 'Xuron' shears, ostensibly sold as railcutters but invaluable for all manner of tasks

about the RTR wagon; they will, for instance, remove tension-lock coupler mount blocks in one satisfying munch. The only thing they will not cope with is hardened steel wire, which calls for side cutters with tempered jaws.

More refined gripping calls for a pair of tweezers – fine pointed jewellers' ones, not those flat-ended things that women use to do unspeakable things to their eyebrows. Other than that, all you need is something to measure with – a 6inch steel rule is ideal – and some form of scriber. If you do not run to a pukka engineers job, stick a sewing needle in the pin-vice and carry on. A square is handy to check things aren't going skew-whiffy, but an ordinary school geometry 45° set square will suffice.

The rest of the armoury can be culled from the domestic department; rubber bands, clothes pegs, scissors, loo paper, bulldog clips, the weights from the kitchen scales, all will be called forth in their due season. The only other necessity is a workplace, and a flat surface to build on. A bit of thick plate glass (or a small mirror) is good as plastic solvents do not affect it and neither will they weld plastic mouldings to it. You can make a pretty fair stab at gluing an RTR body to, say a bit of MDF, if you are a touch liberal with the Daywat Poly. Take heed of the words of One who Knows...

## Materials

Leaving aside specialised components such as etched brake gear or cast details, the most generally useful material for working with RTR wagons is undoubtedly styrene sheet and strip. The main ranges are Slaters 'Plastikard' and the American

'Evergreen' materials. I generally use Slater's sheet but Evergreen's strip, which is more convenient when you have a foot in the American HO camp; *Railroader* articles always quote Evergreen sizes in constructional articles. Slaters make 'Microrod' as well, which I use, and if you are a bit mazed as to what to buy, they also do 'assortment' packs of Microstrip and rod that will probably cover most eventualities.

The other really valuable range of materials is also from across the water, in the form of the 'Plastruct' extruded ABS sections. Most better model shops have a 'Plastruct' dispenser on their counters, and a selection of small 'I' 'T' and 'L' sections will solve a lot of modelling problems for you. Plastruct girders also make great wagon loads! It is not overly expensive and with modern solvents, is compatible with the styrene materials and the moulding plastics used by the RTR makers.

For the rest, it's down to wire, stripwood, paper and odds and ends. I find the range of straight drawn brass wire sold under the Alan Gibson label and available in 0·33, 0·45, 0·7 and 0·9mm diameters serves for most detail work – aided by the odd bit of fusewire. Making couplers may call for some steel wire, such as the 11 thou. guitar string specified for Alex Jacksons or the 36-gauge steel I use for my own 'Bringewood' coupling, of which more in Chapter 3. Stripwood has more to do with wagon loads than wagons *per se,* while the paper and odds and ends come in handy for the most surprising things.

## Adhesives

Sticking is the assembly method asso-

*Given that working on plastic RTR wagons calls for a lot of sticking, a reasonable selection of adhesives helps keep your options open.*

*Marg-tub logistics help to keep chaos at bay and wagon building projects on track.*

ciated with RTR wagon bashing, and calls, I have found, for four basic types of adhesive. As we are working mainly with plastics, it's obviously the joining of these materials that forms the main concern. These days, liquid solvents have replaced the old fashioned tube type 'plastic cements' and a suitable solvent will do most jobs. The one I use is 'Daywat Poly' which will bond styrene sheet and strip, plastic mouldings and extruded ABS sections with equal facility which MEK solvents such as Mek-Pak or Polsol won't.

Daywat Poly is actually a fairly vicious chemical compound called '2 Butanone' which rates quite a chilling entry in the 'Hazardous Loads' handbook with which all firefighters are familiar. If faced with a large spillage of same, the prudent will leg it swiftly to a far horizon but in the sort of small quantity we modellers handle, it is not that daunting – if treated with due respect. Observe all the COSHH practices on the label (Care of Substances Hazardous to Health, if you do not tangle with Health and Safety matters in your daily life) and use as directed. That is, in a well ventilated space, with care, using minimal quantities and, most definitely, while NOT SMOKING. Keep the bottle stoppered when not in use and, for the sake of good domestic relations, keep it well away from any polished surfaces. It will even do for Volvo paintwork, as I found when attempting to repair some plastic trim on the family barge.

Not all joints are plastic-to-plastic, however, so some more general adhesives are needed. For attaching paper, card and small metal castings to plastic wagons, I use clear contact adhesive such as 'UHU' or 'Bostik 1'. Fixing larger or load bearing

metal components, such as axleguards or coupler mountings, calls for something a bit stronger and more rigid, and I find that an ordinary 2-part Epoxy adhesive such as 'Araldite Rapid' or UHU 'Strongbond' is effective. Fixing small details, securing knots on wagon sheet-ties and effecting some types of repair is best carried out with a cyano-acrylate 'instant glue'; I find Loctite's 'Gel Cyano' particularly useful, and again there are precautions to observe when handling these materials.

Not strictly an adhesive, but useful in both adhesive and gap-filling capacities, are a couple of proprietary fillers. Plastic Padding type Elastic sets up in about 10 minutes, sticks to plastic tenaciously and is easy to work when set. Milliput 2-part epoxy putty performs much the same role but is easier to control in its uncured state, being much akin to Plasticene in consistency. It takes about 3 hours to go off and can be cut, drilled and filed *ad infinitum*. It's very useful both to repair damaged mouldings and as a modelling medium in its own right. I have added such features as end vents with it before now.

## Miscellanea

I made mention a page or two back, of the need to keep track of all bits involved in wagon building projects, as well as keeping the work on course. I have evolved a procedure for doing this, very necessary in the chaos of my workshop. It revolves around 500g size margarine tubs, 'Gold' being the favoured brand *chez Rice* – as much for the size and shape of its container as for any nutritional virtue it might have!

The drill is to assemble the wagon plus

any bits needed for the proposed conversion in one of these tubs. As well as the hardware, each tub also contains an ordinary 5″ × 3″ file card, on which is written such vital data as the intended specification of the finished model, the parts needed and any salient prototype references. When I have accumulated all the necessary bits for the particular project, I put a red tick on the card; that way, when casting around for an evening's entertainment, I do not get stuck into jobs that are going to come to an abrupt halt half-way through for lack of some vital part – something which I find enormously frustrating.

The back of the file card is used to make notes as to the way things are being done, which, at the end of the day, forms a record of the genesis of each wagon, as well as reminding you of what you were up to should the job be interrupted. I keep these cards in a little drawer, and it is from the *derrières* of a dozen or so such that most of this book has been drawn. It may sound a mite involved, but when you are as absent-minded and disorganised as I am, you need all the help you can get!

Well I think that is enough preamble. It's time to get to grips with a wagon or two, although not, as yet, in the flesh. We need to decide on those vital running criteria which will, we hope, result in our wagons rolling properly, as well as determining whether what Messrs. Dapol *et al* have given you by way of a chassis is in any way appropriate to the body sat atop it. 'Underframes' is the topic, the inevitable bread and scrape that always seems to come before life's squidgy-bits-with-the-cherry-on-top. Bear up, it could be worse...

*A special underframe for a special wagon – the 'Presflo' hopper has unique running gear.*

*Heavy metal – an early (ex-private owner) 21T steel coal wagon has a lengthened and 'beefed-up' RCH-type underframe.*

# UNDERFRAMES AND RUNNING GEAR

*Much closer to the traditional SWB wagon chassis is the underframe of GW 'Mica' 6T meat van 105829, built in 1930 with 4-shoe vacuum brake gear, but otherwise following standard RCH practice.*

It is in the underframes of RTR wagons that most of the short-comings of the breed are found, in both practical and visual terms. The underframe is almost always the area offering the greatest scope for improvement – a process that can, on occasions, call for the chassis provided to be buried in a quiet corner, being replaced by something better from elsewhere.

Chassis faults come under two headings – appearance and performance. Taking the latter first, what are the factors to look out for in terms of wagon performance? Given that, in the context of most model railways, the shunting of wagons is a principal activity, it is reliable trackholding and the satisfactory functioning of couplings that have the greatest significance. I will have plenty to say about couplings in the chapter devoted to such matters; what I want to address here is the matter of trackholding.

A goodly part of the trackholding equation is, of course, down to the quality, or otherwise, of the track. And that, of course, lies outside the remit of the Carriage and Wagon department... But there are a number of factors affecting reliable running that can be improved in the building of a wagon fleet. Principally, these are the matters of wheel type, bearing quality, and weighting. These are the areas in which RTR wagons vary considerably, but they are also areas susceptible to ready improvement.

For reasons outlined in the last chapter, it is in 00 gauge that most of the inconsistencies arise. Both the EM and P4 standards define, very precisely, the wheel profile and the associated wheel-to-track relationships. Wheelsets manufactured for those standards conform to those standards, which gives the EM or P4 modeller a head start in the reliable running stakes. By contrast 00 stock can ride on anything from Lima's grotesque European-style coarse scale wheels to Kean-Maygib or Gibson wheels using the fine EM profile.

## Wheels for 00 Wagons

I have identified five basic 00 wheel profiles currently available – three RTR, two replacement – which is the basis of as good a muddle as might be desired. Starting with Lima, the real 'odd man out', we find quite the nastiest wheels I have had to deal with, with horrible deep flanges and sharp, square edges – ideal for catching errant point blades or slightly misaligned rail joints. Earlier specimens had no root radius between the flange and the tread, though this has now been introduced, to the benefit of smoother running. The faces of these wheels are often deeply recessed, although again recent specimens are better. The wheel treads are flat, not coned, and the wheels are 3mm wide. There seems to be but one size, 11·5mm diameter, fitted

to all Lima stock irrespective of prototype. Lima further differ by using a 25mm long pin-point axle, when everybody else is on 26mm. These are turned metal wheels, hub-insulated on one side only; they do at least run true!

Hornby come in at No.4 in the wheel charts, with a moulded plastic wheelset best described as 'chunky'. At 3·5mm wide these are wheels in the best trainset 'steamroller' tradition of yore, although the flanges are mercifully less pronounced than Lima's 'stiletto heel' jobs, and of a much better profile. Hornby wheels will at least run on scale bullhead track without clunking all over the chairs! Once again,

WIDTH: 2·5 - 3MM

FLANGE – ABOUT ½MM. THICK.

CONING (INCLINED TREAD)

ROUNDED EDGE

ROOT RADIUS BETWEEN FLANGE & TREAD

there is a very deeply recessed face to the wheel, with a pronounced 'rim' which Hornby insist on further accentuating by picking it out in white. Hornby wheelsets do come in spoked and 3-hole disc variants which are fitted as appropriate, while the effective axle length conforms to the 26mm 'standard'. The treads also have prototypical 'coning' – a 1-in-20 slope of the tyre face from the flange out to the front edge which, on the prototype, is matched a 1-in-20 inward inclination of the rails, aiding smooth running by keeping the wheelsets 'centred' on the track.

At number 3 we find the Airfix-derived wheels now used by Dapol and Bachmann – Replica. This is by far the best RTR wheelset to have appeared on the British market and basically resembles, in most respects, the old BRMSB 'scale' 00 profile. Like Lima, these wheels are 3mm wide (a shade under if you are going to be pedantic) but there the likeness ends. The flanges are about half the depth of Lima's at 3/4mm and have nicely rounded edges and a good profile. There is not much of a root radius and the tyres are regrettably flat, but the rim thickness is fine, and the spokes of the classic 8-spoke wagon wheel are commendably fine. The face of the complementary 3-hole design looks like the prototype, and the overall appearance of the wheels is acceptable. The on-tread diameter of 13mm is a tad overscale (real wagon wheels used the great, truly *British* nominal diameter of 3′ 1½″, or 12·5mm at 4mm scale) which is not really significant; Hornby do the same. These wheels are moulded in a hard, slippery plastic (Delrin?) and mounted on turned steel 26mm pinpoint axles.

Once you move into the replacement wheelsets, things get a good deal better. In the number 2 slot, Romford offer a very good updated version of the old BRMSB 'Nucro' wheel. These are available in a number of formats, including modern disc-braked designs and are of all-metal manufacture hub-insulated on both sides. With an overall width of 2·5mm and flanges 3/4mm deep, these are a step finer than the best of the RTR wheels. The profile is good, with coning of treads, a generous 'root radius' between the tread and the flange, and a rounded edge to the flange itself. The spoked wheels have nice, fine spokes, and the wheels come bright nickel plated. Axles are 26mm pinpoints of the 2mm diameter now standardised by the makers of all 'scale' wheelsets. These Romford wheels run beautifully 'true' and look very good, while their bright nickel treads should help keep track clean, being less inclined to pick up dirt than plastic wheelsets.

For ultimately fidelity, however, the honours lie jointly with the two 'scale' wheelmakers, Kean-Maygib and Gibson. These ranges are all but identical in quality and price, so I treat them as one here. In common with these same makers' EM and P4 wheelsets, these 00 wheels have plastic centres with a blackened steel tyre. This conforms with the EM Gauge Society recommended profile, so is of 90thou. (2·285mm) width with flanges just over ½mm deep, proper coning, and a subtly-curved flange profile closely related to full-size practice. The 2mm diameter steel axles are, once again, of the standard

*4mm scale wagon wheels. In the front row, the RTR offerings – Lima at the far left, followed by Hornby and the 'Hong Kong' types. At the rear, 'scale' alternatives – Romford 00 spoked, disc braked and 3 hole, Gibson and Maygib 00, EM and P4 types.*

26mm overall length, a blessed isle of conformity in a sea of chaotic contradiction. There would not be much point to such a high-falutin' profile if the rest of the wheel didn't match it for fidelity, which these types most certainly do. Fine spokes, including vintage style 'split' spokes, are matched by properly modelled 3-hole and disc types. Also included in these ranges are the various 'special' wheels used by certain types of vehicle – 2′ 8″ (10·5mm) diameter 'Lowmac' wheels, and the 10-spoke variant of the standard wagon wheel used by heavier (more than 13 ton) types, also found on GW brake vans.

**Track/Wheel Compatibility**

Of course, all this hi-fidelity is not a lot of good if the wheels spend most of their time bumping through the ballast, which brings us back, for a moment, to track and wheel/track compatibility. You may have noticed that, amid the welter of figures in the wheelset descriptions above, there has been no mention of our old friend, the back-to-back dimension. This is because, in the context of trackholding, it is irrelevant; what matters is the 'check gauge' – the distance from the *back* of one flange to the *face* of the opposing flange. It is this measurement that determines the suitability of a wheelset to operate on a given type of track.

In a properly regulated standard such as EM or P4 (or NMRA RP 25, if it comes to it...) this is a critical dimension that is carefully related to the situation at the crossing (frog) of a point, which is the most critical factor in reliable trackholding. How many times do your wagons derail when being pushed through a facing point? And how many times on plain trackwork (leaving out dogleg joints and other such untoward intrusions)? QED I fancy... Well, while there is, as yet, no proper standard, we do fortunately find pretty close concurrence among three out of our five wheel types; the Airfix/Dapol/Bachmann wheel, the Romford and the 'scale' Gibson/Maygib types all use a check gauge of 15mm. And this, in turn, sits quite happily with the 'fine' Peco Streamline pointwork (code 75 rail, yellow packaging).

So, as a rule of thumb, if you are using code 75 Peco or the bullhead code 75 'finescale 00' trackwork with points built to the old BRMSB standard, or, better still, to the new fine 00 standard promulgated by C & L in their point templates and associated track gauges, then you can use the narrow-tread 'scale' wheels – Romford and Gibson-/Maygib – with impunity. If you are on the older Peco 'Universal' Code 100 Streamline, you really need a bit more tread width to cope with the big 'holes' between the point crossing noses and wing rails, in which case the 3mm-wide Dapol/Bachmann wheel is about the best bet. Sorry to be so vague, but it's not my fault that we do not have a proper standard to follow!

For the purposes of this book, I decided to use either Romford or Gibson/Maygib wheelsets in my 00 models. Those specimens built to EM or P4 of course rise above all this confusion... I have found that my 00 wagons operate well through the Peco Code 75 points, and through my own and friends' home-built fine 00 track. The locos, though, are another matter, with Hornby and Lima being the problems. Fortunately, many of these, especially the diesels, are susceptible to drop-in wheelset replacement, while most of the more recent steamers, Hornby included, have fine enough wheels to work on Streamline Code 75.

**Bearings and Weights**

Wheelsets are, of course, just one aspect of my advocated 'standard specification' for wagons. The other two factors are 'rollability' and weighting. As noted, most modern RTR stock comes on pin-point axles, with all the promise of free running that these imply. A promise which is, by and large, borne out in practice; it's rare to encounter a 'sticky' item of stock these days.

A simple way to test the running qualities of wagon chassis is to determine how much of a gradient is needed to get them rolling. I use a yard of track on a piece of 2″×½″ stripwood, together with some wooden bricks nicked from No.2 daughter. These are, fortunately, on a ¼″ module of thickness; thus a thin brick under the

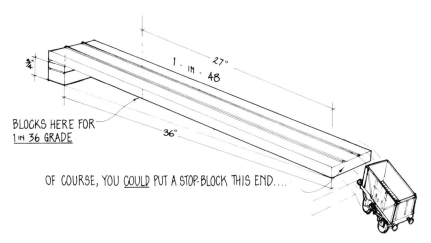

BLOCKS HERE FOR
1 IN 36 GRADE

1 IN 48

36"

1 IN 27"

OF COURSE, YOU _COULD_ PUT A STOP-BLOCK THIS END....

end of my 'test yard' gives me a grade of 1 in 144; a 'half thickness' brick gives me 1 in 72, a 'thin and a half' 1 in 48, and a full inch brick 1 in 36. The ultra-gentle 1 in 72/144 grades are really only of academic interest, though for the record a Hornby Dia. OAA 45-ton open fitted with Romford wheels did start on the 1 in 144. I use the 1 in 48 and 1 in 36 as parameters; if it starts on 1 in 48, that's good, if it won't start on 1 in 36 it needs attention. Anything between the two is just fine.

Few RTR wagons fail this test. If they do, the cause is usually either a moulding fault on the plastic wheels or a slightly over-length axle. There is obviously a spot of manufacturing tolerance on those 26mm pin-points and sometimes replacement wheelsets don't function as well as the originals. Springing the axleguards apart very slightly will often effect a cure. I have had the odd case of a trace of moulding flash on the edge of brake shoes rendering the brake gear rather more functional than decorative, easily rectified with a sharp craft knife, while Lima wagons sometimes have sloppy bearings that can allow those monster flanges to touch a wagon floor.

Lima bearings present another problem, in that their use of a 25mm pin-point axle makes it difficult to replace these wheelsets with alternatives. All is not lost, however, as Lima use a 2mm axle diameter, in common with Romford and Gibson/Maygib, so it is possible to substitute these wheels on the original Lima axles. Possible, but not easy, as the non-insulated Lima wheels are a _very_ firm fit on those axles, and persuading them to part company is tricky. The only reliable way that I have found of doing this, without either bending the axles or blunting the pin-points – these axles are rather soft – is to remove the insulated wheel, which pulls off easily. Then, gripping the axle as firmly as possible in a drill chuck, the remaining wheel is heated with a blow lamp or large soldering iron, and carefully levered off with the fine nose pliers.

The alternative is to deepen the bearing-indents in the chassis a tad to take standard 26mm axles; I use a $^5/_{64}$" or 2mm twist drill between my fingers and proceed by trial and error. Do check first, though, as I found on a couple of recently acquired Lima 'big bogie' vehicles – a 60ft. BHA steel-strip wagon and a 45ft. 6in. PWA van – that I could slip Maygib wheels straight in; for all that the Lima axles I took out were still 25mm long (and a wondrously sloppy fit!)

## Uniform Weighting

The argument in favour of a reasonably uniform weight over each axle is based on the basic precept that, if each wheelset has roughly the same weight holding it down, they will all behave in roughly the same manner – which, with luck, will involve staying on the rails! There is also a strong argument against trying to push a relatively heavy vehicle with a very light one, especially over sharp curves. In point of fact, I have found that so long as you have a _minimum_ weight, to which all wagons are ballasted, then wagons that are up to 100% heavier than this do not cause problems. What you really do need to avoid is a super-lightweight plastic wagon in the same rake as a gruntingly heavy cast one.

Weighing a representative sample of 4-wheel steam era RTR wagons gave a range of weights from just over 20 grams to very nearly 60 grams; adding in a plastic wagon kit (Cooper Craft GW open) and a cast van (D&S GN box van) extended the range down to 15 grams and up to almost 85 grams, a not-untypical spread, given that may layouts use a mix of RTR and kitbuilt stock. The bigger modern wagons, predictably, come in at the top of this range, going from a Replica HEA merry-go-round hopper at a bit over 40 grams up to a Joueff 'Polybulk' at more than 100 grams. In other words, there ain't much uniformity as things come.

So what to do? The first thing is to consider matters on a 'weight-per-axle' basis, when the 100+ gram bogie 'Polybulk' and a 50 gram box van (Mainline body over a Ratio chassis with the Mainline steel weight on the van floor) are on much the same footing. It is the empty 'lowfit' or the surprisingly insubstantial Dapol 21T hopper wagon (a mere 20 grams – there being nowhere to conceal the usual steel weight) that will be apt to cause problems. The obvious answer is to add ballast to the lighter wagons, up to at least some minimum weight consistent with good track-holding. That weight I have found to be around the 25 gram per axle mark of the 'Polybulk' and box van.

This desirable weight can be added in a number of ways. Box wagons are obviously no problem while the common Dapol and Bachmann/Replica chassis will accept quite a lot of sheet lead below the floor if the standard steel weight is insufficient. A foot or two of 3mm thick by 4" wide lead flashing from a builders merchant will weight a lot of wagons! Tank wagons can acquire avoirdupois by having a couple of $^1/_8$" holes (one to let the air out) drilled in their bottom, through which a filling of plaster-of-paris can be introduced. Hopper wagons are more of a problem, especially that Dapol 21 tonner. I have crammed every available crevice with bits of lead but still failed to get much past the 30 gram mark. Anyone got any spare Uranium 238 or Cobalt?

PLANK DETAIL SCRIBED ONTO LEAD

FALSE FLOOR OF LEAD SHEET HAMMERED OUT _THIN_

_Weighing wagons is a vital part of the practical process of wagon building. Here, the 'Moy' coke wagon tips the letter-scales I use for this purpose at the desirable 50 gram mark, courtesy of some underfloor lead sheet._

There is, of course, one gloriously easy and authentic way to add a bit of weight where needed, and that is to follow the very best of prototype practice and load your wagons. You can conceal all the lead you want under a sheet or a 'false top' cargo of minerals. Even if faced with an open merchandise wagon destined to run empty, as in the picture, the pile of 're-turned tarpaulins' is a usable salvation; the bottom part of the pile is folded lead sheet! Lead can also be hammered out wafer thin to provide a 'false floor' for open and min-eral wagons, while the plastic packing case on a 1-plank 'lowfit' can have a heart of lead. I could go on in this vein, but I think you get the idea and I will be going on about loads in general in Chapter 6.

I use an ordinary set of postal scales to weigh wagons and I find that uniform weighting at the suggested 25 gram/axle plus consistent wheelsets and carefully set up couplings do permit reliable, and hence enjoyable, shunting. I have applied these basic criteria to EM and P4 wagons just as much as 00, with equally beneficial results. The only difference between my 00 wagons and their P4 brethren is that, in P4, I usually opt for some form of compensation.

## Compensation

The basic idea behind wagon compen-sation is that, by allowing one axle to rock slightly about a pivot, the vehicle will fol-low the 'three legged' principle and keep all the wheels firmly in contact with the track. This is obviously an advantage particularly in the matter of trackholding over less than flat permanent way. However, it is only really anything of a necessity in P4, and then I know quite a few modellers who do without. However, bearing in mind the close tolerances associated with P4 wheel-sets and trackwork, it has to be a good idea.

RTR wagons are not, it must be said, designed with compensation in mind. The most usual system, using a rocking version of the 'W-irons' (the W-shaped flat iron or steel brackets on which the axleboxes and springs are mounted) on one axle and a fixed version on the other is not practi-cable in the context of a one-piece moulded RTR wagon chassis. Applying compensation to a typical RTR underframe calls either for a fold-up rocking cradle which provides 'inside bearings' for the axle between the wheels, or for the little bodge illustrated in my sketch and the pho-tograph alongside. Here the pinpoints of a normal axle are filed back slightly (or the bearing-indent deepened, which amounts to the same thing) to make the axle a 'slack fit'. This will result in the wagon 'sitting low' at that end, but the right ride-height is restored when the wire pivot is installed – I melt it into the floor with a soldering iron. The 'slack' axle can now rock slightly about the pivot, imparting the necessary com-pensating action. A lot of my RTR P4 wa-gons use this crude scheme with success.

## Underframe Types

Having wittered on at length over prac-tical generalities, it would now seem like a good idea to have a look at the actual underframes that prop up our RTR wagons,

*Not quite as empty as it appears! Most of this 'pile' of returned wagon sheets is actually folded sheet lead – useful ballast.*

*Middle and bottom. The MJT 'inside' rocking axle system works well on many RTR wagons – here on an Airfix LMS 20T brake van.*

14

with a view to deciding what needs doing to them to fit them for our purposes. Starting at the beginning, historically speaking, we have the underpinnings of the steam era wooden body wagons – in prototype terms, the post-1930 RCH 17ft. 6″-over headstocks steel channel underframe 10ft. wheelbase wagon chassis.

Unscrambled of jargon, this is the standard underframe used by the 'Big Four' railways from 1930-on, for most of their common-or-garden wagons. The RCH – Railway Clearing House – was the regulatory body governing freight traffic over Britain's railways in pre-Nationalisation days. As part of this regulation, they issued standard specifications for wagons, to which all private owner (PO) wagons had to conform. Subsequent to the 1923 Grouping that created the LNER, GW and Southern companies from the 165+ pre-grouping railways, the RCH standard became the basis of most common-user wagon designs, though with detail differences as to axleboxes or buffers.

The RCH specified three basic underframes, starting in 1923 with an updated PO mineral wagon chassis that was 15ft. long over the headstocks (bufferbeams) with a 9ft. wheelbase. This came in 10 ton and 12 ton versions, the 12 ton having heavier ironwork and thicker axles. The standard wheel was of 8 spokes, usually solid but sometimes of 'split' configuration. The RCH went up a size in about 1926 with a 16ft. 6in. long, 9ft. or 9ft. 6in. WB specification, and finally, in 1930, arrived at 17ft. 6in. and

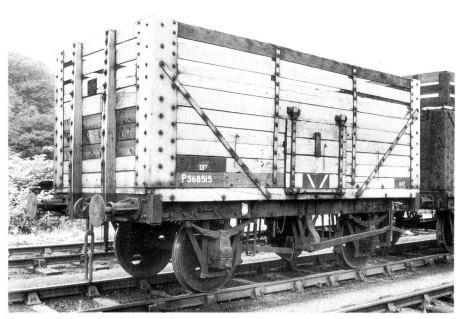

*RCH underframe, wooden type, on an ex-PO coke wagon. Counting chairs (which are usually on 2ft. 6in. centres) I make this a 10ft. WB example, which is unusual. All RCH details present and correct.*

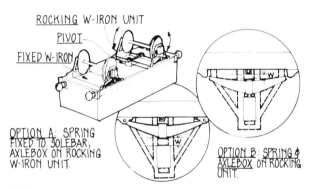

10ft. The weights, both tare (empty) and loaded, were going up at the same time, calling for heavier 10-spoke or solid disc steel wheels. These last had three holes in them, partly to reduce weight, and partly to ease craning of wheelsets or 'spragging' of wagons by putting a steel bar (a sprag) through the hole as an emergency back-up braking system.

It has to be said that very few wooden bodied PO wagons were built on this 17ft. 6in. chassis type, so most of the delightful models of such wagons in the various RTR ranges are, technically, incorrect. That is as may be, but they look pretty good to my eye and I do not let the extra foot or so of

*Here is an absolutely typical RCH 9ft. WB steel underframe 16ft. 6in. wooden body mineral wagon – in this instance an LMS-built example, hence the number and non-RCH axleboxes.*

15

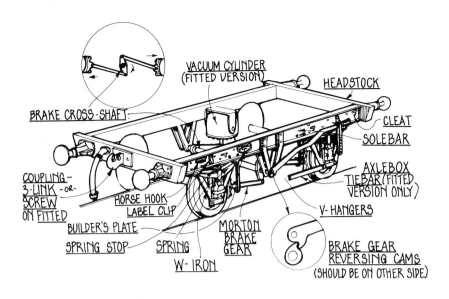

BRAKE CROSS-SHAFT

VACUUM CYLINDER (FITTED VERSION)

HEADSTOCK

CLEAT

SOLEBAR

COUPLING - 3-LINK -OR- SCREW ON FITTED

AXLEBOX TIEBAR (FITTED VERSION ONLY)

HORSE HOOK LABEL CLIP

V-HANGERS

BUILDER'S PLATE

SPRING STOP

SPRING

MORTON BRAKE GEAR

W-IRON

BRAKE GEAR REVERSING CAMS (SHOULD BE ON OTHER SIDE)

13T
W 118372

*Middle and bottom. Underframe extremes could be found beneath the same basic wagon type. Here, the standard GWR 5-plank open body sits on a 9ft. WB 2-shoe 'single side' braked chassis, or (bottom) on a 10ft. WB 4-shoe AVB fitted 'XP' chassis.*

13T
W 139154

XP

scale length worry me overmuch. The superb finish and lettering more than make up for such deficiencies. Hornby's 4-wheel wagon underframe *is* a scale 16ft. 6in. long but has the 10ft. wheelbase, which may contribute to a characteristic 'too tall' look that many Hornby wagons seem to have. However, the 17ft. 6in. underframe as modelled by The Rest is entirely appropriate under the majority of post-1930 general merchandise wagons, vans, flats and tank wagons.

All these underframes had a form of the common 'Morton' brake gear, with levers at one end of each side working brake shoes through a cross-shaft and a series of cranks and rods. Earlier wagons had such a brake on one side only, though usually with a lever both sides. However, most of the wagons fitted with 17ft. 6in. chassis had 4-shoe 'both sides' brakes as commonly modelled, so we are usually O.K. there. In later years a lot of these wagons, retrospectively, were fitted with AVB (Automatic Vacuum Brake) gear with a brake cylinder acting on the cross-shaft. To withstand the outward thrust of these 'unbalanced' power brakes (unbalanced in that shoes were acting on one side of the wheel only) the bottom of the W-irons were linked by a steel strap or tie-bar. If you see a wagon with vacuum hoses on the bufferbeams but no tie-bar between the axleguards, it is not vacuum-braked but 'through fitted' or 'piped'; this was an arrangement devised to allow unfitted wagons to be run in 'fitted' trains without impairing the functioning of the automatic power brakes.

From the late 1930s on, more and more wagons were being built new with power brakes for express (XP) freight service. These were 'balanced' power brakes, with 8 shoes in co-acting balanced pairs, one pair per wheel. These are 'clasp' brakes, and there were several designs of 8-shoe gear used by the Big Four and by BR The two commonest designs perpetuated by BR for new construction, after Nationalisation, were the LNER '3-hanger' type and the equivalent LMS twin-hanger arrangement.

### Long-Wheelbase Underframes

Thus far, I have been considering the undergear of the traditional British short wheelbase 4-wheel wagon, which formed the backbone of the national wagon fleet well into BR days. However, the limitations of these small capacity wagons had long been realised, while they were inherently unsuited to a lot of the more specialised traffic carried by the railways. There is a long history of 'special' wagon types, ranging from low loading implement wagons through high speed passenger rated 'perishables' stock to massive bogie vehicles suited to long or heavy loads. None of these types used an RCH-pattern 'standard' underframe. With the advent of higher-capacity versions of the commoner wagon types, however, a long-wheelbase 'standard' underframe did evolve, typically of 21ft. 6in. length over headstocks and on a 12ft. wheelbase. These underframes were used under such designs as the 21 ton and 24 ton steel coal wagons pioneered by the GWR, tube and steel plate wagons on the LNER and the first generation of steel coal and coke (remember coke? – great stuff!)

hoppers.

The move toward longer wheelbase four-wheel wagons has continued in more modern times, culminating, I suppose, in the 6·32m (20ft. 9in.) WB of the BR air-braked underframe, no less than 33ft. 6in. long over headstocks. This chassis is found beneath most of the latest (last?) generation of 'common user' general merchandise wagons, vans and flats, rated at 45 tonnes GLW (Gross Loaded Weight) and passed for 75 mph running. With their disc brakes, these are very 'clean-limbed' underframes, relatively easy to model.

The other recent trend has been towards a whole range of highly specialised non-common user 'single traffic' wagons, ranging from the seemingly omnipresent hopper stone wagons through the large bulk carriers such as the 100 ton bogie tank vehicle and the 'Polybulk' and 'Tiger' covered hoppers to the 60ft. long steel strip and coil wagons, not forgetting the 'Freightliner' container trains. These vehicles all employ 'dedicated' underframes, specifically designed to meet the needs of the traffic and usually conforming to European regulations and requirements for unrestricted running in Britain and mainland Europe.

This has, of course, been a real 'lightning tour' around the history and anatomy of the wagon underframe, an area offering possibilities for a lifetime's dedicated study. All I have been concerned with is to relate the chassis found beneath RTR wagons to their likely prototypes, with the object of avoiding any glaring mismatches. For a more comprehensive view of the almost endless variations, recourse is needed to one of the specialist wagon books listed in the bibliography at the rear of this modest volume. By and large, I tend to follow the oft-repeated Advice to Modellers and find a picture of a particular wagon to follow. How much minor anomalies in the detailing or numbering of wagons worry you is a matter for your 'modelling conscience'; I find mine is wonderfully salved by a good layer of dirt over the wagon number...

*For 'fast freight' service, the late 1930s saw the increasing use of 10ft. WB underframes fitted with 8-shoe clasp AVB gear and, in the case of this LMS-built 3-plank open van-type 'J Hanger' long-spring suspension for a better ride at speed.*

*High capacity for a low density traffic – coke – saw the introduction of long underframes – here 24ft. on 12ft WB running gear. This is an unfitted ex-PO wagon, limited in service to 25mph.*

*Even longer and a lot faster were the new 75mph 45T GLW air/disc braked wagons that saw in the brave new world of TOPS (now coded OAA rather than 'open AB'). A long way from 9ft. WB, 10 tons and an average speed in traffic of 15mph.*

## The RTR Chassis as a Model

Having whizzed around the various prototype wagon chassis, what do we find the RTR wagon makers have made of them? On the whole, a pretty fair job, especially in the matter of the steam era 17ft. 6in. and 21ft. 6in. underframes. Fortunately all those vehicles currently-available, derived from the old Airfix and Mainline ranges, use a version of the 1977-designed Airfix chassis, which was very good indeed, much better than Mainline's attempt at the same thing.

Whereas the Mainline chassis had brake gear in line with the solebars, and hence a country mile from the wheel tyres, Airfix used a very cleverly-positioned compromise which looks fine on 00 wheels (although it is actually slightly 'in front' of the 'true' position) and aligns exactly with EM and P4 wheels. This was very smart thinking back in 1977 and it avoids a potential problem for 'scalers up' of these RTR wagons – EM or P4 wheelsets drop straight in. Other aspects of these Airfix-designed chassis are equally praiseworthy. The actual brake gear is exquisitely detailed, with very lifelike brake shoes replete with pivot bolts, and a proper arrangements of the Morton brake gear, with the twin interlocking 'yin and yang' double-comma cams on one side to reverse the action of the lever, so that pulling it 'down' always applies the brake.

None of the other attempts at this chassis get anywhere near the fidelity of the Airfix version. Mainline's effort, apart from having brake gear not on speaking terms with the wheelsets, also has rather unconvincing buffers – Airfix's were, again, delightfully fine and accurate representations of the prototype RCH 'ribbed' design. The Mainline chassis does have a vacuum cylinder, lacking on the Airfix, although as Mainline missed out the necessary axleguard tie-bar for a vacuum fitted wagon, Airfix were more authentic once again. Both Airfix and Mainline chassis can be criticised for a spot of infilling of the W-irons above the springs and a lack of relief detail on these last. Lima actually do the best job of any of these RTR makers on the axleguards, but that's where the good news ends on Lima's version of this ubiquitous chassis. The buffers are not too bad, but the brake gear is a joke, even further from the wheels than Mainline's while the solebar detail is wholly fictitious.

So, for these steam era wagons, the old Airfix chassis and its contemporary derivatives get the Rice vote. Both Bachmann and Dapol have updated their Airfix-based chassis; Bachmann have a nicer axlebox but a chunkier buffer type, while the Dapol version, which is (hooray!) made in Britain, is a tad more refined about its brake gear than even the commendably delicate Airfix affair, and is a really excellent production. As it is freely available from Dapol and not expensive I look no further for replacement underpinnings for such ex-Mainline bodies as come my way (which, given that their swapmeet prices are pence rather than pounds, they not infrequently do...).

Airfix also produced a clasp-braked 'fitted' version of the 17ft. 6in. underframe following the early BR version of the LMS AVB gear. This was, for some reason, no-

*Typical of more recent wagon chassis are the leaf sprung, air braked, roller bearing 15ft. wheelbase underframes, here beneath slurry tank wagons. This is similar to the chassis of the Hornby TTF tank wagon illustrated elsewhere in this tome.*

*The original 1975 vintage Airfix 17ft. 6in. RCH chassis was pretty darn good and those 'chopper' couplings were a lot easier on the eye than full width tension locks, too.*
*Bachmann's latest version of the Airfix underframe design incorporates dummy 3-link hooks and a new type of tension-lock mount that looks to be Peco-compatible. A little lobbying from Beer, perchance?*

*The 'long' RCH underframe 12ft. WB and 21ft. 6in. over headstocks, here under a 21T wooden-bodied coal wagon, an interesting prototype from Dapol.*

where near as good as the unfitted chassis, with heavily infilled W-irons, unrealistic axleboxes, and brake shoes way out of line with the wheels. The rest of the chassis; solebars, buffers, brake linkages, is good, but if they could provide brakes in line on their other underframes, why not on this one? It's a shame, as this is effectively the only fitted 17ft. 6in. underframe to be offered. However, it can be 'doctored' to improve matters and is well worth persevering with. The alternative source of a 17ft. 6in. fitted underframe is Ratio's plastic kit for the GWR/RCH 10ft. wheelbase wagon chassis, which has retro-fit Morton vacuum brake gear, complete with axlebox tie-rods. I make a lot of use of this excellent and economical kit as a replacement chassis for RTR bodies.

It is possible to 'retro fit' vacuum brake gear to the Morton brakes of the standard Dapol, Replica, Bachmann and Airfix chassis, using cast whitemetal or plastic brake cylinders by ABS or Ratio. Both the 17ft. 6in. and 21ft. 6in. chassis are amenable to this treatment. This does, however, leave quite a gap in the range of chassis available in either RTR or kit form. It is possible to modify the Ratio kit chassis to take the LMS clasp brakes, using either cast parts from ABS or etchings from D&S models, MJT, and other specialist trade sources. The LNER 3-hanger version – which is common beneath a lot of the bodies represented in the main RTR ranges, being extensively used by BR – is just not available, so if you want to model one of these wagons, it will call for a bit of DIY – not that difficult, as I will demonstrate in the 'examples' section at the end of this book.

But what, you may be asking, of Hornby in all this? Do they make no usable chassis models? Well, if it comes to these short-wheelbase steam-era wagons, the answer is no, I'm afraid. As I have already mentioned, they manage to combine the 10ft. wheelbase with a 16ft. 6in. overall chassis length, and I haven't yet found any prototype example of such an underframe. It is a pity as their rendering of the BR twin-hanger AVB is really quite nice, although combined – ask me not why – with wooden solebars! However, the excellent in-line clasp brake shoes are on a separate moulding, I discover, and I have been experimenting with a spot of transplant surgery – Hornby axleguards, springs and brakes on a set of home-made solebars beneath a Dapol body.

*Comparisons are odious, but the Ratio plastic kit chassis fitted to the Mainline (now Bachmann) 'Lowfit' is a great improvement on the rather crude original – as well as being vacuum-fitted, as a 'Lowfit' obviously should be!*

*The great lack among RTR (and kit, if it comes to it!) wagon chassis is a good 8-shoe clasp AVB fitted version. This is Airfix's attempt (still alive today), out of line brakes and all. Nice buffers, though...*

*It's not difficult to 'vacuum fit' the standard Airfix – Dapol – Bachmann underframe for 4-shoe AVB gear – a cast brake cylinder let into the floor, a 'microrod' cross shaft, some melted-in brass strip tiebars and a change of buffers does the trick.*

## Steam Era Specialised Underframes

Not all railway wagons available in RTR form come on one of these 'standard' underframes and the various makers have produced a variety of 'one-off' chassis suited only to a specific vehicle. In some cases, such as the old Airfix or Wrenn (ex-Hornby Dublo) 'Lowmac', the underframe forms an integral part of the body moulding. Other examples of 'integrated' models, which lacked separate chassis, include bogie vehicles such as the excellent Mainline bogie bolster wagon. Here the solebars and the wagon deck/sides form a single unit, with only the bogies added as separate items. Lima have a very nice 6-wheeled express milk tanker in their range, with, again, a special chassis, although the specialisation doesn't extend to fitting the right size of wheel, more's the pity.

The other principle group of freight-stock vehicles riding on special underframes are brake vans, which have very distinctive and characteristic running gear. Long wheelbases, up to 16ft., are the order of the day, and, by and large, the various RTR makers do have a pretty good shot at these chassis. Leading the pack once again are the two old Airfix designs, for the LMS and GW 20-ton brakevans. These are fully up to the mark set by their wagon chassis, and need only the most minor of cosmetic refinements to fit them even for finescale service; I've adapted both types for P4 use without problems. These two vehicles now figure in the Dapol range. There is a GW brake van in the Replica/Bachmann catalogues, but this started life as a Mainline model and falls some way short of the standard of the old Airfix model in both body and chassis departments. This isn't to say that it's a bad model, but the Dapol offering is that bit better all round.

When it comes to the standard LNER-derived BR 20T brake van then Replica-/Bachmann have only Lima for competition in the RTR stakes, the Dapol entry coming in the form of a slightly updated version of the old Airfix plastic kit; excellent, but not admissible in the pages of this particular book. Fortunately, the Replica/Bachmann and Lima models are of slightly different variants, which makes them both useful. Unfortunately, neither is a top-rank model. Lima's underframe is not too bad with a good rendition of springs and axleboxes and a reasonably prototypical set of solebars. The footboards are rather chunky, and the buffers, while a bit 'vague' are not unrealistic. The main trouble is the usual Lima one of undersize wheels set too low in the axleguard to compensate; fit the correct wheel size and the bang goes your buffer height.

Bachmann's ex-Mainline chassis is, like all ex-Mainline items, a touch on the 'chunky' side, but for all that a much better rendition of the highly characteristic underframe of these vans. On this version of the BR brake, the characteristic end platforms, which Lima include with the body, form part of the chassis. Back in Mainline days, the basic body also saw duty on a short-wheelbase chassis as, supposedly, an LNER 'Toad D'. Neither body nor chassis were more than approximate in this role and the surgery required to produce a

*This is the sort of wagon you're never likely to see in RTR form, as just about everything is non-standard. Well, it gives the scratchbuilders something to get their teeth into!*

*A 'special' underframe well portrayed – this Airfix (now Dapol) GW 20T brake van sits on a very commendable underframe, with misaligned brake shoes about the only fault.*

*Every now and then a sort of flash of inspiration hits Hornby, who can turn out superb models like this ex-LBSC brake van if they put their minds to it. The chassis is accurate and well-modelled. Shame about the rest of their steam era range...*

worthwhile 'D' made a triple-heart-bypass look simple.

Hornby are always full of surprises. While a lot of their rolling stock is biased uncompromisingly at the toy end of the market, every now and then they come up with a cracking good model, such as their ex-LBSC brake van. This, being a 'one-off' sat on a special chassis which was a commendably accurate rendition of the prototype, and called for only the most minor of cosmetic attention. This brake van was all the more valuable for being suited to the needs of the neglected Southern modeller. I just wish they'd have these brain-storms more often.

### Post Steam Era Wagon Chassis

The dawn of the new age for British freight rolling stock took place in the late 1960s with the advent of the 'TOPS' system, heralding a new range of wagons built to a totally different 'spec' to the traditional RCH-derived designs that had dominated the earlier years of Nationalisation. 'TOPS' – Total Operations Processing System – was a computer based traffic control system that had, amongst other worthy objectives, the greater utilisation of wagons and a much higher speed of transit. This called for higher-capacity general-purpose wagons rated to run at much higher speeds – up to 75 mph – than had been usual. (Traditionally, unfitted mineral/slow freights had been limited to 25 mph, fitted or part fitted 'fast freights' to 45 mph and fully-fitted, specially passed trains, such as the 'blue spot' fish trains, to an 'express' speed of 60 mph).

It is in the modelling of these contemporary vehicles that those relative underdogs of the steam age, Hornby and Lima, come into their own. It's not just that Replica *et al* do not offer much in the way of up to date stock, with Replica's admirable HEA 'Merry-go-Round' hopper being the only example I've come across, but also that when it comes to these new designs, Hornby and Lima seem to get it right. Hornby have a whole range of BR 45-ton GLW wagons based on the 33ft. 6in. over headstocks, 20ft. 9in. WB air-braked chassis, at which they make a very fair stab. It's a bit unconventional in 'scale' terms in that each pair of axleguards, with wheelset, form a swivelling 'truck' restrained by flexible plastic 'tails' locating in stirrups toward the centre of the wagon, a design compromise forced by the need to accommodate running over very tight 'trainset' curves by what amounts to seriously lengthy 4-wheel vehicles.

These swivelling shenanigans do result in the whole wagon sitting a bit over a millimetre high, with corresponding error in buffing height. I 'de-swivel' and lower the wagon in one go, resulting in a dramatic improvement in appearance. The recipe for the surgery is in the 'examples' section. Otherwise, this is a very nice wagon chassis, adequately detailed and relatively 'fine'. The disc brakes are, regrettably, missing, but the correct large-headed 'Oleo' buffers appear, as do roller bearing axleboxes and nicely-modelled springs. The 'de-swivelled' chassis with body-mounted couplings is happy enough on model railway, as opposed to 'trainset' curves.

These BR 45-tonners are about the only contemporary wagon types to share a common underframe design. The bulk of the wagons now running on BR are, essentially, specialised PO types and use all manner of running gear according to the needs of the particular traffic. The model firms have perforce to treat all these vehicles as 'one-offs' which means that each model type will need its own dedicated chassis. And, by and large, this has had the desirable result of producing models that are a great deal more accurate than has been the case in respect of 'standard' wagon types, where the temptation to use a 'near enough' underframe, or to distort a wagon body onto existing but inaccurate running gear, has often proved commercially irresistible.

It is impossible to generalise about the quality of these chassis from Hornby, Lima and Joueff, although I tackle some typical specimens in the 'examples'. Disc brakes are a bit of a blessing, in that they are (a) less obtrusive and (b) impossible to model in the wrong place! Wheels for some of these model designs can be a bit of a problem, although Romford's disc brake 3ft wheel is excellent. There are various odd sizes beneath some of these wagons which cannot be matched exactly in the replacement wheel ranges – it's always best to fit wheels that are too small rather than oversized. But the need for major surgery or complete transplants just doesn't arise with these types – a reason, perhaps, for 'going modern'?

### Chassis Summary

As will, I think, have become apparent, it is in the field of the traditional steam-era 'standard' wagons that there is the greatest scope for upgrading RTR wagons. Rather than deal with modifying wagon chassis in splendid isolation, I have tackled the practical aspects of chassis modification in the context of the series of 'Case History' wagon builds which form Chapter 7. However, before leaving the grit and grime of the running gear for the delights of the Body Beautiful, it behoves us to consider a vital, thorny and, I would claim, somewhat neglected aspect of model wagonry that has a crucial bearing on operation and running quality – the small matter of couplings.

*Hornby's BR 20ft. 9in. air-braked underframe can, with a bit of work, be made into a very fair representation of the real thing. The Romford disc brake wheels help a lot.*

*Lima's covered grain hopper suffers from the prevalent RTR 'too high' affliction, rectified by minor surgery as described in Chapter 7.*

*Last fling of the traditional small capacity British wagon is represented by the series of late 1950s/early 1960s roller bearing 8-shoe AVB fitted vehicles on 12ft. WB. This is a 20T all-steel shock-absorbing open, neither steam age fish nor hi-tech diesel era fowl.*

*The early 1960s saw the birth of many special-purpose vehicles, such as this experimental air-discharge silo wagon coded 'Prestwin'. These types were the ancestors of today's highly specialised 'dedicated' wagon designs.*

# COUPLINGS AND BUFFERS

*The real thing – in this case an 'instanter' 3-link coupling devised by the GWR for loose or close coupling capability.*

It is one of the crosses that we British railway modellers have to bear that the type of coupling adopted by our prototype was neither automatic, nor capable of being adapted, in model form, to work as an auto-coupler. We are faced with a pretty stark choice in the matter; we either fit scale 3-links, and adopt a sober lifestyle compatible with their use, or we disfigure our models with an auto-coupler that, however admirably it may function, is more or less an eyesore.

Eyesores don't come a lot more painful than the all-too-ubiquitous tension-lock that has somehow become our 'standard' coupler. A sort of shiny caricature of a Volvo front bumper, topped off with a mammoth Moby Dick harpoon, lurks beneath the buffer beam of every RTR wagon in the land, about as unobtrusive as an Edna Everage party frock. Quite why we've been saddled with this monstrosity is a little beyond me, given that there are a number of simple well-proven and considerably more discreet alternatives in use elsewhere in the world. The Märklin and Flieschmann couplings work on similar principles to tension-lock without requiring anything like as massive an amount of hardware, while the NMRA horn-hook is positively retiring by comparison.

Not only are we saddled with this blunderbuss of a coupling, but it is installed in such a way that it's no easy matter to replace it with something better. I'm sorry to harp on about the way they do things in America, but surely the idea of a standard coupler mount, into which the modeller can install the coupling of his choice, makes commercial as well as practical sense? But no, remove the mounting block of the tension-lock from the average RTR wagon and you're left with a gurt great hole in the floor, right where you need to mount your alternative hardware. This is, to put it mildly, not very clever.

Now, I'll concede that tension-lock functions pretty well as a coupler, indeed, it has some very positive virtues, and yes, I do understand the needs of the trainset market, which demands a coupler robust and simple enough for young enthusiasts to cope with (although my daughters, aged 8 and 3½ can get to grips with Kaydees on the American HO layout, delayed action and all!). What I don't accept is that the tension-lock as it stands is in any way suitable for use on layouts that have any pretension to realism, and I do very much resent having it thrust down my gullet on a 'take it or leave it, you ain't gettin' no say in the matter' basis. It's about time the makers – particularly Dapol, Replica *et al*, who are in the 'model' rather than trainset market – gave us the facility to at least get the damn' things off without having to set about their products with a saw!

I suppose the trouble is that, once again, we have a lack of any sort of unified approach to the problem, and of those several alternatives to tension-lock that are on the market, no two have the same mounting system. Installing better couplers on RTR wagon chassis is, as usual, a case of making the best of a bad job. And the first job is to decide what, having junked the Moby Dick specials, you are going to fit. There are several established choices, to which I'm going to add another in a page or two, oh frabjous day! It would seem logical to look at the alternatives in order, hopefully, to provide some basis for making a choice.

### 3-link Couplings

If appearance is your top criteria, then you need read no further. The scale (more

*The Bulldog Blunderbuss: is this the world's most obtrusive auto-coupler?*

or less depending upon source) 3-link both looks, and works, exactly like the prototype. Which means, of course, that manual coupling and uncoupling, by means of some form of shunter's pole, is the only possible means of operation. And, let me tell you, it's a method of working fraught with drawbacks. For a start, it means that you can only couple/uncouple stock where you can both get at it and see what you're about. If you're going to use 3-links, then you need to decide on them *before* you design your layout; if they are to be anything other than a source of unending frustration, then there are certain conditions that must be met. Not to beat about the bush, these couplings are a fiddle. Any trace of the DT's and it'll take you all night to couple up the average goods train. They're also hard on the scenics – if only I had a fiver for very bush, signal or telegraph pole I've uprooted with my sleeve when attempting to manipulate these uncooperative devices! Even if you avoid lineside fitments, it's all too easy to derail the stock when you try and withdraw the pole. I once sent an entire rake of 'Tregarrick' wagons flying over the heads of an ExpoEm audience when finishing off a coupling manoeuvre with a flourish!

However, all this said, 3-link couplings do have quite a bit in their favour. I don't pay much heed to the argument agin the 'great hand from the sky'; we're accepting far larger compromises than that in our model railways – the 'Lot's wife' syndrome of all life frozen except the trains, the lack of steam, smoke or sound, and half-a-hundred other howling anomalies. Anyway, at least with the 'great hand' it's a case of 'now you see it, now you don't'. The visual blight of auto couplers is always visible. Other virtues of 3-links include correct (or nearly correct) wagon to wagon distance, the ability to 'pick up' a train in a beautiful 'one wagon at a time' start, and lifelike buffer contact during pushing manoeuvre.

Now, there's a double edged sword if ever you like. Buffer-to-buffer contact when propelling had traditionally been seen as a recipe for buffer-locking and consequent derailment, which it most certainly can be. Avoiding this particular malaise calls for a little understanding of the causes, and, it must be said, total elimination of locking isn't always possible, especially in 00. In fact, it's the poor old 00 modeller who is more likely to experience this problem, due to the very considerable amount of lateral play between his wheelsets and the track. (Typical width over the face of flanges in 00: 15·5mm; track gauge, 16·5mm; slop 1mm. EM comes down to around 0·7mm and P4 to 0·5mm). Given that, at 4mm scale the average wagon buffer head is around 4·5mm diameter, being able to get it nearly 2mm out of line – if the 'sideplay' had gone in opposite directions – isn't a very healthy start. Add in lateral displacement due to curves, especially reverse curves, and it's all too easy for those buffers to fail to buff at all.

By and large, I've found that you can use 3-links successfully in 00 provided that you observe one or two basic rules. The first of these is that you won't propel stock around trainset type curves on the buffers – I find that 30in. radius is just about the minimum possible with reliability. You also need to

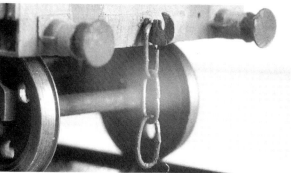

*Scale 3-links* look *very nice.*

make sure that your stock has good buffers, with decent sized heads totally free from any burrs, mould part-lines and other potential 'catching points' that would prevent the buffers sliding freely across each other. The buffers must be spot-on for height and centres (a lot of RTR ones aren't, especially Lima) and should be mounted plumb to the bufferbeams, not drooping, cocked-up, skewed or otherwise misaligned. Buffers with a very curved face to the actual bufferhead are also Bad News. The best replacement buffer I have found from the practical point of view is the MJT type that has a whitemetal body but a turned steel head. Kean-Maygib and Gibson sprung buffers also work very well, but are less easy to fit to RTR stock.

As for the 3-link couplings themselves, there are quite a few to choose from, ranging for the exquisite dead-to-scale Exactoscale type to the overscale but more pragmatic types offered by Smiths, Jackson-Evans and others. My own feeling is that, on a working layout, hooks that are a size or two up on true scale make life a bit easier, but it's a personal judgement. In the context of a P4 layout, it's hard to get away from the Exactoscale hooks, but I can't live with their scale chain links. I buy the hooks in bulk direct from Exactoscale and use some fine, but not *too* fine, chain sold by the EM Gauge Society. The resulting coupling looks acceptable to my eye but isn't *too* difficult to use.

Part of the secret of avoiding grief in the use of 3-links is to make a proper shunter's pole that works along prototype lines, as in my sketch. This type of hook on the end of a pencil torch is probably the best bet for dealing with 3-links. Personally, I've never had any joy whatsoever with magnetic shunting poles and soft iron coupler links, but there are those who swear by such a system. I swear at it...

Provided that you take into account the particular needs of the 3-link coupling when designing the layout (relatively easy curves, a baseboard height suited to coupler manipulation without needing to be a contortionist, and a careful placement of structures and lineside furniture to avoid

obstruction) then it can be perfectly satisfactory, and it is at least railway-like and, of course, realistic. In the context of wagons, it's really quite acceptable; where 'link' couplers get to be a *real* pain is where you're dealing with fitted locos – all those hoses get right in the way – or, worse still, on corridor stock. To actually install the things on wagons, even RTR wagons, is simple. You can either drill a hole (or pair of holes opened into a slot with a small screwdriver) in the bufferbeam, and retain the hooks with springs and split-pins as usually supplied, or by twisting/bending-/folding them over, or by adding a good dollop of epoxy behind the beam. Using my

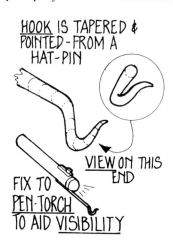

HOOK IS TAPERED & POINTED – FROM A HAT-PIN

VIEW ON THIS END

FIX TO PEN-TORCH TO AID VISIBILITY

metal hooks, I just melt them in with the soldering iron, and add the links later.

## Peco Couplings

This is a true 'old stager' known, if not loved, by all Hornby-Dublo *aficionados*. Throughout the 'fifties, 'sixties and most of the 'seventies, it was *the* coupling used by those 'scale' workers not going ga ga over 3-links. It works well enough, although it has an aggravating tendency to uncouple on bumps and needs 'firm shunting' to couple reliably. The uncoupling is by means of mechanical ramps, which, like a well-known type of brassière, are designed to 'lift and separate' the tails of the coup-

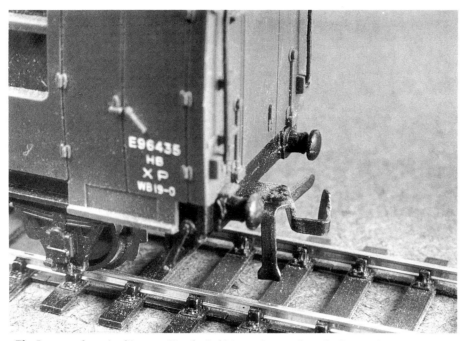

*The Peco coupler – in this case, Hornby-Dublo's version, made under licence from 1948 until 1964.*

lings. There is, *per se*, no 'delayed' function (that is, the coupling is not so designed that, after passing over the uncoupling device and parting, it is left in a state in which it will not re-couple on continued propulsion of the uncoupled vehicles) although if you were gentle on the throttle, you could usually obtain the desired result, owing to the need for firm contact to activate the coupling in the first place.

As with most of what I will call the 'intermediate' auto-couplers, the Peco is designed to propell vehicles without buffer contact, a system shared with tension-lock, my own 'Bringewood' coupling and, to a certain extent, the 'Sprat and Winkle'. This is one obvious way of avoiding any possibility of buffer-lock occurring. Peco couplings will operate over curves of trainset proportions, and are reasonably robust. The main snag with them is that, these days, virtually no RTR stock makes any provision for their fitment – a few of Hornby and Lima's 4-wheel wagon chassis are the only ones I've come across that will take them without the need to provide new mountings. Add that to the undoubted fact that, while less obtrusive than tension-locks, these are still a very 'visible' coupler, and it's not hard to understand the decline of the Peco option.

### 'Serious' Auto-Couplers

Those modellers who are after authentic operation coupled with discreet appearance and who cannot find it in their hearts to forgo the odd dram of *Uishge Beatha*, usually have recourse to one of the 'serious' auto-couplers – that is, those devices that have, somehow, acquired the 'finescale seal of approval'. Real hair-shirt devotees opt for the 'Alex Jackson', a sort of very minimalist harpoon job sculpted from 11thou. steel guitar wire; more pragmatic souls opt for the considerably less critical 'Sprat and Winkle'. There is a third alternative finding some favour these days in the form of the 'DG', a miniature Maerklin-style coupler originally developed for 2mm finescale use. All of these couplers work magnetically, incorporate delayed ac-

tion and are a great deal less obtrusive than either Peco or tension-lock. All have drawbacks and advantages, and really warrant more treatment that I can give them here. Nevertheless, I feel thumbnail coverage is in order, at least of the Sprat & Winkle, which is probably the most relevant. But before I come onto this, I'll dispose of the other two, as they have requirements that, by and large, are only met in finescale situations.

### Alex Jackson, DG

The main difference between these two is that you have to make AJ's from scratch, whereas DG's come in etched-brass kit form. Both are fairly complex and sophisticated in their action, both call for buffers that buff (and all that goes with that par-

ticular requirement) and both give scale wagon to wagon distances – which in turn means wide-radius curves. The AJ couplings, in addition, need to be accurately centred, and to couple successfully need the vehicles to which they are mounted to be accurately centred on the track. Which, for reasons already discussed, more or less lets out 00 right away. AJ's need to be accurately made and set up, when they will work supremely well. But they don't need to be far off the mark before the performance goes down the pan. DG's are a bit less critical, so far as I can gather; I'm afraid I don't have any direct experience to go on.

These rather particular requirements, particularly in relation to the AJ's, which are, without doubt, the least obtrusive auto-coupler I've come across, really do limit their use to finescale layouts in EM or P4, where the tighter wheelset/track tolerances and generally easier curves avoid some of the alignment and buffing problems. I don't really think I can say much more in these pages. Both the EM Gauge Society and Scalefour Society provide details of these couplings and their installation within their manuals and technical literature. Martin Brent manufactures and sells a very neat bending jig for making the AJ's but both types do call for accuracy and skill in their production and installation.

### Sprat and Winkle

Before you all write to Irwell and ask, the colourful moniker of these couplers derives from the name of the model railway of which they first appeared, Derek Munday's version of the LSWR's Meon Valley Line, which was apparently known locally by this fishy title. The coupling itself is a sophisticated derivation of the old H & N coupler, a device going back to the immediate post-war period. It is a very practical coupler that isn't difficult to install, and one which is reliable in service

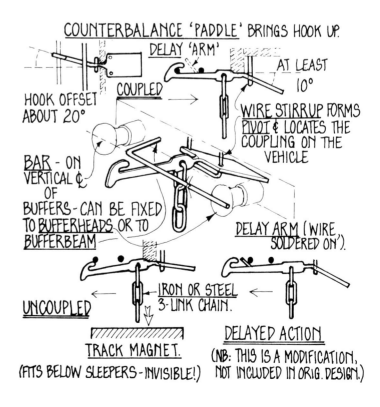

**SPRAT & WINKLE COUPLING**

under the sort of conditions pertaining on most model railways. It works well in the context of any gauge or standard, and, while not as self-effacing as the Alex Jackson device, is still a lot less obtrusive than any other commercial offering.

The Sprat & Winkle can be made in two versions; one does use the buffers when propelling, the other has a wire bar right across the buffer faces, effectively cutting out any chance of buffer locking. Basically, the S & W uses an inverted version of the tension-lock idea, with an etched hook passing underneath to latch on to a wire bar; the sketch should make the principle clear. The bar is pivoted on a little etched fold-up bracket, to the rear of which is a flat brass 'paddle' which acts as a counterweight to bring the hook back up once it has passed under the wire, or been pulled downwards by the uncoupling magnet. These magnets are positioned between the rails, and act on the coupling via means of a couple of soft iron links suspended from the hook in front of the pivot, where they give the impression of a dangling 3-link.

As with all auto-uncouplers, the S & W acts when the couplings are slack, either when the train is being propelled, or if it is stopped over the magnet and then 'set back' to slacken the couplings. The magnets are long enough to act on two couplers simultaneously, so both hooks are drawn out of engagement. If the train is now further pushed, there are two little 'fingers' on top of the hooks which will prevent the couplers from re-engaging, allowing the uncoupled wagons to be propelled to the desired spot and left. One uncoupling magnet at the toe of a siding, or at the throat of a fan of sidings, will thus permit wagons to be parted and left anywhere on those sidings without need for further manoeuvring. This 'delay' facility, common to all the more sophisticated 'serious' auto devices, is the key to truly realistic 'hands off' shunting.

### The 'Bringewood' Coupler

Enter my own contribution to this whole grisly business, a coupler which, if not as 'serious' as those mentioned above, is certainly not frivolous. Rather than set off in some completely new direction, I decided to have a look at my good old *bête noir*, the tension lock, to see if I could swipe its virtues while overcoming the twin drawbacks of obtrusiveness and the lack of delayed action. I was also keen to maintain compatibility with the ordinary commercial tension-lock, as it seems to me that one of the main difficulties with all the others is that you've got to convert in one 'hit' or put up with the inconvenience of 'adaptor wagons', with disparate coupler types each end. The 'Bringewood' coupler – named, in best Munday tradition, after the layout for which it was first devised – does all of these things, I'm glad to say. It had a lot in common with the Sprat and Winkle, but is essentially a refined development of the tension-lock, in itself derived from the old 'Lanal' coupler that originated with Eric Lanal in the USA.

My version of this long running hook-and-bar saga uses a fine steel wire bar, mounted at the same height as the normal RTR tension-lock. The hook is a sort of

*The sprat and winkle coupler, which comes as a flat etching to form up. This is actually the 3mm scale version, which many 4mm finescale modellers prefer, including Gwilym Mccoach, whose LMS brake van this is.*

*These show the handmade version of my 'Bringewood' coupler, a magnetic delayed-action variant of the usual tension lock. It is, I think, considerably less obtrusive than the plastic version.*

cross between the tension-lock and Sprat & Winkle designs, and can either be bent to shape from the fine steel wire, or etched from mild steel. As with tension-lock, the hook is pivoted below the buffer beam of the wagon, although in my version the pivot is set back from the beam, nearer to the axle position. As with the S & W, there is a 'tail' beyond the pivot, but in my case this is the magnetic 'dropper' which operates the coupling. The isometric drawing should make all this clear.

What I like to consider the 'clever bit' is the delaying device. At its most basic, in the bent wire 'skeleton' version, this does depend on the buffers for propulsion once uncoupling has taken place, although there is a simple 'mod' that can be applied to overcome this if it proves a problem. The etched 'production' version which I hope will be available by the time this book appears, incorporates 'buffer free' propulsion in its design. The action of the coupler can be seen in the diagrams; as with the other devices, the couplings need to be slack for uncoupling to take place, when, once over the magnet, the 'droppers' are pulled down, lifting the hooks. The wagons close up until either (a) the buffers touch – wire hook or (b) the 'stop' hits the bar of the opposing wagon – etched version. Once the wagons are clear of the magnet the hooks drop down over the bars, with the curved arm of the 'delay' stop the 'wrong' side of the bar. If the loco is now reversed the curved stop will once again lift the hook clear of the bar, preventing re-coupling as the wagons are parted.

Coupling action is identical to standard tension-lock and, under load, the hook 'locks' on to the bar in much the same manner, preventing uncoupling when pulling trains over a magnet. As the bar is at the same height as commercial tension-lock, then the hook of such a coupling will latch on to the bar of the 'Bringewood', although the much finer hook of the latter will not engage the massive 'bumper bar' of the RTR coupling. However, so long as one hook engages on an opposing bar, you're coupled. Indeed, in situations where the stock can be kept 'one way round' it's possible to get away with hooks on one end only. The only criteria to ensure reliable action of the coupler are that the hook should drop down under its own weight, and that the pull of the track magnet is strong enough to lift the hook clear of the bar. Thus, the pivot is arranged so that the hook and tail are just 'off balance' in favour of the hook. On 'Bringewood' and subsequent layouts built using this coupling, I have used the track magnets sold for use with 'Kaydee' couplers, which are only magnetised along the edges, calling for the tails to be bent to one side; I try and arrange them to be just behind the wagon wheel, and no more than 1mm above rail level. If the 'Sprat and Winkle' magnet was used, then this offset would not be necessary.

I have about thirty 00 wagons fitted with the wire version of this coupling and have found it quite reliable and robust enough for general use. It is, in DIY wire form, incredibly cheap and not difficult to make, as I hope my sketch will show. The ingredients are simple enough, some 'Mercon-

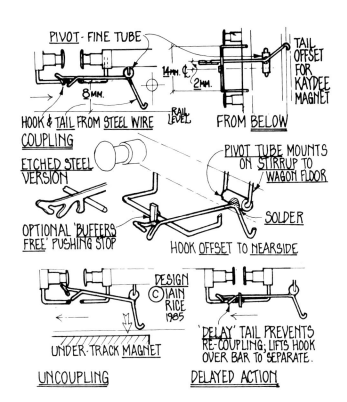

PIVOT - FINE TUBE

HOOK & TAIL FROM STEEL WIRE COUPLING

14MM ℄
2MM
RAIL LEVEL

TAIL OFFSET FOR KAYDEE MAGNET

8MM.

FROM BELOW

ETCHED STEEL VERSION

OPTIONAL 'BUFFERS FREE' PUSHING STOP

PIVOT TUBE MOUNTS ON STIRRUP TO WAGON FLOOR

SOLDER

HOOK OFFSET TO NEARSIDE

DESIGN © IAIN RICE 1985

UNDER-TRACK MAGNET

UNCOUPLING

'DELAY' TAIL PREVENTS RE-COUPLING; LIFTS HOOK OVER BAR TO SEPARATE.

DELAYED ACTION

## BRINGEWOOD COUPLING

trol' copper capillary tube to make the pivots and some 0·45mm brass or nickel-silver wire for them to pivot on. The rest – hook, bar and tail, is bent from the fine (36 SWG) spring steel wire. I got a big coil of this from Cove Models who sell it for point operations, via wire-in-tube; it strikes me as a mite willowy for that purpose, but it's ideal for the coupler. The etched commercial version presently under development will use an etched steel hook and a brass wire bar, hopefully chemically blackened, with a fold-up etched brass bracket to provide a mounting for the bar and the pivot for the hook.

It is possible to set these couplers to vary the wagon-to-wagon distance, simply by moving the whole assembly to and fro slightly. In this way, the coupling distance can be set any anything from scale to a gap that would, theoretically, get you round 12in. radius curves. I settled on setting the bar slightly (20thou – I use a piece of Plasti-kard as a jig) in front of the buffer faces; this gives me a coupling distance a tad over scale (but much closer than commercial tension-lock) but still lets me push 'buffers free' around 2ft. radius curves, in which mode the 'delay stop' acts as the propelling agent, keeping the bars apart and the buffers out of contact. One of the joys of the thing is that it's non-critical; so long as the bars are all the same height

(easy enough to adjust by 'tweaking' up and down if required) and the hooks are all roughly the same length in front of the bar, and offset to the same side, it'll work.

Actually mounting the thing to RTR wagons isn't either difficult or particularly hard and fast. As shown in the sketch, I usually build it up on a small piece of brass sheet, which I can either nut-and-bolt or screw to the wagon floor with a small self-tapping screw, or glue in place. Quite a few of my couplers are held on with small pads of strong double-sided adhesive carpet tape while on others I've simply melted the tails of the pivot mountings and bar into the plastic wagon floor. So long as you end up with the bar in the right place, and the tail 'dropper' close enough to the track for the magnet to 'get hold of', you're in business. Don't worry, by the way, if you find only one hook engages on a bar out of every pair, which is apt to happen with the handmade version of the coupler, due to inevitable slight variations. The couplers still work just as well on 'single hook' engagement; in fact, I find that this makes uncoupling rather easier, as you've only got one hook to free from a bar.

Well, so much for the 'Bringewood' which I hope at least a few people will find useful as an alternative to tension-lock. Whatever your choice of coupling, I feel that almost anything is better than the cur-

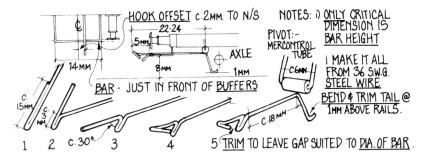

HOOK OFFSET c.2MM. TO N/S
22-24
5MM
AXLE
14MM
8MM
1MM
BAR - JUST IN FRONT OF BUFFERS

c.15MM
c.3MM
1  2  c.30°  3  4

PIVOT:- MERCONTROL TUBE
C.6MM

c.18MM

5 TRIM TO LEAVE GAP SUITED TO DIA. OF BAR

NOTES: i) ONLY CRITICAL DIMENSION IS BAR HEIGHT

I MAKE IT ALL FROM 36 S.W.G. STEEL WIRE BEND & TRIM TAIL @ 1MM ABOVE RAILS.

rent RTR standard, and I look forward to the day when we can buy RTR wagons which at least make some provision for alternatives. Details of the various substitute couplers I've listed are in the 'sources' index so hopefully it will be possible to free more wagons from the tyranny of tension-lock.

## Buffers

I've already touched on some desirable qualities to look for in buffing equipment, when discussing the functional aspects of buffer performance, but given that buffers are often among the less satisfactory cosmetic aspects of RTR underframes, what can be done to improve them? I generally adopt two tacks – to fit new heads to existing RTR moulded-on buffer bodies, or to completely replace them with something a good deal more satisfactory, from another source.

As noted in the last chapter, only the ex-Airfix underframes possess buffers that are accurate to prototype. The rest are, at best, approximations, and some are quite grotesque. I've also found that they are not always in the right place, which obviously looks wrong, as well as impairing the proper functioning of the buffers if the coupling in use should require this. Some prototype wagons also have very distinctive buffer types which the RTR maker, 'making do' with a standard underframe, cannot replicate. We can, though, and this sort of upgrade can make a very big difference to the 'look' of any wagon. Photographs are, once again, the best source of information, one more reason for making 'portraits' of actual wagons.

There are a very wide range of buffers available from the specialist trade, in a variety of formats. Both Kean-Maygib and Gibson make some very nice sprung wagon buffers, with turned brass bodies and steel heads. These utilise minute coil springs which are 'soft' enough to compress under the sort of loadings imposed when shunting 4mm scale wagons. As well as being a nice touch, the use of these soft-sprung buffers has practical value where buffers have to buff, as the heads will always remain in contact on curves, compression of the 'inner' pair of buffers allowing the outer pair to stay in touch.

In addition to supplying complete sprung buffers Kean-Maygib also sell a bulk pack of just the heads and springs, and these I find extremely useful. Those fine Airfix-style buffers are rather delicate and it's very common to end up with wagons having one or more buffer heads missing – a lot of my cheap swapmeet 'finds' are in this condition. The missing heads can be simply reinstated using the Maygib turnings; cosmetically all that is needed is an appropriate hole drilling (carefully) about 1mm or so into the Airfix buffer housing, and the Maygib head, shank suitably shortened, gluing into place. You can go one better than this, however, and fit sprung buffers to your Airfix-type chassis by drilling right through, using two sizes of drill.          You will need to do a bit of carving away of the chassis behind the bufferbeam to get clearance for the 'tails' of the buffer shanks, which are simply bent over slightly to set the buffer head

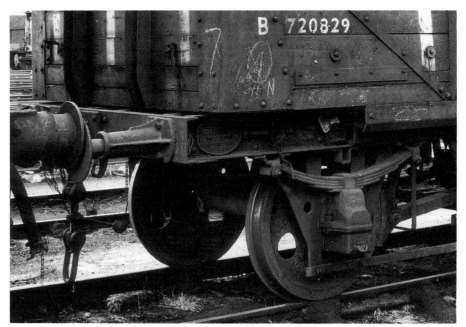

*One of the problems with RTR stock is the variation in buffer heights. Of course, that sort of thing never happens on the prototype, does it?*

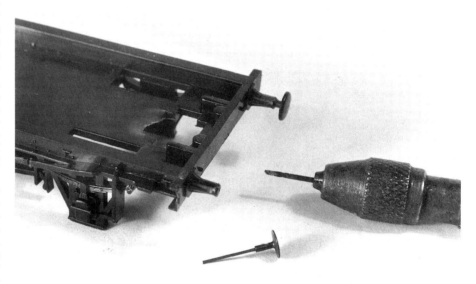

*Busted buffers are a common problem on swapmeet finds, especially on old Airfix underframes. The remedy is a cut-down Maygib buffer head turning.*

*It is sometimes necessary to move buffers to get the correct height, as here on a Lima 45T bogie fertiliser wagon. The moulded buffers are sawn off and remounted on fresh Plastikard backing plates.*

out at the right distance and retain it; again, the diagram should make this clear.

Often, however, the RTR wagon is just so 'orrible that it will take more than a better head to redeem it. So, going one better than the Queen of Hearts, I lop the lot off with a sharp craft knife and file the bufferbeam flat, finishing off with the sanding board used 'wet'. This usually has the added virtue of disposing of the mould part-line with which many RTR wagon bufferbeams are disfigured. Check that the centres are correct at 5ft. 9in. (23mm or 11·5mm each side of centre) and drill pilot holes for the locating shanks of the new buffers. It is rare for wagon buffers to be on anything other than the vertical centreline of the beam, but there are some modern high capacity types where this is not the case. A check of the prototype picture against the position of the moulded on buffers you've just removed will show whether these were in a correct location or not. At all events you need to end up with your buffers at the correct height above rail level, 14mm or 3ft. 6in. to buffer centres.

The vast majority of the buffers on the market are of cast whitemetal and I list a few suppliers of these in the 'sources' index. Two ranges that I find particularly useful are MJT and Kenline; the MJT buffers, particularly, are very nice, incorporating 'cast-in' turned steel heads. ABS also do a substantial range of wagon fittings, including buffers, and there are other sources. A good model shop should be able to offer a selection, while the better model railway shows usually have a specialist trade present where such items can be obtained. I usually stock up when I see these parts – they are not expensive, and it enables me to get to the 'marg tub full' red

tick stage that bit quicker. Obviously, you're not always going to be able to find the 'exact' buffer for every wagon type, but it's usually possible to come up with something a good deal closer than the RTR effort.

I find the best way of attaching cast buffers to the plastic RTR chassis is to use a combination of contact cement and the plastic solvent. Drill or ream out the pilot-hole in the beam until the tail of the cast buffer is a good, tight fit. Then smear it with a little 'UHU' or 'Bostik 1' applied with the tip of a cocktail stick and fit it in place. Now

touch a brushful of 'Daywat Poly' to the base of the casting so that a drop of solvent runs into the joint. Allow the thing to set off undisturbed – I generally clamp the chassis (gently!) on end in the vice, so that gravity holds everything in place. Great stuff, gravity. And that's it. Once painted, the cast buffer blends in with the RTR chassis and it's amazing just how much a simple change like this can take away the RTR 'look' from a wagon. Almost as much as the body re-working and paint job that completes the process...

*Above and below. Cast whitemetal buffers can be substituted for unsatisfactory or misplaced RTR buffers. The 'Moy' coke wagon has had the moulded-on buffers replaced by Kenline RCH-type. Painting the new buffers and the buffer beam to match the body makes a huge difference to the 'look' of the whole wagon.*

*Junk box gold! This sad Wrenn 'Saxa' salt wagon body (a real old RTR favourite going back to 0 gauge tinplate days) surfaced from one of Pete Lindsay's copious 'oddments' boxes in the Exeter model shop. The price proved negotiable!*

*Bachmann's ex-GW fruit van shows just what quality RTR bodies offer. Could you make louvres like that? Dam' clever, these Chinese.*

# THE BODY BEAUTIFUL

*This delightful salt wagon is really a covered open rather than a van – it started out as a very secondhand Wrenn body – see opposite page! A re-work and a Ratio chassis effect the transformation.*

There can be no doubt that the modern moulded plastic wagon body, following on from the incredible (for the time) standard set by the Hornby-Dublo 'SD6' series, is in virtually every respect a thoroughbred scale model. They do vary a bit, of course, from maker to maker, and to a certain extent with date of introduction. But only the very 'cream of the crop' of scratch-builders can get anywhere near the standard achieved by Dapol, Bachmann and friends, while I doubt if anyone can aspire to the lettering standard possible with modern micro laser printing technology. What, then can be done to improve upon these principles of the plastic-moulders art?

Well, for a start, good though these mouldings are, the needs of the process do impose a few limitations on the actual modelling. If the tooling isn't to be incredibly complex and costly, then certain undercuts are just not practicable, while 'full relief' on certain details cannot be achieved in the context of a one-piece moulding. We can take these compromises out of our models by, for instance, replacing a moulded-on grab iron or lamp bracket with wire or strip; we can add 'lips' or roof overhangs that the needs of mould-extraction rule out of court, and we can add 'reverse side' detail where this is missing.

But that's far from the end of the story. It is both a strength and a weakness of the injection-moulding process that all the models produced from a given set of tooling will be as alike as the peas from the famous proverbial pod. Admirable as it may be in so many ways, such uniformity can be viewed as a drawback when related to modelling a prototype full of minor variations. It *is* possible to introduce such variables by use of 'inserts' in the tooling – interchangeable mould parts carrying different detailing. This is how Lima, for instance, produce several variants of a basic diesel design. But this is an expensive process which certainly cannot be justified in the case of a low cost product such as an

RTR wagon, intended to retail at three or four poor old devalued pounds.

Actually, I'm quite glad this is the case, for I find it both challenging and satisfying to provide these little bits of non-conformity for myself, while being spared the basic task of building the rest of the wagon in the first place. The sort of 'mod' that I'm talking about might include the addition (or removal of) bits of strapping, changing a van from non-ventilated to ventilated status, or adding 'retro fit' or upgrade detail such as vacuum brakes or tarpaulin bars. Swapping the type of underframe fitted to a given body moulding can open up more possibilities, while there is always the matter of suitable loading to be considered. Most of all, though, it's the chance to produce a truly individual model; I get far more of a buzz if people ask: *'Is* that a Dapol/Replica-/Hornby or did you build from a kit/from scratch?' rather than remarking 'Oh, I see you've got one of those Dapol/Replica-/Hornby/XXXX; nice aren't they?'

Part of this process lies within the province of the paint brush which I will come on to in the next chapter. But quite a lot can be accomplished by some relatively simple modelmaking work with wire, Plastikard and a few well chosen detail parts. As every wagon is, hopefully, going to be different, then I can only generalise about the materials, techniques and approach at this stage; the specific examples in Chapter 7 should show how these elements are combined to obtain the desired result. Obviously, the first step with any modelling project is to decide upon the objective, which brings me back, once again, to the matter of setting standards, and the importance of sticking to them.

I have expressed my admiration for the Hornby-Dublo SD6 range of moulded plastic wagons on innumerable occasions, which is why so many people think it odd that, in a 'Dublo' collection that runs to some 135 wagons, I don't have a single SD6 example. The reason is simple, they're too good. In the context of a collection whose basis is the use of lithographed tinplate, a

medium which, while charming and attractive, is about as realistic as the average chancellor's budget forecast, the introduction of a full-relief, finely detailed, realistically finished moulded plastic model is an anachronism that simply serves to make all the tin trucks look as flat and crude as they undoubtedly are. This is an extreme example, of course, but what I'm saying is that if you 'go mad' on one wagon and give it the superdetailing works, it'll simply make the rest of the fleet look unsatisfactory. Replace one moulded handrail with a nice fine wire one, and you've got to do the lot.

However, I *have* got quite a few 'worked-over' SD6 wagons in my 'scale' wagon fleet where they sit happily alongside more recent RTR wagons and stock built from plastic, whitemetal and even etched brass kits. The proviso is that *all* these wagons, whatever their origins, will be to a like standard, all the handrails and grab irons are wire (which will also involve re-working the kit wagons to conform); they all have realistic fittings such as roof vents, buffers and brake hoses; and they are all painted in the same way, weathered in the same way, and loaded in the same way. If a programme of upgrading in some respect were to be introduced, I would do it in easy stages across the whole fleet. That way, you don't get extremes with an 'out of the box' specimen shouting at a fully-worked example.

The other element in deciding the objective of a given RTR wagon conversion is the prototype reference, the relevance of which I explored in Chapter 1. Study of this reference with the end standard in mind will suggest just what needs doing to the wagon body to make it conform. I find that all detailing work comes into one of two categories: substitution or addition. Substitution, in this context, is the lopping off of an unsatisfactory moulded-on detail, and its replacement with something that looks better. The additions are just that, providing bits that are missing from the model as it comes.

## Substituting for Moulded Detail

Once you've decided to replace some fitting on the moulded wagon body, the first – and trickiest – job is to remove the offending item without damaging the rest of the moulding in any way. How difficult this is depends on the exact item to be expunged, but it's usually a case of some careful work with a craft knife, followed by cleaning up with the fine abrasive 'rubbing sticks' – see back in the 'toolbox' section of Chapter 1. On occasions, the chisel implement – a sharpened small screwdriver serves – will be more suited to the cutting job. This can be particularly useful in, for instance, removing a grab iron moulded on between other raised detail, such as strapping, that would otherwise get in the way of the knife.

Other methods of getting rid of unwanted details can be a little less refined. The 'Xuron' shears are very good for snipping off unwanted bits – they will cut very close to a surface, unlike conventional side-cutters, while, if you can get hold of the offending bit of wagon anatomy with a pair of pliers, it can be twisted or 'fatigued' off. Some bits can be drilled away by careful use of small drill bits, preferably twiddled between the unaided fingers for ultimate control over the proceedings. On occasions, I have had to cut holes in the side of wagons to get rid of unwanted detail, restoring the side with a Plastikard piece 'let in' or filling the resulting hole with Milliput.

Such surgery can be quite difficult to carry out, and if you haven't tried this sort of stunt before, it may be worth acquiring a couple of cheapo-cheapo swapmeet 'scrapper' wagons to try your hand on. It's also as well to bear in mind that the idea is to improve the overall look of the wagon; unsatisfactory moulded detail may, at the end of the day, still look better than a super-duper casting in the middle of a totally mutilated wagon side! If you're worried about damaging detail or lettering you need to keep intact, protect those areas of the wagon body with ordinary masking tape.

Don't be too upset if you end up, after removing some offending part, with a wagon side that has some variations in the 'quality' of the surface. The paint job will hide a lot of this and anyway, one of the things I aim to do in my RTR wagon reworkings is to get away from the 'crisp and perfect' look characteristic of plastic wagons. In fact, I spend quite a bit of time introducing just such imperfections into a lot of my wagons; that's how the prototypes were, so an authentic model needs to follow suit. The technique is known as 'distressing' and I'll come to it in a moment. For now, having removed unwanted or unsatisfactory detail, we need to replace it.

### Adding New Detail

Substitute or additional detail can be added either by fabrication in metal or plastics, or by purchasing an appropriate etched or cast detail part. The techniques involved in fitting such detail very quite a bit, so I'll take each basic method and describe it in detail. I find that, broadly speaking, I will be fabricating detail in plas-

*This Dapol BR 21T coal hopper has had 'the works' – all the moulded-on grab irons have been replaced with wire, while the axlebox tie rod is now fine brass strip rather than a thick and clumsy plastic effort.*

*Three pictures left: removing moulded-on detail calls for a sharp knife and chisel implement (sharpened screwdriver) and a lot of care. I'd normally keep my fingers more out of harm's way, but it wasn't possible while taking photos! The rubbing stick, used 'wet', smooths away tool marks.*

tic materials, which I generally do 'in situ', or I'll be 'melting in' such items as grab irons, lamp brackets, securing/lifting rings and pipe work bent to shape from wire or strip. Pre-made details – castings, etching or home-brewed fabrications – are much more straightforward and can usually be secured by gluing in place, though occasionally I resort to using nuts and bolts, push-in spigots or wire ties, – of which more in a moment.

## Fabricating Plastic Detail

The addition of plastic detail work is, not surprisingly, the simplest way to re-work moulded RTR wagon bodies. Carefully executed, and given a bit of disguise under the paintwork, this approach can produce a pretty well 'seamless' result, and it is possible to make quite major changes to a vehicle in this way. The sort of detail that lends itself to reproduction from sheet and strip styrene is, fortunately, the type of feature that it will often be necessary to reproduce. Strapping, for instance, of all sorts – flat side strappings, corner plates, drop hinges, reinforcing plates, end stanchions, wagonside top reinforcement, stays, bracket and anchor points. Other 'flat' details might include chalk-boards, builders plates, owners plates, placards, blanking panels, patches and repair sections. On a chunkier note, door tracks and door stops, mounting blocks, ventilators, end steps, latching gear and loading pads also lend themselves to modelling in thicker plastic sheet.

If you're trying to match up existing moulded-on detail, it's important to get the right degree of 'prominence' in the new work, not always easy – I quite often resort to sanding bits of Microstrip a shade thinner to get an appropriate degree of relief. 'L' and 'T' section angle strapping can be a beast, and on occasion I've lopped off moulded-on strapping and replaced the lot – original locations plus additions – in Microstrip or 'Plastruct' ABS sections, just to get it all looking the same. I almost always build up plastic detail work 'in situ' – apart from all other considerations, it it's firmly welded to the wagonside I'm less likely to lose all those carefully cut bits in the clutter on my workbench!

You won't get far along the plastic-detailing road before you run up against the need for bolt or rivet heads; strapping, especially, is apt to break out in a veritable rash of these aggravating little zits. To model them, I borrow a well-established technique from the pukka scratchbuilding guys, by using tiny cubes of styrene – 10thou. × 10thou. – to represent a bolt head of approximately ¾" diameter at 4mm scale. This is probably a bit on the big side in some instances, but it looks o.k. and is reasonably easy to cut, especially if you can lay hands on 10thou. square 'Microstrip'. Otherwise, it's a case of cutting the merest sliver off the edge of sheet of 10thou. then dicing the resulting strip up into the mini cubes in best 'Masterchef' fashion. Don't try and cut too many at once, as they pick up static charge for a passtime and go absolutely everywhere.

To locate and fix these embryo bolt-heads, they are picked up on the tip of a fine brush moistened with solvent (I use a

*New plastic detail comes courtesy of styrene strip and a suitable solvent.*

*Here, a Bachmann LNER dropside 'Lowfit' is turned into an LMS pattern fixed-side version, courtesy of new Plastikard corner plates and 'Plastruct' T-section end stanchions, both fitted with cube rivets.*

*Cube rivetting; the simple, quick way to add rivet or bolt head detail.*

No.1 watercolour brush, Daler 'Dalon' nylon type – see next chapter) by which means they are carried to the desired location and winkled off onto the would-be strapping. Once they have been persuaded to part company with the brush and stay in place – roughly – on the strapping, the brush is loaded with solvent, and touched to the cube/strapping joint. You now have about 15/20 seconds during which time the 'bolthead' can be chivvied into place with the brush tip before the solvent goes off and the joint 'grabs'. Re-flooding with solvent will gain another 20 seconds 'adjustment' but don't overdo this or the whole job will go soggier than a Salvador Dali Timex. Once you have got all your boltheads in the right place, however, it can pay to wash over the whole strapping with a last brushful of solvent; as well as ensuring that nothing is going to come adrift the action of the solvent also tends to 'round off' the corners of the cubes, giving a much better representation of a typical hemispherical bolthead.

While I tend to use 'Daywat Poly' solvent for most plastic welding work, it is a pretty nasty solvent and I have found that it's a bit *too* much of a good thing when it comes to the styrene cube rivet. So I tend to go over to Mek-Pak or Polsol for this work, although I generally stick the basic strapping in place with 'Daywat', which does bond very well with the material from which RTR wagon bodies are made.

One of the great advantages of the cube rivet is that you can put it just about anywhere, on any sort of surface, or onto the flanges of 'L' or 'T' section strappings. You can use cubes to reinstate rivets or bolts accidentally done away with when removing moulded on detail, or to make good the occasional lapses of the RTR makers. And, of course, if you should go so far as to try a spot of scratchbuilding, either in the context of building a new, correct chassis onto an RTR body, or in the pure form of a wagon built from raw materials, then it's a very useful technique to have tucked away up your sleeve. It may pay to play around putting rivets on scrap Plastikard until you've got the hang of the process, and it certainly pays to spread your cubes out on a bit of glass to pick them up on the brush, otherwise it's all too easy to weld them to the bench!

Strappings of various sorts are both the commonest and the trickiest components you are likely to tackle in plastics. Most other detail consists of either a single, simple strip – roof rainstrips, for instance – or small blocks of thicker material which provide chunkier items such as doorstops. If you find you need to add such components to painted areas of the wagon body, there's no need to scrape away paint to obtain a sound bond – Daywat Poly will go straight through almost any paintwork without problem, so use it sparingly. The old adage that says it's a lot easier to put a drop more on than trying to get an excess off is especially true here, where stray solvent can ruin both the finish and the underlying plastic moulding.

If you get ambitious, it is actually quite possible to 'build in' quite large areas of a wagon body with styrene sheet and strip. I have, for instance, replaced the corrugated metal ends of the common LMS/BR 12T van body (Airfix, now Dapol, and also I think, in the Bachmann ranges – it's excellent, accurate and very versatile) with timber versions scratchbuilt in plastic, either by filing all the moulded detail on the ends flat and rebuilding with scribed planking and strapping built in situ or, more drastically, by sawing the end right out and replacing it with an all-Plastikard item. Mind you, given that Ratio do a good kit of the LMS variant of this van for much the same money s Dapol's RTR version, whether the drastic surgery involved in my 'end transplant' is worthwhile is a touch questionable...

## Melting Moments

This is, I suppose, 'one up' on the 'Sticky Moments' just described. 'Melting in' metal components is a quick, clean and versatile technique for adding detail but, for obvious reasons, it's one fraught with potential hazard; the soldering iron that slips and digs into the wagonside (not to mention the damage done to the tip of any intervening finger) is not to be taken lightly. However, there are some precautions that will help to avoid this sort of mishap, while mutilating bits of RTR wagon body with a soldering iron can actually be a useful technique, as we will see under 'distressing' in a page or two.

The commonest item calling for 'melt in' is the ubiquitous grab iron, of which there are more about the average wagon body than you might credit. Fortunately, these are not too difficult to replicate, as I hope the little photo-sequence shows. The real secret is to have one 'leg' of the grab iron a millimetre or so longer than the other; this means that, initially, you only need to worry about accurately positioning the 'entry' leg, as once this is in place, the grab iron is secured, making it relatively easy to align the second, shorter leg. A card 'spacer' of appropriate thickness will help you to get the grab iron the right distance out from the wagon side, and will also offer some protection should the soldering iron tip slip. This is more likely to happen if you try and push too hard – it's best to let the wire get hot enough so that the plastic melts properly, when gentle pressure is sufficient to push the grab iron home. It's also safer to deal with one end of the grab iron at a time, seating the thing home in a series of alternating small instalments rather than one 'big hot hit'.

Other dangers to watch out for include the grab iron that tries to 'fall over' and lie flat on the wagonside, rather than going in at the required right angle – see the sketch for a graphic illustration of this particular

SPACER – CARD, OR, BETTER STILL, FORMICA.

*Melting-in a grab iron, using a 25W antex iron and a spacer filed up from a scrap of Formica laminate.*

hazard, and the little jig that can help avoid it. Once again, more general protection for the wagonside can be offered by some masking, although in this case I find it's best to use thin card (Cornflake packet is ideal) taped in place, rather than relying on conventional masking tape which is adversely affected by heat. To act as a guiding/gripping tool while melting in detail, I find that the fine pointed jewellers' tweezers are best, as they don't act as a 'heat sink' and steal all the 'oomph' from the soldering iron, which even the finest nose pliers are apt to do.

The other essential to successful melting in of detail is to make sure that you are getting good heat transfer from the tip of the soldering iron to the component being heated. Which means a clean, well-tinned bit wiped free of excess solder. Trying to accurately control the heating of small components is not aided by some blackened, pitted wreck of an iron, covered in the crud of the ages to act as both an impediment to the heat flow and a source of inconsistency between one part of the bit and another. What *is* helpful is a relatively small tip diameter on the iron, so that you can really see what you're doing; if your iron is of the variety that can take 'quick change' tips, as my 25W Antex does, then it may be worth acquiring a spare bit of suitable diameter (I use 3mm) and modifying it with a couple of non-slip grooves, as in the sketch, producing a dedicated 'melt in' bit.

Besides grab irons, other details that benefit from the 'melting moment' treatment include pipework, especially on some of the modern air-discharge and tank wagons, and lifting eyes or securing bolts/eyes. These last are especially useful on wagons which are to be loaded with items which call for proper roping. I'll be dealing with the actual roping in Chapter 6, but the rope-eye made as in my sketch here is robust enough to be used for its intended purpose. Lamp-irons don't figure on every wagon type, by any means, but were fitted to some vans and other vehicles which could end up as 'tail traffic' on passenger trains. Prototype photos will suggest whether they're appropriate, while the sketch shows how I reproduce them from fine brass strip (John Flack's 1mm × 0.2mm – see 'sources' index).

Not all pipework detail lends itself to the 'melt in' treatment, particularly if it is relatively complex and involves joints, valves and other features. Here, I find, it's best to build the thing up as a sub-assembly away from the wagon, and then to install it by gluing it into suitable holes, or by making it slightly 'springy' so that it will stay put of its own accord. The most satisfying way of producing this pipework detail is by soldering together suitable wires, adding flanges from fuse wire wrapped and soldered and handwheels either from etchings, or from Cambrian's useful little sprue of moulded wheels. There are some examples of this sort of work in Chapter 7.

## Adding Cast and Etched Detail

I've got to admit it, I'm a sucker for all those seductive little packets of metal detail parts that firms like ABS and Kenline

*A melted-in lamp iron from brass strip. The iron was only cut free from the length of strip after melting-in.*

*Melted-in eye bolts make functional replacements for the moulded versions on the LMS 'Low-fit'. These eyes were used to rope the 'load' on.*

*Detail pipework for the Hornby TTF tank wagon was fabricated from thick wire on a brass sheet base, ready to stick in place below the wagon chassis.*

*'Aladdin's Cave'*

put out. I have several drawers in the workshop storage cabinet bulging with buffers, brake gears, roof vents, vacuum cylinders, pipework, axleguards, door bars, end vents and heaven only knows what else. I never take too much notice of what the label on the packet actually says the bits inside are for – if they match up to what I'm seeing in the prototype photograph, then they get used. I'm just as bad when it comes to plastic detail – I can never resist Ratio's 'scrap mouldings' box at shows, and find things like their roof vent sprue invaluable.

There are some truly gorgeous etched wagon parts appearing these days, but I find that, in the context of RTR-based wagons, they are sometimes a bit *too* good; items like the brake gears produced by Mike Clark's 'Masokits' (made, apparently, for masochists, which lets me out...) which are exact replicas of their prototypes down to the last adjustment hole in the linkage, tend to make *any* moulded plastic brake gear look crude. But more general components such as the 'Basic' V-hangers and brake shoes produced by D & S Models, I do find very useful.

Quite a lot of the etched components I use to upgrade the bodies of RTR wagons are not actually intended for this purpose; D & S Models have a fine etched signal ladder that is just the business for replacing clumsy moulded plastic access ladders on tank wagons, covered hoppers and the like, while the etched chequer-plate available from a number of sources makes wonderful walkways and decking on a lot of modern wagon types. I often fix ladders using 'melt in' techniques but if this isn't

possible, I use spigots and holes, securing finally with epoxy resin adhesive.

Fitting most of this type of detail work is a case of gluing it in place in some way or other. However, I like to make my models reasonably robust, so if I'm going to glue, I do like to ensure that there's enough surface area in contact to ensure a good bond. This isn't always so with small cast details, and where this is the case, I may opt to fit a spigot or even a small screw. This entails drilling into the casting to get reasonable purchase for the spigot (a peg intended to fit into a hole as a form of fastening or screw) which is then secured with suitable adhesive – I find the 'Gel Cyano' very good for this. A locating hole is drilled in the side of the wagon body, and the spigot retained with more adhesive or, in the case of a screwed spigot, by an appropriate nut in-

side the body. The sketch should make all this clearer, and an example of the use of this technique, to install the side 'marker lights' on the LMS 20T brake van, appears in the 'Examples' chapter.

One other system for securing detail, that works well on RTR plastic bodies, is the use of a wire 'tie' as, once again, illustrated in the sketch. The tie is of 5amp. fuse wire, wrapped around the item to be secured, then twisted into a tail. This then forms a spigot which can be inserted into a suitable hole drilled in the moulding, being retained by bending over the 'tail' inside the body and securing with a drop of Gel Cyano or Epoxy. Otherwise, chunkier castings or flat details with a good surface in contact can be attached with contact cement such as UHU, which is fine for things like roof vents, air tanks, hatches and so

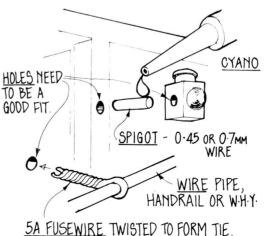

HOLES NEED TO BE A GOOD FIT.

CYANO

SPIGOT - 0·45 OR 0·7mm WIRE

WIRE PIPE, HANDRAIL OR W·H·Y·

5A FUSEWIRE TWISTED TO FORM TIE.

*Introducing imperfections helps the realism of moulded plastic wagon bodies, whether it be a spot of craft knife 'graining' or soldering iron tip 'dents'.*

*A typical 'refining' operation is the reduction in the visible thickness of wagon sides, achieved by tapering the edges.*

on. The dodge already mentioned in connection with buffers – 'helping' the joint by introducing a spot of solvent to soften the plastic being glued – is just as relevant to the attachment of body fittings. And, of course, it goes without saying that *all* of these detail-adding and fixing techniques, although described in the 'body' chapter, are just as relevant to the re-working of wagon underframes.

**'Distressing'**

Thus far, I have been considering the alteration and adaptation of RTR wagons in what might be termed an 'ex-works' context. In any wagon fleet, obviously, there will be some wagons that are in 'new' condition, and which will thus need to be finished to suggest that they haven't as yet seen much service. But, assuming realism to be the aim, most wagons will be in a less pristine condition. The state of any individual wagon will be determined by the use to which it had been put as much as by age. Mineral wagons, for instance, have a hard life, and are loaded and discharged by means that are far from 'kid glove'. They will, therefore, tend to deteriorate faster and further than, say, a ventilated van in perishables traffic.

What we are really talking about here is damage, the sort of run-of-the-mill minor defects that do not affect the serviceability of a wagon, but do affect its appearance. Broken planks in the sides or flooring of wooden wagons, boards that have been replaced (but often not repainted) or even boards that are missing altogether, dings and dents in the tops of steel mineral wagon sides and dents and scores in the sides themselves; and load-inflicting damage to the decking of implement wagons

are amongst the scars collected in everyday service. Replicating these sorts of imperfections makes for model wagons that are both realistic and individual. The techniques used to introduce these sort of effects are known as 'distressing', a term that has long been used in America to describe methods of taking away excessive perfection from modelling materials.

Examples of distressing techniques might range from simply scraping a smooth plastic surface with a knackered craft knife blade to suggest wood-grain, to carving out whole chunks of material, gouging and abrading surfaces to replicate rough-treatment damage. The process is of course, carried on in the paint job, and it is astonishing just what a difference can be made to a model wagon fleet, to have different examples, of similar wagon types, exhibiting individual 'battle scars'. Really, there are no hard and fast rules as to how to go about this sort of licensed vandalism – I've had endless fun playing around with scrap wagon bodies to find the best way of obtaining a particular effect.

Most often, though, I find that the tip of a craft knife and the bit of the soldering iron can be used to represent the commonest types of damage. Really, it's easier to illustrate than write about, so that's what I've done in the photo sequence alongside, where I'm roughing up a wooden PO wagon and positively marmalising a 21T hopper. In both cases I am basing the maltreatment on photos of 'in service' wagons. The actual process of inflicting the damage needs to be carefully done, if you'll pardon such an apparent contradiction in concepts! I work quite slowly, building up the treatment to arrive gradually at a convincing result. I often combine the modelling and painting aspects of 'distressing' in

one operation, although I describe the paintwork in the next chapter. While it's rather fun to produce the odd 'rolling wreck' do bear in mind that most wagons will only exhibit a very limited amount of minor damage, and anything that would render the vehicle dangerous in service would result in a red 'not to go' label and a trip to the wagon repair works, if not a visit *from* the emergency repair team.

**'Refining'**

A sort of opposite operation to the above, this is the term I use for the business of taking away the 'thick and clumsy' look that some plastic mouldings can exhibit. The kind of thing I have in mind is over-thick wagon sides, thick edges to roof overhangs or 'L' and 'T' strappings, and chunky moulded detail such as ladders or, on the wagon chassis, brake gear. Much can be accomplished in the elimination of such eyesores by scraping down the plastic with the edge of a craft knife and finishing off with files and the sanding block or rubbing stick. Ladders and such like usually have a pronounced tapered 'draft' on them to assist in mould release. This means that components which may well be to scale dimensions on their front face are considerably oversized when viewed overall or, particularly, in silhouette. Carefully filing the sides of such mouldings flat will make them look a great deal more delicate; I find you can often thin such details 'front to back' as well, which can also help rid them of excessive visual 'heft'.

## 'Cutting and Shutting'

Thus far, I have been dealing with minor cosmetic improvements and alterations on wagon bodies that are fundamentally correct, or at least acceptable, in their dimensions. Among the RTR ranges, however, there are quite a few aggravating instances of models which, while accurate in detail, incorporate fundamental errors in their proportions that offend the eye. I've already mentioned the Hornby BR 'VEA' van which, being too short, looks too 'tall'. Replica/Bachmann have a couple of bad examples of the opposite, where bodies have been 'stretched' to fit an overlong underframe. This sort of error can sometimes be corrected, by taking a slice or two out of the body moulding, then joining the bits back together. This process, applied by our US cousins to cut-down cars for 'hot rodding', is known graphically as 'cutting and shutting'.

Whether or not you can successfully accomplish such drastic surgery on an RTR wagon body depends, I find, on two things. Firstly you need a subject free from diagonal strapping or other features that will no longer align when a slice is taken out of the middle – which is why I've never found it worthwhile trying to take that excess foot out of the otherwise splendid Airfix/Dapol RCH-type PO wooden wagon body. You wouldn't do a lot for the lettering either, come to think of it! The other consideration is to look for a subject with 'natural' vertical lines, where it will be relatively easy to disguise the joins involved on re-assembly. Fortunately, both the Bachmann examples I had in mind, the 16T steel mineral wagon and the BR 20T brake van, do qualify on both these counts, and can be successfully truncated. In case you are wondering, the joining positions would be either side of the doorpost uprights on the mineral wagon, and among the vertical plankwork of the brakevan side.

Some wagon bodies incorporate distortions within the detailing of a correctly dimensioned wagon body. Masters of this particular nonsense are, once again, Hornby, who, using a 16ft. 6in. underframe, actually produce an RCH pattern PO wagon body of correct overall dimensions, but with a doorway two feet too wide, and consequently the rest of the wagon body sides are too short which, in turn, makes the diagonal strapping run at too steep an angle. Don't ask me why... The end result looks, as the photo shows, most odd and renders the body useless for scale conversion; it would be easier to take that foot out of Dapol's body moulding than sort out Hornby's doors.

### Filling and Dressing

The last class of general improvement I find I need to tackle on RTR wagon bodies is the expunging of any evidence of mould part-lines and the assembly of composite mouldings. Part-lines are not usually a problem on wagon bodies, seeming to be more prevalent on underframes, particularly buffer beams. If present, they are carefully scraped off with the side of a sharp craft knife blade and smoothed down with rubbing sticks. The joint lines of composite bodies (bodies assembled from several

*Hopeless case; whilst the overall dimensions of this Hornby PO wagon are correct, the door is far too wide and the underframe is totally fictional.*

individual parts, as in the two tank halves visible in the photo of the Hornby 'Traffic Services' tank wagon) are often not apparent, being disguised by overlaid detail, or occurring on parts of the model not normally visible. Where they *do* show, though, they can be a real visual intrusion, as on the Hornby wagon illustrated – these tank-ends are, in reality, a one-piece pressing and are characterised by their 'seam free' nature. Getting rid of this crack makes a big improvement in the look of this wagon, as the picture of the finished job in Chapter 7 will hopefully show. The filling was accomplished by, firstly, cementing the two halves of the tank together with 'Daywat Poly' then filling the crack with a trace of 'Milliput'. The whole thing was allowed to dry thoroughly before being carefully smoothed down with 240 grit wet and dry paper used 'wet' (dipping it frequently into a small bowl of water).

### Paintwork Damage

Many of the operations described in this chapter will result in at least some areas of the factory-applied paint job (often one of the best aspects of RTR wagons) being damaged. Obviously if a total repaint is in prospect, then there's no problem, but on most occasions it will be necessary to restore the finish of the damaged areas to match the existing paint. This is not actually that difficult to do, especially in the context of a weathered wagon, where the unifying action of the weathering process almost always hides any slightly imperfect matching of touched-in areas of paintwork. I cover the actual techniques in the next chapter, but the point that I'm making here is that it *is* possible, and that fear of messing up the paint job should not really have to stand in the way of carrying out the far more significant improvements that the re-detailing and modification work can bring. There's no doubt, though, that a wagon at this stage, after butchery, but before painting, can look pretty awful. All the more reason, then, to hurry on to Chapter 5, where we can cloak all these multitudinous sins in a forgiving coat of paint...

*A classic case for the filling and dressing treatment is the awful crack up the end of the Hornby TTF tank. The two moulding halves are cemented with Daywat poly, then the crack is filled with watered-down 'Milliput' and sanded smooth.*

*This Wrenn-based ex-GW 'Mica B' reflects the air pollution prevalent in the 1950s era for which it is finished. This is a 'complete' paint job – the Wrenn body comes in a horrid shade of seasick green, not a prototype livery to my knowledge!*

**This Trix-based RCH PO wagon has had its factory paint pretty well worked over to represent run-down wagon post-Nationalisation condition, complete with 'bare wood' replacement planks.**

# PAINTING AND WEATHERING

**Equipment and Materials**

Fear not, fear not – there are no airbrushes, spray booths or other bits of fancy and expensive kit lurking in these pages. It never ceases to amaze me just how besotted some people – particularly Americans – become with airbrushes. I can't be fagged to spend ages fiddling around masking up 98% of some model or other just to be able to – zzittt! – spray the other 2%; a bit that, like as not, I'd have whizzed over with a brush in half the time it's taken to type this sentence. Contrary to some opinion, I don't rate the airbrush much as a weathering tool either. I accomplish virtually all my RTR wagon work with a couple of watercolour paint brushes and Humbrol's excellent 'hobby acrylic' range of paints. I use the same paints for weathering, with the addition of coloured chalks and Carr's 'weathering powders'.

Brushes first. For this sort of work, you most definitely do not need to blow great-aunt wotsit's legacy on high-quality artists watercolour sables. Synthetic brushes are just fine, and for several years now I have used the Daler 'Dalon' range, series D77, which have nylon bristles. I find I use a smallish brush – No.0 or 1 – for the touching-in and detail work, with something a bit more meaty – a No.2 or 3 – for chassis painting, roofs and other larger areas. The other brush that is useful for weathering by 'dry brush' technique is a small flat type, the D88 series in Dalon's range; I use a No.2. The only sable that does appear in the inventory is a real 'tiny', a Rowney

series 40 No.000 for lettering work, and picking out really small details such as solebar wagon plates.

For paints, I use Humbrol acrylics virtually exclusively. The only exceptions are the white designers colour that I use for hand-lettering (easy to expunge mistakes) and another Humbrol product, aerosol spray cans of their 'Krylon' matt black that I use to spay complete wagon underframes where I can paint these as a separate item. For some odd reason, modelshops don't seem to stock 'Krylon' paint, although I have come across a spray can of Humbrol 'Model Black' which may very well be the same thing. I get my 'Krylon' from the local craft shop, along with all the other materials and brushes listed. If you get stuck, they are in the 'sources' index. One last product I find useful to protect lettering in designers colour or chalk/powder weathering is matt watercolour fixative, which is a meths-based vinyl compound. The one I use is by Windsor and Newton, and comes either in a little bottle to 'spray it yourself', or in aerosol cans. Ordinary artists fixative, which is a bit cheaper and very readily available in aerosol, would be fine if you haven't got any designers colour lettering to waterproof.

**Paint Colours**

But what, I hear you cry, of all those seductive little pots labelled 'LNER this' or 'GWR that' (and which seem to cost an arm or a leg)? Well, I'm afraid that I'm not in the least interested in what the paint-maker

Given that one of the chief virtues of the modern RTR wagon is the superb standard of finish that most of them exhibit, then the chief concern of a paint job in the context of this book is to make good any blemishes caused by modifications, to 'blend in' any new detailing, and to enhance the factory finish. Once again, we do find a distinct 'cut off' in finish between the two halves of many RTR wagons, with the body fully painted but the underframe left in raw plastic. The limitations of the moulding process may also result in an unrealistic colour split, in that parts of the underframe that should be finished in 'body' colour are left in raw chassis black which will, in itself, often consist of an unrealistic, intense, shiny 'plastic black'. Even if all other aspects of an RTR wagon are to be left alone, there is almost always scope for a bit of subtle work with the paintbrush.

So, initially, we're concerned with touching-in body colour, and perhaps extending it to parts of the chassis that factory paint-jobs cannot reach. Which means that we are into the business of colour-matching, not always easy to do, and an absolute pig to describe in print! In addition, we need to be able to realistically paint underframes, wheelsets, roofs and other bits of wagon anatomy that the factory either ignores, or makes 'too perfect' and certainly too uniform. Then, finally, we need to add that stage of the finish that sets out to replicate, not so much the prototype's paint scheme as what the environment *does* to that paint scheme – the subtle business of weathering.

chooses to call the colour he puts in any given little pot; all I'm interested in is whether or not it will serve for what I want to do with it. Certainly, in the context of touching-in RTR paint jobs, where we will almost certainly be mixing to obtain a matching shade to the factory paint, you might just as well start out with a few basic colours and mix from them, rather than buying umpteen pre-mixed colours which are only slightly different from each other, and equally 'slightly different' from whatever Dapol (or whoever) have come up with!

The Humbrol acrylic range contains a lot of very useful colours which, while they may not be intended for painting model railway wagons, are eminently suitable for that purpose and can be very readily inter-mixed to get good colour matching. They also have good covering power, go on very nicely by brush, and are water-based for easy thinning and brush maintenance. I find that I make use of 10 basic matt colours for wagon work. Firstly, and most obviously, are black and white, Humbrol Nos.5033 and 5034. I buy these in the large 30ml. size, which only costs about a third more than the normal 12ml. potlet. For the rest of my basic pallet, I have three primary colours – yellow 5024, blue 5025 and red 5060, plus a green, 5030. The remaining four colours are all shades that approximate to 'standard' wagon colours: light grey 5027, a good LMS/BR wagon grey; 'earth' 5029, a basis for a lot of 'dirty' weathering colours and a starting point for SR wagon brown; 5067 'Panzer Grey', not very far from the GW shade, and 5070, a 'brick red' colour that gets you well on the way to a lot of the red oxide (PO wagon) and bauxite livery shades, as well as doing the business where a spot of rust is required.

You will notice that there are no primers of any sort in the list so far. In the context of painting RTR wagons, they are rarely needed, as the acrylic paint will both cover and adhere to the plastic moulding without need for any sort of priming. However, where we can – quite literally – come unstuck is in trying to paint bare metal with acrylic paint, when the adhesion is pretty marginal. I use two approaches to keep paint on such surfaces, either pre-blackening the metal with a proprietary compound such as Carrs 'Metal Black' or liquid gun blue, or by priming metal parts with a cellulose primer, brushed on. The main component calling for priming is the bare, shiny silver axle of some replacement wheelsets and the Dapol/Replica/Bachmann wheels. Well, when did you last come across a prototype wagon with a chrome-plated axle? I generally use ordinary grey cellulose car primer for this type of work, spraying a small quantity into a container – empty film canister are good for this – and then brushing it into the axle, grab iron or whatever. I try not to use my best 'front line' brushes for this, although Daywat Poly will clean them pretty thoroughly if you haven't any older, slightly tired specimens about the place.

I don't find it necessary to prime white-metal detail castings, as the slightly porous nature of their surface seems to provide plenty of 'key' for the acrylic paints used direct. The only other time I find I need to

*Colour matching. Trial patches on the bottom of this Mainline 'Moy' coke wagon helped me to arrive at a good match for the buffer beams and buffers.*

use primer in any quantity is when I am intent on repainting a wagon completely, when a spray coat of grey acrylic primer serves very nicely to 'blank out' an unwanted factory-applied livery and give a good basis for the application of new livery colour. This is particularly useful if you are 'rehabilitating' one of the fictitious liveries that so many RTR wagons seem to come in. The BR fitted 12T van on the front cover, for instance, started life as a 'Persil' liveried van in green and red – not exactly a colour scheme often encountered about the freight yards and byways of steam age Britain.

## Colour Matching

This is really the key to RTR wagon painting, in as much as we are only concerned with making-good small areas of paintwork, rather than with total repaints. While, ideally, close matching is required, in practice there is a fair bit of leeway before less-than-perfect correlation becomes obtrusive. Apart from the fact that we're dealing in small areas of colour, which don't 'register' to the same extent as a larger patch might, we are intending (I hope) to overlay the basic finish with some degree of weathering, which is a great help in unifying the overall 'look' of a wagon. It's also worth bearing in mind that, unless the

wagon is being modelled in 'ex-works' condition, then slight variations in colour due to touching-up are quite prototypical!

So, how do you go about mixing paint to match an existing shade? This is, in fact, a very complex subject, and does depend to some extent on variables such as lighting and an individual's colour perception. However, I'll do my best to set out a sort of 'rule of thumb' approach, although I must stress that even in the most expert of hands, this is still a process of trial and error. There are no magic formulae, and very few short cuts. The basis of colour matching lies in an appreciation of the effect of adding certain 'tints' to an existing colour. This is the basis of the 'colour wheel', with which all art students are only too familiar. It's not really possible to expound too far on such basic colour theory here, especially in the context of a book illustrated in black and white! However, the most relevant thing to remember is that a neutral colour, such as grey, can be 'shifted' (either way, in terms of warmth) by adding red, to make it warmer and bring it nearer to a brown, or by adding blue, which will take you through air force blue-grey to a cool blue. Adding black to our neutral shade will, of course, darken it (but without changing the degree of 'warmth'), while white will lighten the shade in the same way. Technically, a shade is a 'par-

*Just painting buffer beams and buffer bodies in body colour is a huge improvement on RCH-type wagons.*

ticular gradation of a given colour' – it is varied by adding neutral tints, a tint being a colour added to another colour for the purpose of altering the colour of the first part, if you follow the drift... Neutral tints are, basically, black, white and grey; all other tints are non-neutral, and change the actual base colour as well as lightening or darkening it.

I hope that last paragraph made sense, as it should provide some sort of 'grid reference' to help you decide where a particular colour stands in relation to the one you're trying to match. In terms of the good old RTR wagon body, I find that the best approach is to make use of a hidden (in the context of the finished model) part of the body to conduct colour-matching trials – the bottom of the body moulding itself is usually at least partially sprayed in the livery colour, which gives you something to go on. So far as wagons go, for most of the time we're looking at a shade of either grey or red oxide, with occasional whites. These are colours represented in the basic selection outlined a page or two ago, so the obvious thing is to start with the nearest shade to your RTR wagon from among that selection. To this end, you may find it useful to put a 'stripe' of each of these colours on a piece of Plastikard to aid basic matching-up, making a sort of basic 'reference chart' with which factory paint can be compared. Having selected the starting point for your 'mix', you are ready to cut loose with the potlets in search of that perfect match. But first, a word on paint mixing techniques and on lighting...

## Paint Mixing

'Mix the contents of the tin thoroughly' is the most familiar piece of advice in relation to painting. If I were more of a cynic, I might suspect that such advice originated with paint manufacturers, who know that once fully mixed, paint starts to deteriorate and its shelf life is substantially reduced... This is not so much of a problem with acrylics as it was with the old oil-based enamels, but why spend ages mixing up a whole dratted tinful of paint when you only need a few drops? Far better, say I, to extract a brushful or two of pigment – from the bottom of the pot – and a like amount of 'body' or varnish – from the top – and mix them in some suitable container. I use foil bun cases (from Bakewell Tarts, yum-yum) or those little pots that milk and cream come in (usually UHT, yuk-yuk) at restaurants of the baser kind. Apart from all other considerations, portioning out pigment and body separately allows you to vary the 'density' of the paint, to give greater covering power where required. On a cautionary note – in some acrylics, the pigment may be settled into a fairly solid mass in the bottom of the pot, in which case trying to spoon it out with a brush will do the brush no good at all. I use a small plastic spatula as used by dentists for mixing amalgam, but any small stiff implement will do, so long as you can hoick out a lump of pigment into your mixing-pot with it.

The same technique is used for additional colours being added to the brew in the pot. Strictly speaking, one should clean out the brush between dips into the various paintpots, but I'm afraid I don't bother. I

have the whole lot uncapped in front of me on the bench, and dart and dip hither and thither as the occasion demands. Surprisingly, these heathen proceedings do not seem to result in contamination of the basic colours in the pots, except possibly white, which may warrant a waggle in the water jar and a quick wipe on a tissue. Always proceed on the basis of 'a little can be made more, but a lot can't be made less' – it's awfully easy when mixing to match to end up with about ten times the quantity of paint you actually need, owing to corrections for slightly excessive additions of this or that adding ever more paint to the brew. On the other hand, if you don't want to go through the whole process twice, make sure you mix *enough* for the job in hand...

## Let There Be Light

Conventional wisdom has it that colourwork should always be done in either daylight or 'daylight balanced' light. For real accuracy, this is certainly true, but in the context of a 'near enough' match on a wagon which will almost invariably be viewed under artificial light, then I find that same artificial light – specifically, tungsten light from an ordinary bulb – will do to match by. What is important is to have good illumination to work by – you can't attempt any sort of a colourmatch in sepulchral gloom. The normal workbench anglepoise with a 60W bulb should suffice. If, of course, you can work under natural light, then it's much better to do so; wagon painting out in the garden of a bright spring morning, with the birds a-singing' and a good cup of coffee to pull at between dips can be counted as one of life's little pleasures, I feel.

## Trial and Error

Right, to business. Mix up a spot of your chosen 'starting point' colour, and paint a small patch on your trial portion of wagon. Let it dry – or blast it with a hairdryer if, like me, you're impatient – and compare with the reference. Decide, first, whether the shade is too light or too dark. Add a spot – and I mean a SPOT – of white or black as appropriate. Paint another test patch, dry and compare. When you've got the shade about right – and it really isn't that hard – then you can start to tint for the correct colour. Compare your test patch with the original on the basis of its red content. Is it warm enough, or is it already 'redder' than the original? If you really can't decide, then it's probably about right. Ask yourself the same question in relation to blue and to yellow. Blue is, I find, the hardest to judge – but in terms of wagon livery colours, I find it's rarely very significant.

Adding blue to a basic red oxide mix will result in a tendency to a plum purple-red that is actually quite good for a lot of the deep red PO wagon liveries. If you want to stay with an oxide/bauxite shade, but need it to be less rosy, add blue and a spot of yellow, which will move more towards a brown. If your red oxide is not orange enough, then add yellow, with maybe a spot more red to keep it from getting too ochre. I find that, to match a lot of 'bauxite' shades on RTR wagons (and boy, there are

plenty to choose from – RTR makers aren't any too consistent in the exact shade they use, as, of course, BR wasn't) then the basic Humbrol 5070 'brick red' needs a good spot of yellow, a dab of red and touch of black to 'bring it back a bit'.

Greys are generally easier to match up than the red/red oxide shades. The 5027 light grey is very slightly on the warm side of neutral, but a lot of PO wagons and the light grey BR/LMS shade were a touch warmer still, and a mite paler. So it's a tiny spot of red or red oxide, and then a dash of white to make it a shade lighter. The characteristic GWR dark grey is actually a fairly blue shade, and I find that the Humbrol 5067 panzer grey needs a touch of blue, a tiny spot of black, and perhaps a hint of red to match the Replica/Bachmann shade. Roof greys are, of course, a lot less critical. I generally repaint entire roofs rather than trying to touch-in detail, and I'll often paint even unmodified roofs to get variety.     As I think will have become apparent, experiment is the order of the day in colour matching. With practice, it's surprising how close you can get to 'factory' shades, but as I keep stressing, absolute accuracy isn't essential. The only general caveat I would add is that, by and large, it's best to err on the 'too light, too blue' side rather than being over-dark and inclined to the more strident red. When applying your final 'mix' to the wagon, be sparing with the paint, and try to 'feather' the edges of your patch. Don't use the paint too thick – one of the snags with acrylics is their rapid drying time, and they start to cure quite quickly, calling for frequent additions of small quantities of water to keep the paint flowing freely from the brush. It's also a good idea to keep washing the paint out of the brush, particularly from the roots of the bristles where it tends to accumulate, causing the brush to clog and loose its suppleness. If you get a brush really clogged with acrylic paint, dip it in the 'Daywat Poly', let it soak for a moment or two, re-dip, then wipe on a tissue. The results are astounding! The crud of ages removed in seconds.

## Plain Painting

Thus far, I've been concerning myself with the ticklish business of 'making good' the basic, factory-applied paint job of our RTR wagons. There are other paintwork matters to attend to, however, which are concerned more with addressing the deficiencies of that factory finish. The most glaring of these is the common practice of painting the body, but not the chassis. Hiding that raw, shiny black plastic beneath a nice coat of a soft, subtle matt black is an instant 'fidelity upgrade', even before we further enhance the realism of the chassis with a spot of weathering. In most cases, I separate the body from the chassis, remove the wheelsets, and spray-paint the whole thing with the Humbrol 'Krylon' matt black. In those cases where this isn't possible or appropriate, then the chassis is brush-painted with the normal acrylics, using a slightly brownish black made by mixing 5033 matt black with a dollop of 5029 matt earth, unless, of course, the prototype wagon is one having a chassis painted in body colour, or a more recent

design using either light grey or aluminium finish on the running gear. It's nice to see that GWR wagons in the 'Hong Kong' ranges do now come with the chassis moulded in a grey plastic to match the body, though I'd still opt to paint it to get rid of the 'shine'.

Most steel underframe wagons do have black-painted chassis – that is, the sole-bars, W-irons, axleboxes, springs and brake gear are painted black. The head-stocks and buffer bodies, however, are almost invariably painted in the body colour, a feature which the factory-applied paint-jobs are unable to cope with. So, here again, a simple lick of paint about the buffer beam can make an instant difference to our RTR wagon. The photograph of the two wooden body PO wagons hereabouts should show the improvement resulting from this minor but telling upgrade. Again, slight colour mis-matches can be 'lost' in the weathering job.

Other 'plain painting' is concerned with roofs – already touched on – and areas like wagon interiors and/or decks. A rake of 'lowfits' or 'conflats' all exhibiting decking of a uniform brown are just as lacking in variety and realism as a string of vans with identical grey roofs – or a train of unloaded opens whose interiors are that same familiar old tan shade. We don't need startling variety – just some slight and subtle variations on that basic shade. Or, better still, some subtle variations on a basic shade that is a touch more convincing in the first place. Weathered, unpainted wood – which is what wagon decks and interiors usually were – is not some rich, uniform shade of brown. Observed from life, it tends to a brownish silver-grey, with influences from the load the wagon has been carrying. Coal wagon interiors have sooty overtones, implement wagon decks are oil-stained, container wagons have rust stains from the securing chains, and so on. Really, this sort of paintwork crosses the borderline into the 'weathering' department, so more in a moment. But, initially, we need to get away from the sort of brown or tan shade that the RTR makers opt for. I mix a brew for each individual wagon to get that slight variety, with the ingredients 5029 earth, a spot of 5033 matt black, and a good measure of 5034 white – the amount depending upon the 'load factor' already mentioned.

### Painting Wheelsets

The other components of wagons so often neglected by the paint-shop are the wheelsets. Even if you're retaining the plastic RTR wheels, their appearance can be considerably improved by painting, while the bright plated Romford metal wheels demand such attention. Even the Gibson-/Maygib wheels, with their black or dark grey plastic centres and blackened steel tyres, still repay attention with the paint-brush.

Painting wheelsets is fiddly, time-consuming and hard on the bristles of your paintbrushes, so I tend to resort to the spray, especially on spoked types. The Romford all-metal wheels need priming to get good adhesion, which I accomplish with an ordinary spray can of grey aerosol car primer. This cellulose paint has good adhesion on metal, but it's nasty stuff and should be used outside if at all possible. The same goes even for the 'Krylon' which is not, as its name suggests, acrylic, but is a xylene-based paint, and demands good ventilation. I tend to paint wheels 'in bulk', suspending them from coathangers by means of wire hooks, as in the diagram, so that I can get 'all round them', spraying front and back of both wheels and the axle. The plastic Dapol/Bachmann wheels just get the 'Krylon' treatment, but the Maygib and Gibson wheels I tend to brush-paint, concentrating on the centres and the faces of the tyres.

It is generally held that a painted wheel-tyre is more inclined to pick up and distribute dirt about the track, and if you're fitting metal-tyred wheels, then it makes sense to clean paint off the running surface of the tyre. This I do by rotating the wheel-sets in a spare wagon chassis 'pared down' to give good access to the wheel-tyres, which are cleaned with a tissue dipped in cellulose thinners or 'Daywat', followed by fine (240 grit) wet-and-dry paper. Tedious, but still, I feel quicker than either brush-painting the wheels or trying to 'mask off' the tyre before spraying. With the plastic wheels, I don't bother to clean treads, as these wheels are just as inclined to pick up dirt 'bare' as they are painted. In truth, I haven't found this to be much of a problem on my American HO layout, on which the majority of the stock runs on similar plastic wheelsets which I paint in exactly the same way.

### Weathering

To weather a wagon, I have often read, one simply mixes up some 'dirty thinners', and sloshes the resulting brew all over the hapless wagon. Well, maybe if you want to replicate a wagon involved in a mishap with a large quantity of dirty thinners, such an approach may suffice. Replicating the look of a real wagon that has been worked under the influences of atmosphere, from the loads it has carried and the track it has run over, is, I would suggest, a good deal more subtle and sophisticated a process than can ever be accomplished by sloshing anything, anywhere.

Observation is, as always, the key. Unfortunately, it is no longer possible to observe the sort of steam era stock that many of us are modelling in regular service, although modellers of the contem-porary scene are thus blessed. So, failing 'the real thing' as a reference, we must fall back on photographs and on some common sense deduction to guide us. A spot of study and reflection will suggest that the weathering effects that we need to reproduce on our wagons are far from haphazard, and result from a number of definite, identifiable influences. Once it is understood what influence causes which effect, then it's possible to undertake a weathering job on a wagon with a fair chance of achieving a convincing result.

Considering a wagon that is 'ex-works', pristine in fresh new paint, what are those factors that are going to degrade that finish to a 'typical' running condition? Well, first off, we have the sun – or, more specifically, ultra-violet radiation from that source, assuming any manages to fight its way through good old British 11/10ths cloud cover! This degrades paint in two basic ways – it breaks down the varnishes, destroying the 'gloss', and it bleaches, fading the colour. A nice, ruddy-red shiny 'bauxite' van will, after a few years, end up a slightly sad shade of rusty pink. Greys can go almost white, greens get 'washed out', and blues fade the most dramatically of all. Only black seems to resist this bleaching action. So, the exact shade that the paint on any given wagon will have reached depends upon the length of time in service since it was last painted. What price now your little pot of 'standard wagon grey'?

The second factor affecting the appearance of our wagon is that of environmental dirt. This comes from two basic sources – atmospheric dirt, basically soot and ash, which arrives from on high and thus tends to accumulate on TOP of horizontal surfaces, and track dirt, either as dust or mud, which is flung up by the wheels as the wagon moves, and is thus concentrated on the lower portion of the wagon, accumulating BENEATH strappings, door tracks, stop-blocks and so on. To the environmental dirt we must add load residue – an accumulation of material reflecting the use or uses to which the wagon has been put, which will add itself to the environmental dirt, especially in the interior of an open wagon, and in the vicinity of the loading doors, discharge shutes and so on.

The third player in the game is the weather, other than the continuing influence of solar ultraviolet. Rain washes dirt off again, particularly from the upper parts of the vehicle and the tops of horizontals. The wind, on the other hand, is more capricious; it can blow existing dirt off, and add new dirt from fresh sources, as well as

I DO UP TO 12 WHEELSETS AT A GO.

*The picture that is worth a thousand words.*

of the rest of the work. This is a technique of having a very little paint on the tip of a brush, used in a very 'dry' state so that the paint will not flow at all, but has to be 'dragged' from the brush by the textures of the model. It is, to put it mildly, not very kind to paintbrushes, so don't use your best watercolour specimens if you ever want to get a point on them again. I use a tired pointed watercolour brush or the small flat brush, and keep them just for this work. The paint consistency wants to be on the thick side, and you need very little on the brush – remove any excess by stroking it on a piece of rough paper towel. This will tell you when you've got to the stage where the brush will just deposit traces of colour on the raised parts of the texture, which is the effect we're after.

Where I need to simulate larger accretions of dirt, I combine drybrushing with the use of a 'wetter' mix of paint, applied with a watercolour detail-painting brush, which is then 'blended in' to the rest of the finish by 'drybrushing out' – using the flat brush without any paint, and dry, to 'drag' colour out from the more solid areas and feather it into the surrounding paintwork; there are very rarely hard edges to dirt patches. The 'wet brush' technique is also used to simulate rust and soot staining or limestreaks resulting from rainwater run-off, and the characteristic 'mud stripes' thrown up wagon ends by the wheels of the adjoining vehicle in the train. Other 'wet brush' effects include small areas of glossy brown-black to simulate oil leaks or spills – don't forget that a lot of axleboxes leaked oil.

The last major technique is the use of dry powders. I tend to produce my own powder by rubbing artists' pastels on a piece of coarse sandpaper, then applying the resulting dust with a soft paintbrush (a make-up 'blusher brush' is ideal, being made for exactly this job, although the normal 'Dalon' brush used clean and dry does quite nicely). The most useful colours are a charcoal grey (not black, which is too 'dead'), an umber/earth brown, a light grey-/brown, red ochre and white or cream. You can buy proprietary weathering powders from Hubert Carr – these are actually ground pigments, and are quite a bit 'fiercer' than pastels, so need to be used sparingly. The powder weathering is always the last job, as it is best to use it over the top of painted work, and then protect the whole thing with a gentle spray of fixa-

redistributing what is already on the wagon. Not only that, but the combined influence of wind and rain can turn dusts into muds which stick firmly to the wagon, forming streaks and smears that can become ingrained into the paintwork. Water run-off may, conversely, wash some areas clean, or carry down soot or lime to put vertical streaks of contrasting colour over grime and livery alike.

The fourth influence is the deterioration of the vehicle beneath the paint. Wood can crack, rot or split open; corrosion can worm its way beneath the finish of ironwork, or spread from damaged areas on steel-bodied vehicles. Minor damage, of the sort described in the section on 'distressing' in the last chapter , will often form the 'centre' of an area of deterioration in the finish of the vehicle. Paint will be eroded from 'wear points' such as door hinges, latch bars, door-bangs and pin-and-peg door fasteners. Loading and unloading operations of the somewhat rough-and-ready nature associated with mineral traffics can strip paint from whole areas of the wagon, and many steel-bodied mineral wagons rusted right out, calling for new sheetwork to be welded in. Rust doesn't just affect the actual metalwork, but, in conjunction with rainwater run-off, acts as a pretty effective pigment, leading to streaking and rust staining of woodwork or adjoining non-rusty metal.

All of these variables are modified by time – length of exposure, number of loads carried, distance travelled – and so call for consideration of the 'age' of a wagon. A wooden-bodied Railway Clearing House PO wagon in 'pool' condition in the BR period would, for instance, probably be pretty decrepit, calling for a lot more in the way of weathering treatment than the nearly new all-steel fitted open next to it. I like to try and reflect a realistic variation in aging and weathering across my wagon fleet – it's too easy to fall into the trap of doing much the same weathering job on every wagon that comes along, to the detriment of realism and variety.

## Weathering Techniques

I use three basic weathering processes on my wagons: thin washes of colour, drybrushed 'highlighting' (more accurately, 'lowlighting') and dry powders. Grotty bits of grubby tissue and the tip of a grimy finger also figure in the application of weathering agents. I use washes, initially, to 'tone down' the livery of a vehicle, taking the sting out of the colours and softening any staring white. Apart from the effect of dulling the paint to simulate paintwork degradation, this wash also helps to 'bring back' the vehicle into the setting of the model railway – equivalent, after all, to viewing the prototype from $76 \times$ the normal model viewing distance. I use a sort of grey-blue-brown mix to tint the wash, to combine a dirtying effect with an 'atmospheric dilution' tint to take away the upfront, close-to nature of the factory paint job. You can let acrylics down to a thin wash with water, which is then brushed over the whole wagon, carefully avoiding excessive accumulations or 'runs'. Use a big brush, and 'brush out' thoroughly. If you get too much on, wipe excess away with a tissue.

I now go over to 'drybrushing' for most

*Designer's colour (gouache) is fine for lettering, but needs protecting with fixative if you don't want to 'weather' it right off!*

tive – use the can from a good way away, or you'll blow all your powder straight off again!

Some interesting effects are possible by combining powders with slightly tacky paint to obtain a real 'textured' finish. A good example is a scrofulous rust patch on a steel wagon; paint the desired area with a dark rust colour, let it go off a bit, then dust on pastel or Carr's 'rust'. This gives a really virulent and pitted patch of corroded metal that is most satisfying. I've done the same thing with china clay wagons, using a creamy off-white paint topped off with talcum powder. Smells lovely!

## Weathering Procedure

Obviously, what you actually do to any given wagon will depend on the particular result you're after. But, to generalise, this is what I find myself doing in most cases, to differing degrees:

1) Wash over wagon with dulling/atmospheric tint, as described.
2) Complete any detail painting, pick out small rust patches, bits of bare wood, lab-

els, etc. Paint on any areas of 'intense' dirt and 'blend in' by drybrushing.
3) Drybrush 'track dirt'. This 'works out' from the underframe. The colour is influenced by the ballast colour, but it is generally a light grey-brown with a tinge of red oxide from brake dust and rail rust. Work from the bottom up, out and away from the wheelsets that are the source. Continue the treatment over the whole underframe and up the lower parts of the body, especially the ends, where the 'wheel streaks' are especially prominent.
4) Similarly, drybrush atmospheric dirt and load residue colours down from the top of the wagon. There's a lot less of this than track dirt, so don't overdo it. Follow it up with a 'highlighting' pass with a much paler shade of the same general colour, to simulate 'wash off' and to emphasise relief detail.
5) Add rain streaks, rust stains and other areas of 'wet' weathering, including paint powder textured patches. Make sure you simulate rain-washing at definite run-off points – ends of door-tracks, rainstrips or horizontal strappings, and at the corners of the wagon generally. Also add stains, oily

patches, patches of fresh paint and similar.
6) Mix up a medium brown/grey touch of red-oxide powder mix, and dust it over the whole wagon, aiming to get a fine 'film' over everything. Add a spot more beneath overhangs to reinforce the effect of 'lodged dirt'. When satisfied, not just with powder but with the whole job, blat on some fixative.

Voilà! One realistic, individual, weathered wagon. The ones I baked earlier are on the cover and in Chapter 7, but for now, here is a little photo-sequence of a specimen 'getting the treatment'. It's actually a very satisfying business, and worth the expending of a couple of scrap cheapo wagon bodies, by way of experiment, to gain experience in the various techniques. Once the bug bites, there won't be a pristine wagon on the property. Let's hope that there aren't too many empty ones, either...

# A BRIEF LOOK AT LOADS

*A bogie bolster loaded with steel sections, chained down with tensioners. If a load like this moves, the consequences can be far from funny.*

Time was when RTR wagons used to *come* with loads. Hornby 'O' gauge tinplate had barrels or crates, pipes or logs; Hornby-Dublo came up with cable drums, containers, tractors and pressed-plastic coal that turned crinkly at the edges. These days, we've got containers – exquisite containers, let it be said – and an amorphous unsecured crate on a (totally inappropriate) 'Lowmac'. The rest are unremittingly empty – and often seem to stay that way.

I could almost write a book just on wagon loads and their replication in model form, but I'm limited to a few pages, so this is going to be a light skit about the more obvious aspects of the topic. The two classes of wagon that look most naked in their unladen state are opens and flats of one sort or another, so that's what I'll concentrate on here. I shall be ignoring 'special' loads, and concentrating on the everyday types of loading. As well as suggesting suitable cargos, I want to touch on the *method* of loading – a topic which engaged the traffic departments of real railways more than somewhat.

## Open Merchandise Wagons

These were once a very common class of wagon, and they were used to carry a very wide range of traffics. They should not be confused with mineral wagons, which are only intended for loose bulk mineral traffic, and hence have a heavier construction – end, bottom or end-and-bottom doors in addition to the normal side doors, and are smaller than merchandise wagons of equivalent payload. Normally, we are talking about the good old 5-plank wooden open, with or without tarpaulin bar, or its latter day all-steel equivalent. The sort of loads carried by such wagons ranged from building materials through crated goods of all sorts to chemicals in carboys or drums, sawn timber, steel wire in coils, hay and feed, sacked goods, pit props, iron and steel castings, liquids and powders in barrels, and some loose traffics such as sand. In a lot of cases, the loads were protected by tarpaulin sheets, and it would probably be true to say that the sheeted open was one of the commonest sights on the steam age railway.

If you opt to model a full-sheeted load, then all you are really concerned with is the sheet and its roping; the load won't be seen and so doesn't need representing. There are, however, a few variables to look out for. Some loads did not come above the tops of the wagon-sides, so the sheet is stretched taught and flat across the top of the wagon body. Other loads assumed a mound, or raised shape protruding above the body sides, so the shape of the sheet will need to reflect the nature of such a load. Where the load is partially sheeted, as in a wagon loaded with sawn timber sticking over one end, then it will obviously be necessary to model the load to at least some extent.

Correct roping and folding of the sheet was a topic to which the railways devoted large chunks of their rulebooks, not to mention sundry notices of exhortation to their staff and a plethora of manuals and handbooks. Observation of photographs will help suggest some appropriate practices. In my little photo-sequence alongside, I am following basic GWR practice (I think!) based on photographs and the Rule Book. The type of sheet modelled here is

typical of the later steam era, in that it has integral ties – but note that these were only intended to keep the sheet itself in place; where the load needed restraining, tie-down ropes would be secured over the sheeted load. I use the excellent printed-paper wagon sheets made by Smiths, and add 'ties' from brown cotton stuck in place with UHU. There are normally at least eight such 'ties', four at the corners and two intermediates on each side. They are taken through eyelets in the sheet edge. There were cleats on the solebars for these ties, while the end ones were often secured around the buffer housings.

Very high loads could not be covered by a single sheet, in which case two were 'doubled', overlapping in the middle of the wagon and with 'crossed over' ends to take up the excess. The partially sheeted timber load is another effective variant, and the arrangement should be apparent from the photo of the finished, loaded wagon. Note the additional ropes securing the load against movement. A further point about wagon sheets is that they were a 'chargeable item' to the customer, and were hired out by the day. Once finished with, they

*The ubiquitous open merchandise wagon, which usually ran sheeted... This one has acquired a permanent sheet and bar – note the fastening points for the sheet.*

*Sheeting a 5-plank open. I use Smiths printed paper sheets and start by adding any ballast the wagon may require. The 'load' – in this case, it's meant to be sacks – is made up of small folded wads of paper hand towel. The securing lines for the sheet are ordinary sewing cotton, stuck to the underneath of the sheet with UHU reinforced with tissue patches. The sheet is secured to the buffers at the ends. I've got this slightly wrong here – the corner pieces with the ties should be outside the top flap, not beneath it. The side ties are glued to the bottom of the wagon with UHU. The final roping secures both sheet and load. I use carpet thread, tied off with straining hitches. Loose ends are rove under the ropes, out of the way. This wagon started life as a 'Harts Hill Iron Co.' P.O. – but it's really a GW-type 12T open.*

were returned to a central depot rather than remaining with the wagon on which they had arrived – so a load of folded wagon sheets is, in itself, a perfectly likely load for an open merchandise wagon.

Unsheeted open wagons do call for some modelling of suitable loads, which can provide an evening's entertainment in its own right. Given that, in many cases, only the upper portion of the load is visible, then there's no need to model the rest of it, and a plastikard 'false floor' or block of wood can be used to 'take up the difference', as in the sketch. It's easy to make such loads readily removable, much as I suggest for mineral loads in a page or so, and I build even 'full depth' loads on a false floor to facilitate this. The illustrations and sketches should provide a few ideas as to the possibilities of this approach. It helps to make the false floor a slack fit, to ease removal, and make wagon/load matching a bit less critical. Fortunately, open merchandise wagons are all "much of a size'.

The actual ingredients of these loads – the drums, sacks, barrels, crates, boxes and so on – come, for the most part, from a wonderful sprue of moulded 'loads' made by Heljan, and available under a number of

MERCHANDISE LOADS.

*Mouldings from the Heljan 'load' sprue.*

*Here is the completed timber load, roped and part sheeted.*

*A load of 'half depth' Barrels and drums on a false floor.*

*A 'mineral' load on a foam sub-base, here being removed by tilting.*

*The 'timber' load, from scrap balsa and spruce on card.*

labels in most model shops. There are usually three sprues to a packet, for about the price of a simple open wagon – for which princely sum you get enough items to load any number of opens! Not to mention low-sides and 1-plank wagons, the odd lorry or two, and the 'stocking' of warehouses, loading docks and industries about the layout. The few things that aren't on that Heljan sprue can be found elsewhere – acid carboys in the 'Merit' range by Peco, some cast loads by 'Gem', and the rest from the junkbox, the kid's toys, bits of wood, plastikard and paper.

In loading an open merchandise wagon, the object is to stop the load from moving, usually by packing it so that the entire floor is covered and the load bears against the sides and ends. You would not find 'half a wagon' loaded to the top of the sides, with the rest of the floor empty. Some loads – the acid carboys, for instance – were packed with straw to take up slack and absorb shocks during shunting. Wooden packing was also used to keep things from moving, but the general technique was to fill the wagon if at all possible. Drums and casks, particularly when lain flat, were often roped to keep them secure, as were sacks. The sheeting of some loads was as much a securing measure as it was protection to ward off the weather.

### Mineral Loads

Minerals are gregarious things, and tend to move about in bulk. It would be unusual to find coal, limestone, iron ore and granite chippings, say, in the same train, so loading mineral wagons is really a case of producing a lot of loads identical in content but different in form. The 'false floor' or load base is, once again, the key to the job. These need to be a pretty good fit in the wagons to avoid an unsightly and unrealistic 'gap' all round the load. To this end, I've taken to making my mineral loads on a base of foam rubber which is quite a tight fit in the wagon. The foam is mounted on a shaped wooden block – from $\frac{1}{2} \times \frac{1}{4}$ inch balsa – and a stiff card backing, as in the sketch. This enables the load to be removed from the wagon by simply pressing down at one end, tilting the load clear of the opposing end. I use a big pair of blunt-nose tweezers to hoick these loads out once tilted – it only takes moments to unload a whole train.

Mineral wagons are usually loaded by some form of overhead hopper or conveyor, resulting in the load assuming a 'humped' form, although this may settle during transit. Very heavy loads, such as iron ore, often end up as quite a small pile in the middle of the wagon floor – make sure you don't overload your wagon for the density of cargo being carried. Mineral wagons are rarely loaded above the level of the sides, which are designed to be high enough to contain the normal rated load. That is why coke wagons, for instance, have extra boards – or 'raves' – above the normal wagon side, to enable them to take a full payload of a low-density cargo. The same is true of other lightweight commodities like wood chips or vermiculite.

Actually modelling the load is best accomplished in two stages – the creation of a suitable 'form' or shape to the load, and

the addition of the actual mineral. I use papier-mâché – tissue soaked in a weak water/PVA glue mix – to build up the shape of the load. I paint this some suitable 'base colour', then coat it with glue – PVA or UHU – and sprinkle on coal, stone or whatever. It may take two or three attempts to cover up all the bald patches. I may also 'weather' the finished load to tone it down in keeping with the wagon. The same basic technique can also be used to create a wonderful load of scrap-iron, a common mineral wagon cargo. The basis of the scrap is wire wool that has been out in the garden for a bit, when it goes all rusty and crumbly. Add in a few bits of suitable painted plastikard and metal, and finish off with a dose of Carr's 'rust' weathering powder for a real iron oxide treat.

As well as minerals *per se*, mineral wagons were extensively used to carry other loose, bulky or heavy traffic. A 'special' case that comes readily to the mind of one who spent much of his childhood in East Anglia is sugar beet, which used to be moved in prodigious quantities in the beet season. Mineral wagons were the favoured vehicle, although when the supply of these ran out you could see hoppers and ordinary open merchandise wagons pressed into service – the latter, I suspect, often running overloaded. I model sugar beet

with little carrot-shaped balls of 'DAS' modelling clay over the usual papier-mâché load former. Although associated with East Anglia, beet traffic was carried in other parts of the country.

*A heavy packing case loaded into an LMS 'Lowfit', using doubled roping to melted-in securing eyes. Note Plastikard strip 'packing' to allow for craning.*

## Lowsided and Flat Wagons

These are quite a large class of wagons varying from 'common use' lowside or 1-plank wagons through 4-wheel and bogie bolsters, well wagons and implement wagons to real heavy duty monsters designed for special loads like transformers or large steel castings. Here, I'm concerned with four main types, represented in the RTR ranges: low-sided merchandise wagons, container flat wagons, bolster wagons and lowmacs/well wagons.

Of these, the most generally used is the lowside open, coded, in fitted form, 'Lowfits' and available in all the Hong Kong ranges. (These abbreviations – Lowfit, Lowmac, Hybar and so on – were telegraphic codes used to describe the different types of wagon, related in turn to loading books which set out the class of wagon required for each different type of traffic). Lowside wagons come in both drop and fixed side versions, appropriate to slightly different uses. Dropsides were useful for loading 'drive on' traffic, vehicles or plant small enough to travel on a 'normal height' wagon without fouling the loading gauge. Hornby-Dublo used to supply a Lowfit with a Fordson Tractor as a load, and this is entirely appropriate – I remember trainloads of export tractors on such vehicles back in my trainspotting days. Other cargoes that might be found on such a wagon include high-density loose traffics such as slates or concrete castings, where the rated load would be contained within the modest height of the sides.

Drop-sided 1-plank wagons were not generally used for containers – indeed, some of them are marked 'not to be used for container traffic' – so that's obviously inappropriate. Containers were, though, loaded onto fixed 1-plank wagons where 'conflats' were unavailable, and this makes an interesting change from the regular combination; the criterion was whether the 1-planker had the appropriate securing points for container hold-down chains, external ring bolts in the headstocks and wagonsides, which we can add to a 1-plank wagon as melt-in detail. The Dapol container is an excellent moulding, while the gorgeously-liveried 'removers' versions in the Replica/Bachmann ranges are almost irresistible. The only snag is, you have to buy the 'Conflat' as well! Dapol will sell you a container on its own.

Other loads carried by low-sided wagons that lend themselves to modelling include large packing cases or crates, pieces of machinery, castings or pig iron slabs, small items of steelwork, some classes of timber traffic and, of course, that good old favourite, the cable drum. I have quite a few lowfits and 1 or 3-plank opens in my fleet, and I have had great fun giving them a variety of loads. The ex-LMS type of fixed side 1-plank converted from the Bachmann LNER dropside – see examples – has a large packing case, from that so-useful Heljan sprue, which is, obviously, heavy. (It is, too, being full of lead to get the wagon weight up to 45 grams!). This calls for substantial roping, and the arrangement shown in the photograph, of doubled ropes secured to the eight ring bolts on the wagon deck (made functional by the melt-in mod) is typical. The ropes are tight,

being tensioned by straining hitches, which are quite possible to tie in miniature – see the sketch.

Proper roping of wagon loads is a difficult topic to cover in a few lines, so perhaps I'd better stick to principles, and suggest that you look at as many photographs of loaded wagons as you can to see how the principles are applied. The main point to bear in mind is that loads in transit are roped so as to *prevent* them moving at all, rather than to restrain and arrest any such movement. In other words, things are chocked, locked, chained or tensioned so that, effectively, the wagon and its load become a single unit. There is no 'slack' in the securing arrangements, so any roping will be tight, and will use ALL the available anchorage points to secure the load in all dimensions; that packing case, for instance, would never be let loose without the fore-and-aft restraints as well as the transverse 'hold downs'. The ropes used are not over-thick, as it's much more difficult to tie off and tension heavy lines; most seem to have been ¾ or ⅞inch manilla, used double or even trebled if the occasion demanded.

Not all loads were roped, as mentioned a moment ago; there were other securing methods, such as chaining down with screw tensioners, the system most often used to restrain containers on conflats. This is actually quite difficult to model, and can take a lot of time. I've used some 40-link to the inch chain (from Sharman Wheels) with screw-tensioners made from wire; they are, in effect, a mini version of a normal screw coupling. There are eight of the dratted things on each container, and I spend longer 'loading' a humble conflat than in building, painting and loading an ordinary 5-plank open merchandise wagon! Chains and screw-tensioners are also extensively used to secure vehicles or plant to lowsides or well/lowmac wagons. Oh for a nice little cast or moulded tensioner...

At the present, none of the main RTR makers have a 4-wheeled single bolster wagon in their range, but the longer bogie versions abound. Suitable loads for bolster wagons include large timber, sawn or in log form, and rolled steel products such as long plate, joists and girders, rail and pipe or tube. The securing of such loads has always been something of a problem, as they are apt to slide sideways on curves, while rough shunting will shoot the load over the wagon end. Such traffic is run at low speed and handled with care! The usual securing method is cross chains and tensioners, but in many instances these had to be augmented with chocks and wedges. Rough timber sometimes had spikes driven into it to prevent longitudinal movement. I've used simple chains and tensioners to 'load' a bogie bolster with a cargo of structural steelwork while my 'lowmac' has end chains with tensioners to restrain its load, an airfield crash tender built from an Airfix plastic kit. Note also the chocks and packing used to mate the vehicle to the wagon. It would not be inappropriate to sheet over a load like this, which would save a lot of work. I'd done the work already, and couldn't bear to hide it!

Packing is the other important element in the realistic loading of most of these 'flat' wagons. It is there for two reasons – to help secure and support the load, and to facilitate craning operations during loading and unloading. That is why the big packing case on the LMS lowfit sits on two timber baulks – how else could crane slings be rigged or removed? Cable drums are 'chocked' with crosswise timbers to stop them trying to roll off during unloading operations, although they are craned with a sling through the centre of the drum, or a special hook-and-bar. Packing is also used to take up excess space between a load and a securing point, to keep elements of a load apart, as in the girders on the bogie bolster (where wooden packing spacers allow for individual slinging of each girder) or to protect the load from the securing chains, which can then be tightened really hard. It's almost always timber of one sort or another, and I model it either with Plasti-kard which has been distressed with a grain pattern, or small pieces of balsa or obechi. It's usually pretty grimy, so I paint it a dark oily brown-grey.

## Loading Summary

I wish I had space to go into greater detail on the whole topic of wagon-loading, as I find it quite fascinating. Once again, it's a wonderful means of adding interest and variety to a wagon fleet. The wagon in itself may not be unique, but the combination of wagon and load most certainly can be! While not ALL the loads described are suited to easy removal or interchange, most of them will oblige, which opens up operational opportunities in the replication of traffic movements that have some real meaning. The loads are related to wagon types, and combining loads, wagons and destinations by means of some from of 'card order system' (a file card-based traffic routing system that determines the destination and loading of a given wagon) can give a model railway a real sense of purpose – and help cut down on the rather aimless style of operating that is so often unrealistic. I have a simple code of coloured dots that I apply to the bottom of my wagon-loads, which tells me which wagon types that load will fit. The same colour-code is used on the 'order card' for each wagon, to ensure that the right 'empty' is sent for the traffic offered.

So, you see, there's a lot more to the business of wagon-loading than may at first meet the eye. Taken in conjunction with the quality and choice of RTR wagon now on offer in our modelshops, there is now the possibility of building up a prototypical wagon fleet that can be loaded and operated in accordance with authentic traffic patterns – but in reasonable time, and at reasonable cost. That, to me, is the great virtue of the RTR wagon and the models that can be so simply derived from it. For a few examples, see my final chapter...

*Long-time RTR favourite, the ex-Hornby-Dublo 'Saxa' salt wagon – upgraded with Ratio running gear, Romford wheels, cast buffers and Rice's 'Nun's Knitting' couplings.*

*The Lima covered grain hopper, cured of its excess height, makes a top-class model.*

# EXAMPLES

Thus far, I have been dealing in generalities and, while it has proved possible to illustrate many of the points made and techniques described, this has tended to be in isolation. The object of this last chapter is to describe, in moderate detail, a selection of RTR wagon conversions ranging in scope from the minor cosmetics applied to the RCH-type 7-plank PO wagon with which I start, through to the substantial 'cut and shut' surgery needed to turn the Wrenn 'Mica B' into a tolerable replica of its prototype. Somewhere in amongst this little selection, you should stumble across at least one example of very dodge, tip and wrinkle that I've mentioned in the text, while there are quite a few that I forgot to mention earlier and will 'slip in' now.

Since a picture, they tell me, is worth a thousand words, then it seemed logical to present these 'case histories' pictorially, amplified with extended captions. So I have exchanged the aged Imperial for the slightly less ancient Contax, and set about the 'bashing' of any number of hapless RTR wagons with photographic interludes. This is, of course, by no means a comprehensive survey of what is possible, and may, in places, reveal my ignorance of certain aspects of the contemporary prototype – for which I will crave a pardon. For, as the Bard says, 'Tis surely better to have bashed and bished, than ne'er to have bashed at all'. Bash on, one and all...

*Two contemporary Hornby wagons, the OAA 45T open and the TTF tank wagon, after varying degrees of reworking to remove the trainset compromises.*

*Pre-dating even the Airfix mid-1970s wagons were the Trix PO mineral wagons that first introduced printed-finish liveries to the UK market. They came on a pretty hopeless underframe but were, praise be, the correct (16ft. 6in.) length, albeit a scale 6in. too narrow, which is not really apparent. They can thus be transplanted on to scale 16ft. 6in. RCH underframes to considerable advantage, as this picture shows. These wagons turn up regularly secondhand, and may be coming back into production from Dapol.*

There are several choices for an RCH 16ft. 6in. underframe, with Peco and Cambrian the main contenders; Cambrian do both wood and steel solebar versions. I lit upon this rather nice cast whitemetal version from Kenline, which is a wooden solebar variant. Kenline make provision for both 15in. and 16ft. 6in. bodies, with cutting guide marks on the backs of the solebar castings. I started by fitting the buffer beams, then trimming the solebars to suit. The castings were glued to the bottom of the body with UHU. Gibson wheels in Maygib pin-point bearings were fitted as I went along, taking care to get the axles square to the body. In keeping with a rather more basic style of PO wagon, I went for single sided brake gear, although the Kenline kit provides brakes for both sides. The basic finished model is shown in the last picture, before I transformed it with an early BR period paint scheme and a pretty comprehensive weathering job.

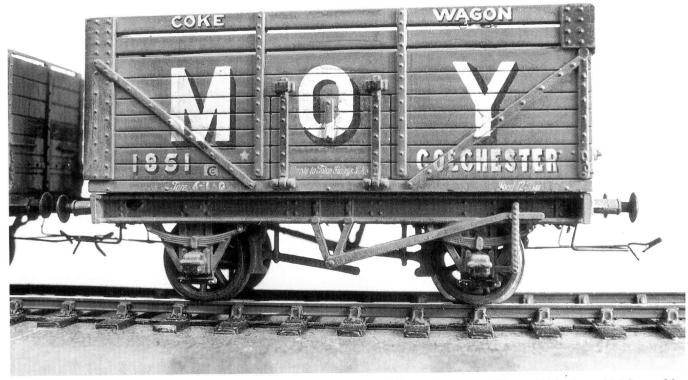

*The 'Moy' coke wagon – without which no East Anglian pre-war goods yard would be complete – started life as a fairly vintage Mainline model. My re-work retains the Mainline underframe, modified to sport Ratio brake gear in line with the wheels, and Kenline cast RCH buffers.*

Modifying a Mainline underframe to get rid of the unrealistic out-of-line brake gear and that superfluous vacuum cylinder is not difficult. All the brake gear with the exception of the V-hangers and levers is cut off, and the two slots for the body-locating tabs opened up into a rectangular hole long enough to accept the Ratio brake gear moulding, which I thriftily salvaged from a Ratio 10ft. unfitted chassis kit built as a 'single side' version; the Moy wagon is likewise braked 'one side only'. The Ratio moulding is cemented in place flush with the bottom of the Mainline floor moulding using Daywat Poly. Wheels are Romford, and the chassis is ballasted with lead sheet to give a wagon weight of 50 grams. A brake cross-shaft of Microrod is added, and the unsatisfactory Mainline buffers replaced with Kenline cast RCH pattern, as described in chapter 3. 'Bringewood' couplers were fitted, and the buffer beams and buffers painted to match the body. The chassis was fully painted, spraying the Romford wheels as in chapter 5. The completed wagon was lightly weathered in accordance with the sequence set out in chapter 5.

Almost as ubiquitous as the omnipresent mineral wagons were the 5-plank, 12- or 13-ton 'Open merchandise' wagons, which usually ran sheeted when loaded. Here is one such – a BR-built fitted version of the GWR design, a very common vehicle, accurately modelled by Dapol from old Airfix tooling. This particular one started out as an Airfix 5-plank PO wagon (Harts Hill Iron Co.), not strictly accurate and a damaged ex-swapmeet 75p. example. The original Airfix underframe was repaired – broken buffers, as usual – and converted to fitted condition using the Kenline cast vacuum cylinder, as illustrated back in chapter 2. Axlebox tie bars are of fine brass strip from John Flack, melted-in to the moulded axleguards, while the buffers have new Maygib heads. The old livery was blanked-out with plastic primer, and a BR bauxite finish applied. The top of one side was damaged, but as I was intending to 'sheet' the load of this wagon, this didn't matter. The actual sheeting process is illustrated in detail in chapter 6. This was another 'cheapie' wagon, the most expensive component being the Alan Gibson wheels.

Here is another conversion of the ubiquitous Dapol 5-plank open, this time as an unfitted version in P4, with single sidebrake gear (though, strictly, I think this should go with a 9ft. WB underframe). The model is pretty well standard Dapol, the only real mod. being the springing of the buffers using Maygib heads and springs. The P4 wheels are by Kean-Maygib, and a measure of compensation is achieved by the use of my 'sloppy bearings and wire pivot' method from chapter 2. This wagon finished up with a part-sheeted timber load, as can be seen in the second picture. The sheet is part-folded back, and the timber is securely roped with straining hitches.

## LOW SIDED AND BOLSTER WAGONS

*'Before and after' examples of the Mainline – now Bachmann – 'Lowfit'. The example on the left has been converted to the LMS fixed-side pattern on a fitted RCH-type chassis. The 'out of the (swapmeet, again!) box' Mainline version has a beautifully finished and very accurate body on completely the wrong type of running gear. We'll see about that!*

This LMS 'Lowfit' started life as a Bachmann body, from their stand at the 1992 Warley MRC Show. This is exquisitely painted and lettered in BR livery as M460648, a fixed side 1-plank wagon on a 4-shoe vacuum-fitted RCH-type underframe with LMS axleboxes. I modelled this underframe by building a Ratio GWR/RCH 10ft. fitted wagon chassis kit direct onto the Bachmann moulding. This is a very common operation relevant to a wide range of 'floored' RTR bodies, so I've described it in detail here. As the Ratio underframe includes a floor onto which the solebars are designed to fit, a spot of modification is in order. I use a craft knife and straight edge to remove the 'top flange' of each solebar, filing the top flat and true as in the second picture. The axleboxes are altered to look like the the LMS type as in the sketch. The underframe is then built on to the body much as Ratio intended, starting with the buffer beams, followed by solebars with wheels – Romford running in Maygib bearings – and the vacuum brake gear. I used the Ratio plastic buffers and vacuum hoses. The chassis was ballasted by gluing a standard Bachmann steel weight below the floor, as in the third picture. It was necessary to trim the Ratio vacuum cylinder slightly to clear this weight. The body modifications were simple but significant. The end drop hinge mouldings were carved away, as were the outermost hinges on each side. The remaining side hinges were trimmed to remove the hinge plates either side of the vertical strap, converting them into non-hinged strappings. New, wide corner plates were fabricated in 10thou. Plastikard with cube rivets, while end stanchions were T-section Plastruct, again with cube rivets. This work is illustrated in chapter 4. The paint job was altered to remove the 'not to be loaded with containers' legend, and the new work was touched in. I added chalk marks, and painted the Ratio chassis and Romford wheels. The whole wagon is weathered, and a load – a large packing case from the Heljan sprue, filled with lead in the cause of ballasting – was added, roped to melted-in eye bolts in the floor, replacing the Bachmann moulded detail. The model was based on a photograph of BR No.M460741 on page 169 of 'LMS Wagons', Vol. 1.

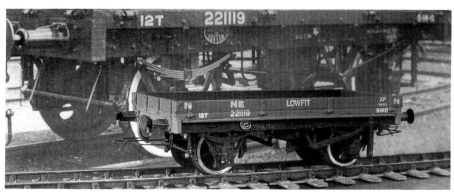

My model of LNER No.221119 is also based on a photograph, of that very wagon, which appears on page 68 of Peter Tatlow's LNER wagon book, which obviously inspired the Mainline model. The prototype underframe, however, is an 8-shoe clasp braked type fitted with the characteristic LNER 3-hanger AVB gear. I decided to build this underframe direct onto the Mainline body, using ABS whitemetal castings for running gear and buffers.

The ingredients of the Lowfit's chassis can be seen here – ABS LNER axleguards, ABS (Fourmost is ABS) LNER AVB gear set, and LNER buffers for fitted stock, Ref. Nos. 505, 506 and 508 respectively. The wheel sets and bearings are from Kean-Maygib.

Solebars and buffer beams are from Plastikard – I used two layers of 50thou. as I didn't have any 60thou. sheet in stock at the time. 4mm. wide strips were cut from 50thou. sheet with a craft knife, and the burrs smoothed with a file. The layers were laminated with Daywat. I started by marking and cutting the buffer beams, drilled (carefully) for the ABS buffers, which have ³/₃₂″ shanks. Too fat, Mr. Swain! As usual, I fitted the buffer beams first. With both buffer beams in place, the solebars were trimmed to fit and cemented in place. The whole bottom of the chassis was then sanded flat on the sanding board, to give a level mounting for the axleguard castings, which were stuck in place with UHU. Once again, great care was taken to get the axles square across the chassis, while the model was set on a glass plate to check that all the wheels touched the deck. The solebar detail – mostly cube rivets and odd bits of strip – was then added, following the photograph in the book. The brake hangers were fitted so that I could make sure that their 'securing bolts' lined up correctly. This type of wagon had an underframe of steel channel, to the inside, which makes life easier! The rest of the brake gear castings could now be added, together with a very simplified version of the pull rods, made from wire as in the photo. The cross rods were epoxy-resined into the brake hangers, and the wires soldered on. Here is the finished wagon, showing a last couple of additions; an extra piece of Microstrip below the bottom 'plank' on each side, to deepen this slightly, and the buffer beam vacuum hoses, which are cut down Ratio mouldings. The paint job was 'ex-works' to match the photo, white tyres and all, so it was simply a matter of matching the bauxite livery on buffer beams, buffers and floor strip, and painting the chassis a suitable shade of 'soft black'. This 'chassis build' sequence is entirely typical of the way I go about providing correct chassis beneath RTR wagon bodies. It is not, I think, difficult, and the results are well worthwhile.

## FRUIT VANS

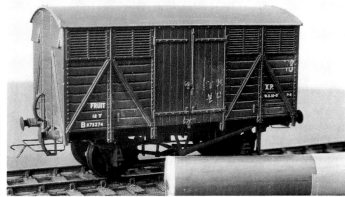

Left. Bachmann's GWR fruit van is a truly excellent model, as is the old Mainline GWR 12T van which spawned it. These are fitted vehicles, and while the latest versions come on Bachmann's 'semi-fitted' chassis, which does have a (very undernourished) vacuum cylinder, it lacks the axlebox tiebars and has the wrong type of buffers. This body is so good that it cries out for a better chassis which comes, once again, courtesy of Ratio. The Ratio underframe fits this body as if made specifically for it, and so is made up exactly as per Ratio's instructions. The only substitution is Kenline GWR 'fitted' buffers, Ref. 542, in place of the Ratio mouldings. Right – I also don't care for pre-printed chalk marks, which Bachmann apply to the BR version of this van. Well, when did you see a rake of vans with identical graffiti? I removed it by buffing gently with a fibreglass brush. Otherwise, the finish is weathered Bachmann, with touched-in buffer beams and buffers. The chassis was painted and roof repainted (for variety). The result is top drawer.

Ratio have fitted and unfitted 10ft. WB chassis kits which will marry well with many RTR bodies. The fitted version has a separate floor and solebars, and this makes a convenient 'drop in' unit for many RTR van bodies.

Here is the unfitted version, which has an integral floor, built as Ratio intended – here seen ballasted ready for fitting to the Saxa body.

The Wrenn body comes with some very chunky grab irons either side of the door. When removed these leave some pretty big holes, far too big for the nice fine wire grabs that form the replacements. The answer is to cement some thickish Plastikard – 40thou. – inside the body, to give something into which the new grabs can be melted.

The Wrenn roof is a bit smooth and featureless, so I gave mine a 'canvas' texture with a single ply of something soft and strong, held in place by flooding it with solvent. The overhanging edges are trimmed when dry. The finished salt wagon can be seen in the frontispiece to this chapter, sporting a rather 'well worn' and grubby paint job that hides the proverbial multitude of sins, not all of them mine! As chapter 4 shows, this particular wagon started out as a junk-box find, as with so many of my RTR-based vehicles.

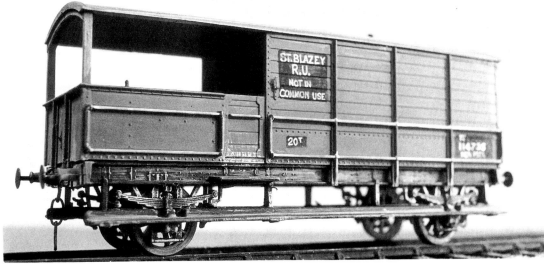

There isn't a huge choice of brake vans in the RTR ranges – especially if you're looking for good models. Neither the Lima nor Bachmann BR 20T brake vans are right, although a modified Lima body on a Bachmann chassis has possibilities – the Bachmann body is miles too long. Lima, as usual, is miles too high. The Dapol kit is spot-on, so I've never bothered with either. There are three really good RTR brake vans; Hornby's SR (ex-LBSC) design, and the Dapol, ex-Airfix, LMS and GWR 20-tonners, both of which are spot-on. I have converted all three, the last two on many occasions, and here is one of five GW 'toad' vans from my P4 china clay layout, 'Trerice'. This is an old Airfix model – secondhand, of course – which has benefitted from the mild work-over that is all that these excellent models call for. I don't replace the moulded handrails with wire, on the basis that the result if I did would probably look worse than the originals. Given that these rails are picked out in white, I find that this subterfuge is only apparent on the closest inspection. I do replace the lamp brackets with melt-ins, while the buffers get Maygib heads and springs. The brake handle on the verandah should be offset to the nearside rather than on the centre line, and I flush-glaze at least the end windows. Otherwise the body is well-nigh perfect. The chassis gets a rocking axle for P4 use – either the wire pivot bodge or an MJT etched rocking cradle – with P4 Kean-Maygib 10-spoke wagon wheels. Inline brakes are provided from D&S etchings (Ref D&S 100/BG4), and the 3-link couplings are Exactoscale hooks with EM Gauge Society links. One last touch was to carefully drill out and cut away the infilling of the W-irons above the springs, which I usually do on chassis I convert to P4. This particular example also received a full repaint from the GWR livery in which it came. It is lettered for a St. Blazey RU (Restricted User) van, appropriate to the china clay district. The weathering job also recognises the clay influence – in this case, the Real Thing!

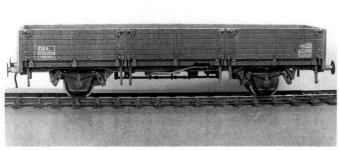
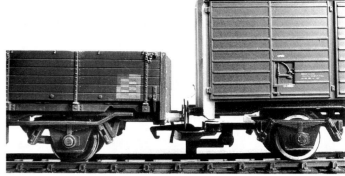

*Hornby's range of 45T GLW (Gross Loaded Weight) air braked stock is the backbone of any contemporary wagon fleet. As they come, these vehicles sit way too high on their trainset-type swivelling trucks. As can be seen from this picture of a modified OAA 3-door dropside open, lowering the body and solebars onto the axleguards effects a huge improvement in appearance, though even thus they're still not quite right; to allow for the over-high running gear, Hornby make the wagon sides slightly too low. Aaargh! Does it matter to the trainset brigade if their hip-swerving OAA is too high overall? So that when we adults scale it up, the end result is right? Hornby do make rods for their own back... Lowering and 'de-swivelling' Hornby wagons is a bit of a fiddle, the more so as the running gear is moulded in Delrin or some similar unstickable plastic. Even Daywat Poly won't touch it! This leaves two alternatives – 'welding' the parts together with a soldering iron, or the use of small self-tapping screws (or nuts and bolts) to join truck to underframe. The bodies are clipped to the underframes over the buffer shanks, and just pull apart. The swivelling trucks also pull off, and can be sawn down to lower them, as well as doing away with the tension-lock couplers and centring 'tails'. I make the lowering cut with a razor saw, just below the 'top' of each truck as illustrated. The lowered trucks are either welded to the rest of the underframe by melting plastic from the large 'boss' on which the trucks swivelled into the frame of the truck (do this in well-ventilated surroundings with a small iron – if you get this plastic too hot the fumes are evil) or drilling through truck frame and floor for a self-tapper or bolt. I use two per truck, as in the sketch. Take care that you get the axles square to the chassis, and that all the wheels touch the deck; compensation of some sort is no bad idea on so long a wheelbase. Cosmetically, it is necessary to represent the hangers attaching the axleguard units to the frames, which Hornby miss off. My effort is shown in the second sketch; fortunately, Daywat works on whatever the solebars are made out of – normal Polystyrene, I suspect. Air hoses are short pieces of insulated single strand GPO wire in holes drilled in the ends of the body mouldings, held with cyano or epoxy. The results are more than passable, if not particularly accurate to prototype. There are, anyway, many variants of this underframe with differing detail. Romford disc brake wheels are a nice finishing touch.*

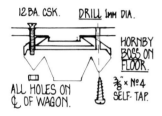

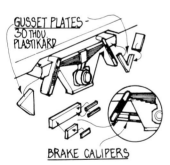

*The swivel-truck arrangement by which Hornby get these long wheel-base wagons around trainset curves results in an underframe that is unrealistic, with a large gap between axleguards and solebars and a greater-than-scale buffer height. De-swivelling and lowering these wagons transforms their appearance.*

*The swivelling trucks are pulled off, and cut down as shown in the photo and diagram. The modified trucks are refitted to the underframe by welding with a soldering iron, or by using screws as in the drawing.*

*As with most Lima wagons, the covered grain hopper benefits from a corrected ride height.*

*The extent of the problem. Bachmann get it right, while Lima are on tip-toes.*

*The only answer is drastic – saw off the axleguards and lower them to the correct height. Here, a 50T stone hopper gets the treatment with the faithful X-Acto.*

*And here are the offending items – corrected at left, 'as sawn' on the right. There is, you will note, quite a difference.*

*Here is the stone hopper with its running gear back in place – fortunately, Daywat Poly works well on whatever Lima underframes are made out of. The grain hopper has already been dealt with, and all is now well. But it's an awful fag if you've got a 24-wagon block stone train to tackle! While all the surgery is going on, I drill the bearings deeper to take standard 26mm axles – Romford's disc wheelsets, in this case.*

*Matters were complicated on the grain hopper by the brake lever, which sits in front of the axlebox pedestal, and is moulded integrally with it. The lever had to be cut away, and made good with styrene strip once the chassis was reunited. Oh, what fun! At least the end result is worthwhile, as can be seen from the lower frontispiece to this chapter.*

## Conclusion.

There are, of course, many more wagons, Horatio, than are dreamed of in your philosophy. Indeed, there hasn't been room to illustrate even half of my own fleet of RTR conversions in these pages, let alone those of my friends and acquaintances. However, I feel that the selection above, together with those popping up in the main text, should be sufficient to suggest the possibilities and, hopefully, to whet the modelling appetite So happy X-Acto and Daywat to you all!

## Bibliography.

The main books that I've used in converting RTR wagons are: British Railways Wagons, Don Rowland, David & Charles, 1985; Historic Wagon Drawings in 4mm. Scale, F. J. Roche, Ian Allan, 1965; BR Standard Freight Wagons – Pictorial Survey, D. Larkin, Bradford Barton 1979; Rolling Stock Worth Modelling Vols. 1 & 2. Bradford Barton, undated; A Pictorial Record of LNER Wagons, Peter Tatlow, OPC, 1976; An Illustrated History of LMS Wagons, Vols 1 & 2, Essery, OPC, 1981; A History of GWR Goods Wagons (Combined Volume), Atkins, Beard, Hyde & Tourret, David & Charles, 1986; GW Wagons Plan Book, Jim Russell, OPC, 1976; Freight Wagons and Loads in Service on the GWR and BR (WR), Jim Russell, OPC, 1981; An Illustrated History of Southern Wagons, Vols. 1 & 2, Bixley, Blackburn, Chorley, King & Newton, OPC, 1984 & 1985; Wagons on the LNER No.1, North British, J. Hooper, Irwell Press, 1991 – together with lots of general albums and magazine articles, not to mention a spot of field research.

## RTR WAGONS SOURCES INDEX

### THE WAGONS THEMSELVES
The products of the main makers, Dapol, Replica/Bachmann, Hornby, Lima and Joueff, are attainable from most model shops. Secondhand specimens can be obtained from shops or swapmeets, often very cheaply. My examples were provided by:-

ACE Models, 31 St Thomas Road, Launceston, Cornwall PL15 8DA. Tel. 0566 776463. Mail Order, ☎ ◩ Prop. Alec Hodgson.

Challis Models and Hobbies, 50B High Street, Shepton Mallet, Somerset, BA4 5AS. Tel. 0749 343527. Mail Order, ☎ ◩ Prop. Chris Challis.

The Model Shop, 15 St Davids Hill, Exeter, Devon EX4 3RG Tel. 0392 421906. Mail Order, ☎ ◩ Prop. Pete Lindsay.

### WAGON CHASSIS
Mostly I use the Ratio plastic versions but there are others:-

Ratio Plastic Models, Hamlyn House, Mardle Way, Buckfastleigh, Devon, TQ11 0NS. Tel. 0364 42764. GWR/RCH 10ft. wheelbase fitted – Ref.560; SR/RCH 10ft. wheelbase unfitted – Ref.124.

Cambrian Kits, PO Box 168, Taunton, Somerset, TA4 1LX (obtained through Mainly Trains, 13 Anchor Street, Watchet, Somerset, TA23 0AZ Tel. 0984 34543); RCH 15ft., 9ft. wheelbase wood and steel solebar, 16ft. 6in. wheelbase steel solebar. Plastic.

Kenline. No address. Exeter Model Shop has stock. RCH 9ft. wheelbase wooden underframe, white metal.

PECO. Pritchard Patent Product Co., Beer, Seaton, Devon, EX12 3NA. Wonderful Wagons chassis 9ft. wheelbase wooden solebar – Ref.R37.

Dapol Model Railways Ltd., Well Street, Winsford, Cheshire, CW17 1HW, Tel. 0606 592122. RTR chassis, RCH 10ft.×17ft.6in.; 12ft.×21ft.6in. wheelbases.

### WHEELSETS
Dapol/Bachmann/Replica type: from Dapol, address as above.

Romford: W&H Models, 14 New Cavendish Street, London W1. Tel. 071 935 5810.

Alan Gibson (Workshop), The Bungalow, Church Road, Lingwood, Norwich, Norfolk, NR13 4TR. Tel. 0603 715862.

Kean–Maygib: Kean–Maygib Precision Engineering, Wendover Road, Rackheath Industrial Estate, Norwich, Norfolk NR13 6LH. Tel. 0603 720792. The last three available at most model shops, including those listed. Wheel bearings (pinpoint) – Keen–Maygib, address as above.

### COMPENSATION UNITS
MJT Scale Components, 41 Oak Avenue, Shirley, Croydon, Surrey CR0 8EP. MJT also do disc brake inserts for Gibson/KM wheels (available from Challis Models and Hobbies).

### WAGON DETAILS AND RUNNING GEAR PARTS
Fourmost Models/ABS, 39 Napier Road, Hamworthy, Poole, Dorset, BH15 4LX. Huge range includes axleguards, buffers, brake gear, ventilators, and almost everything else a wagon can wear. Good modelshops stock these.

Kenline. No address. Another wide range but availability patchy. Turns up at shows – snap up if you see it.

MJT. As above. Wagon axleboxes for use with compensation units, etched brake parts, very nice buffers.

Keen Maygib/Gibson. As above. Turned sprung wagon buffers.

D&S Models, 46 The Street, Wallington, near Baldock, Herts SG7 6SW. Etched wagon detail including brake gear parts.

*There may be many others, which Rice has not discover'd,*
*These are the only ones*
*Of which the news has come to Chagford.*
*(With apologies to Tom Lehrer.)*

### COUPLINGS
MSE/'Sprat & Winkle' (3mm and 4mm versions) PO Box 13, Leamington Spa, Warwickshire CV31 1GN. Tel. 0926 885225.

Impetus/'Bringewood', PO Box 1427, Coggeshall, Colchester, Essex CO6 1UQ.

### MATERIALS AND TOOLS
John K Flack, 107 Hillcrest Road, Bromley, Kent BR1 4SA. Tel. 081 857 4611. Wire strip, milled sections, styrene sheet, rod, 'Evergreen' styrene strip, Swann Morton scalpels and blades, nuts and bolts, drills and taper broaches. Very good mail order, no credit cards.

Dolphin Crafts, 1 Mill Street, Chagford, Newton Abbot, Devon, TQ13 8AW. Tel. 0647 432257. (Jill Mahon, Paul Murphy). Art materials including fixatives, designers' colours and pastel chalks, full range of Humbrol acrylic paints and Krylon spray black. Mail order, no credit cards.